Ancient Chinese Bronzes

THE ARTS OF THE EAST
edited by Basil Gray

THE ARTS OF THE JAPANESE SWORD
by B. W. Robinson

ANCIENT CHINESE BRONZES
by William Watson

CHINESE AND JAPANESE CLOISONNÉ ENAMELS
by Sir Harry Garner

ANCIENT
CHINESE BRONZES

by

WILLIAM WATSON

FABER AND FABER

3 Queen Square

London

First published in 1962
by Faber and Faber Limited
Second edition 1977
Printed in Great Britain by
Robert MacLehose and Company Limited
Printers to the University of Glasgow
All rights reserved

ISBN 0 571 04917 6

To
K. S. M.

Acknowledgements

The author expresses his gratitude to the collectors and museums named in the captions to the plates for supplying photographs or allowing them to be taken, and for permission to use them in this book. Thanks are specially due to the Trustees of the British Museum, the Victoria and Albert Museum, the Museum of Eastern Art, Oxford, the Guimet Museum and the Institute of Archaeology, Peking. The Arts Council kindly allowed a photograph from its catalogue of the Seligman collection to be reproduced. Messrs Sotheby generously placed a file of photographs at the author's disposal. Inevitably some of the bronzes here appear attributed to owners whose possession they have left, in some cases, perhaps a score of years ago. Where no later information was available it seemed best to retain a familiar description for an important piece.

Contents

Illustrations

14*a*. Ting. 12th–11th century B.C.
 b. Ting. 11th century B.C.
15*a*. Ting. 11th century B.C.
 b. Hsien. 10th century B.C.
16. Yu. late 11th early 10th century B.C.
17. Fang Yi. 12th–11th century B.C.
18*a*. Fang Hi. 12th–11th century B.C.
 b. Chih. 12th–11th century B.C.
19*a*. Chia. 12th–11th century B.C.
 b. Bowl. Late 11th century B.C.
20. Ku. 12th–11th century B.C.
21*a*. Yu. Late 11th early 10th century B.C.
 b. Ho. Late 11th century B.C.
 c. Kuei. Late 11th century B.C.
22*a*. Ku. Late 11th century B.C.
 b. Ku. 12th–11th century B.C.
 c. Ku. 13th–12th century B.C.
23*a*. Yu. Later 11th century B.C.
 b. Yu. 11th century B.C.
24*a*. Yu. Late 11th early 10th century B.C.
 b. Yu. Late 11th early 10th century B.C.
 c. Yu. 11th century B.C.
25*a*. Rhinoceros tsun. Late 11th century B.C.
 b. Yü. Early 10th century B.C.
26*a*, *b*. P'an. 11th century B.C.
 c. The Shou Kunk p'an. Later 10th century B.C.
27*a*. Ting. Late 11th or early 10th century B.C.
28*a*. Ting. 11th century B.C.
 b. 11th century B.C.
29*a*. Ting. 11th century B.C.
 b. Ting. 13th–11th century B.C.
30*a*. Yu. Late 11th century B.C.
 b. Elephant tsun. 11th century B.C.
31*a*. Kuang. Late 11th–early 10th century B.C.
 b. Kuang. 12th–11th century B.C.
32. Kuei. Late 11th century B.C.
33*a*. The Ling Fang Yi. Late 11th century B.C.
 b. Yu. Late 11th century B.C.
34*a*. Fitting for chariot pole. Late 11th or early 10th century B.C.
 b. Fitting for chariot pole. Late 11th or early 10th century B.C.
35*a*. Ho. Late 11th early 10th century B.C.
 b. Ho. Mid 10th century B.C.
36*a*. Monster tsun. 11th century B.C.
 b. Owl tsun. 11th century B.C.
 c. Owl tsun. 11th century B.C.

ILLUSTRATIONS

11

83*a*. Knife with ibex-head pommel. 12th–11th century B.C.
 b. Ko with inlaid gold decoration. 4th–3rd century B.C.
 c. Axe, yüeh. 12th–11th century B.C.
84*a*, *b*. Lamps in shapes of ram and deer. Han dynasty.
 c. Gilt bronze ornament. Han dynasty.
85*a*. Pole finial from chariot. 3rd–2nd century B.C.
 b. Harness buckle. 7th–6th century B.C.
 c. Gilt bronze belthook. 4th–3rd century B.C.
 d. Belthook inlaid with gold and turquoise. Han
 dynasty.
86*a*. Belthooks. 4th–3rd century B.C.
 b. Belthook, gilt bronze with jade inlay. 3rd–2nd
 century B.C.
87*a*. Gilt bronze belthook. 2nd–1st century B.C.
 b, *c*. Left: Belthook. 1st–2nd century A.D. Right:
 Belthook. 2nd–1st century B.C.
 d. Belthook with turquoise inlay. 1st century B.C.–
 1st century A.D.
88*a*. Coffin handle. 3rd–2nd century B.C.
 b. Openwork ornament. 4th century B.C.
89*a*. Tiger. 4th–3rd century B.C.
 b. Tiger. 3rd–1st century B.C.
 c. Wrestlers. 5th–3rd century B.C.
90*a*–*b*. Mirrors, 4th century B.C.
91*a*–*c*. Mirrors. Late 4th–3rd century B.C.
92*a*. Mirror with turquoise inlay. 3rd century B.C.
 b. Mirror. 2nd century B.C.
93*a*. Mirror. Shou Hsien type.
 b. Mirror with dragon band. 1st century B.C.
 c. Mirror. 2nd century B.C.
94*a*. Mirror. 3rd century B.C.
 b. TLV mirror. Late 1st century B.C.
95. Mirror. 3rd century B.C.
96*a*. Dragon scroll mirror. 2nd century B.C.
 b. TLV mirror with cloud scrolls. Late 2nd or early
 1st century B.C.
97*a*. Mirror. Late 3rd–early 2nd century B.C.
 b. Astronomical mirror. Dated A.D. 121.
98*a*. Dragon scroll mirror. Late 3rd–2nd century B.C.
 b. Dragon scroll mirror. 2nd century B.C.
99*a*. Astronomical mirror. 1st century A.D.
 b. Star-cluster mirror. 1st century B.C.
 c. Astronomical mirror. 1st century B.C.
100*a*. Animal mask mirror. 2nd century A.D.
 b. Ts'ao yeh mirror. 1st century A.D.
101*a*. Dragon-band mirror. 2nd century A.D.
 b. Astronomical mirror. 1st century A.D.

ILLUSTRATIONS

Preface to Second Edition

Were it possible to recast and amplify this book, the various styles of pre-Han bronze would be described more closely in terms of regional traditions. This appears to be the direction which future scholarship must take, and to offer the best means whereby the student of art and the archaeologist can illuminate artistic and political history. But the text of the book is necessarily reissued without change, apart from minor corrections; and comment prompted by advances made in the fifteen years that have elapsed since the first edition is confined to this preface. Fortunately, the frame of stylistic analysis and dating built in 1961 has not been much affected, although a number of themes only touched upon then could now be taken farther. Nevertheless, the greatly expanded work of Chinese field archaeologists has revolutionized the study. As documented pieces are assembled in increasing numbers, attributed to place and associated with all the contents of the original deposit, the excavator inevitably displaces the epigrapher and literary historian as the prime authority. The vast number of bronzes of outstanding merit which are in collections outside China still bear witness to all the variety of artistic quality for which ancient Chinese bronze is noted; but for their historical elucidation we must look to Chinese publications.

DATING

Radiological dating available thus far still fails to resolve the question of the earliest date of Shang bronze, but does tend to corroborate the historical evidence for placing the Anyang period of the dynasty between the fourteenth and eleventh centuries B.C.[1] The exact date of 1027 continues to be accepted by the majority of scholars for the fall of the Shang dynasty. It has the approval of the Peking Institute of Archaeology, and is supported by calendrical calculations.[2] Within the Chou dynastic period an additional resource for estimating the relative age of sites is the typological study of pottery, which was hitherto somewhat neglected. By placing the potter's *tou, ting* and *hu* in sequence an extensive burial site such as Chung-chou-lu has been subdivided into nine stages from Western Chou to Han. Some of the most important bronzes to be published by the Peking Institute of Archaeology (in a preliminary form, since the material was removed to Formosa) are those of the tombs of the dukes of the Wei state at Liu-li-ko, in Hui-hsien, Honan (not to be confused with the

Shang tombs at the same place), and those from Shan-piao-chen, Chi-hsien, in the same province. The former were divided by the excavators into five periods, according to groups of burials related by their structure and contents, and thus dated between 445 and 225 B.C. According to this interpretation, some pieces attributed to the late fifth and the early fourth century are decorated with schemes resembling those seen on our Pls. 49a, 51a, 56b, 57b etc., and, if no mistake has been made, we must count with a much later survival of middle Chou style than is admitted in this book. It is possible, however, that the initial date of the 'Wei' tombs should be put higher, and less reliance placed on the broad historical inference which inspired the published dating. The bronzes excavated at Shan-piao-chen, being very like those of the famous tomb of the Marquis of Ts'ai (cf. Pl. 59b), corroborate the remark made below on the Honan origin of the Huai style.

THE EARLY HONAN STYLE

Of equal importance to this refinement of mid-Chou dating is the accumulating evidence for local styles prevailing at certain times, and for persistent local bias in the design of bronze decoration, even when fundamental motifs are altered. The Shang style as described here, guided as closely as possible by the pieces excavated at Anyang and Chengchou, remains the initial tradition of Honan; but if the term is taken to include bronze work of the Shang period in general, it must extend to territory only doubtfully subject to Shang rule, and must admit a new diversity of style. Thus a *ting*, decorated with human faces, and a tall, square-bodied *tsun* found in Hunan province, cause surprise if not consternation by their implication of a Shang presence south of the Yangtze (Burlington House *Catalogue* 1973, nos. 79, 83). The *tsun* is of the late Shang kind normal in Honan, but some passages of undecorated relief on the *ting* are aberrant. Other unorthodox pieces, recently discovered, which suggest the activity of provincial Shang *ateliers*, are an unusually smooth-surfaced owl-*tsun* from Shih-lou in Shansi and a vase *tsun* of quite exceptional size, quality and preservation which came from Fu-nan in Anhui. The ornament of the latter resembles the late Shang of north Honan in its exuberant deep relief, but the design of the *t'ao-t'ieh* and its adjuncts follows the manner practised at the earlier southern capital of Ao, in the vicinity of modern Chengchou. This style was thought to have been abandoned at the time of the northward move of the king's seat *circa* 1400 B.C. On the Fu-nan bronze the inclined planes of the relief produce an effect strikingly different from that of the more regular planes of the Anyang ornament, although in this respect it differs also from the early work cast at Chengchou.

PREFACE TO SECOND EDITION

The Shensi and Shansi Styles

The significance of the Pao-chi bronzes as marking an early Chou tradition peculiar to north-west China, as described in the present book, is reinforced by the large group of vessels found at Fu-feng, also in Shensi. In their ornament both groups give a prominent place to elements of iconography and style which burst upon the scene in Honan on the morrow of the Chou conquest of Shang. The masks and dragons of the Fu-feng vessels do not derive from those of Anyang any more than do the Paochi motifs, although they are clearly regional variants of a tradition which unites the north-west with central China. The suggestion previously made that bronze-founding was known in the Chou territory even before the fall of the Shang dynasty, cannot yet be verified directly from excavation, but still the circumstantial evidence of a Chou *art* contemporary with that of Shang is very strong, and increasingly challenges scholarship.[3] The Fu-feng bronzes carry to excess the hooked profiles of vertical flanges which have been recognized as the hallmark of the early Chou manner at the end of the eleventh century. The *lei* of Pl. 49*b*, also excavated in Shensi, comes from the same *atelier*. A *yu* from T'un-hsi in Anhui confirms the Western Chou date of the *chih* in Pl. 38 (Burlington House *Catalogue* 1973, no. 97). The crossing crests of the large birds, constituting the chief ornament, introduce the principle of interlaced design which during the following two centuries ousted static design at nearly all the centres of production. Stages of this evolution are seen in the ninth and eighth centuries respectively at Hsin-ts'un and Shang-ts'un-ling. None of the pieces marked 'transitional' in the captions to the plates can be paralleled among bronzes produced in controlled excavations on Shang sites, and they should probably all be assigned later than 1027 B.C. But the majority of them still do not reflect the full impact of the Chou style as it is seen in the major inscribed pieces of the reigns of Ch'eng Wang and K'ang Wang.

Features of a Chou tradition, with its roots in the north-west, are spread sporadically across north China from Shensi through Shansi to Hopei. At the great foundry at Hou-ma in Shansi, a tall *hu* excavated in 1961 (Burlington House *Catalogue* 1973, no. 100), and dated to about 500 B.C., combines three diagnostic features of style present in this northern zone:[4] (a) a dragon band almost abstracted into anonymity, which is typical of the class of bronzes designated 'royal Chou' by Karlgren, (b) an interlace of snakes which reinterprets the design of crested birds, and (c) projecting stylized figures of tigers, built of repeated spiralled detail, which perpetuate the principle of the vertical hooked flanges of Western Chou. As a matter of ecological difference and political separation (Shang hostilities with neighbours to the north and north-west are evident in inscription), one may presume that related artistic and technical ideas passed easily through the northern zone from west to east. Evidence of a sufficiently early date to illustrate this hypothesis is lacking in Shansi,

B

but bronzes such as those forming the 'transitional' Hai-tao-ying-tzŭ group in Hopei (Jehol) may mark an extension of the northern tradition which took place independently of the occupation of Honan and the destruction of Shang power. By the same token the styles of the Yen-tun-shan group (which includes the Chou-inscribed *kuei* referring to the conquest (cf. p. 52)) may denote a connexion with the northern zone made along the coast rather than a direct influence from Shensi. Such vessels as those shown on Pls. 43*a* and 47*a* (Jehol) and 50*a* (Kiangsu) should perhaps be interpreted as the first appearance in bronze of styles implanted earlier in their respective regions, rather than as marking the rapid dispersal of Chou style after the conquest.

The Hou-ma foundry appears to have continued active until the fourth century B.C., retaining features of the Li-yü style in the decoration of its bronzes. This kind of ornament appears in a late context also at Shanpiao-chen (e.g. M 59, dated to Period IV, *circa* 360–300 B.C.). Consequently the Li-yü style can no longer be seen as only a prelude to Huai style. We must suppose that Li-yü vessels were widely dispersed through central China, and were contemporary with the early and middle phases of Huai, although they were rarer than Huai-style bronze.

THE ANHUI STYLE

The *tsun* from Fu-nan mentioned above raised the question of the possibility of fine casting in Anhui in the Shang period. Two eccentric works also recovered recently in Anhui suggest that an independent manufacture of ritual bronze continued in this province from Shang to the middle Chou period. A *kuei* from T'un-hsi (Col. Pl. D) is decorated almost wholly in simple angular geometry, with the merest hint of a mask; and a zoomorphic *ting*, dated to the seventh or early eighth century (Col. Pl. E), gives an unprecedented (and clumsy) blend of motifs, which bear the strong suggestion of deliberate archaism already practised at this early period. One is reminded that the trend towards abstract geometry which overtook the late-Chou styles is first manifest in Anhui (the Marquis of Ts'ai's tomb), and produced its most original work farther south, in Hupei (see below on the Third Huai style).

THE MID-CHOU STYLE IN HONAN

The stylistic bias of the Honan *ateliers* is seen in the development which can be followed on the Hsin Cheng bronzes (p. 64 ff.). It lies towards geometric reduction of a still sinuous figure abstracted from the birds and dragons of the stereotyped 'royal Chou' tradition; but the trace of the origin persists, and a mere rectilinear diaper like that of the Anhui *kuei* just described is meticulously avoided. In the tight-packed diaper of Hsincheng, neighbouring units of design sometimes interlace, and the tell-tale head of a bird or dragon is nearly always identifiable. The *li* of Pl. 48*a* shows the point of departure, and the vessels of Pls. 51*a*, 57*a* and 57*b*

catch the diaper at stages of shrinkage still short of degeneration into anonymity. Examples of variants of this motif at all points of devolution are seen on bronzes excavated at Liu-li-ko. They are dated by the excavators to their Period II (403–362 B.C.), but offer the main argument for raising these dates. However, in spite of its unsettled dating, the site suggests that a more conservative Honan tradition of bronze ornament was contemporary with the earlier phase of the Huai style. Meanwhile, still remaining distinct from typical Huai design, the ornament of a *ting* recovered from tomb M 60 at Liu-li-ko is very close to the interlocking and animated bands of Li-yü. (A similar design covers the sides of the *yi* on Pl. 63*a*.) Some bells have both the masks and the bands of the Shansi style, but with spiral terminals raised in relief in a manner that heralds the Huai idiom. According to the excavators, M 60 falls between 360 and 300 B.C. Even if this date proves to be too low, the true age can hardly be less than that of tomb no. 80 at the same site, in which bronzes of the *second* Huai style were buried. One may conclude from these facts that different Honan *ateliers* retained their own selection of traditional patterns for varying periods, the Huai style in the strict sense becoming the universal idiom only from sometime in the fourth century, and not the fifth as has been supposed.

The First and Second Huai Styles

The Huai style received its name from Karlgren in the belief that the region of the middle Huai river in Anhui saw its rise. It is best to retain the name in order to avoid confusion, but it can be shown to be a misnomer. More recent excavations make it appear probable, and certainly more plausible, that the Honan masters were the inventors of the new decoration. The evidence comes again from Shan-piao-chen: in tomb no. 1 at this site were found two sets of bronze bells, one of five and one of nine pieces. To the former probably belong the great ex-Stoclet bell in the British Museum and other bells outside China which resemble it (cf. Pl. 68*a*), the whole having composed another chime of nine. The ornament of all of these agrees completely with that of the Cull *hu* (Pl. 55), which is also associated with a place in Honan. It is difficult not to see the Honan pieces as antecedents of the Ts'ai group from Shou-hsien, earlier in date and demonstrably prior in the evolution of style. Other bronzes at Shan-piao-chen, as noted above, closely parallel the Ts'ai work, both sets of vessels denoting a stage later than that typified by the great bells and their like. Thus the bronzes buried with the Marquis of Ts'ai may be taken to represent a Second Huai style; and the inference follows that the foundries from which the new style spread in devolving forms to other parts of China was in the first place Honan and not Anhui. Unless it is the clumsiness of some of the Ts'ai work, nothing allows us to regard it as the product of a distinct tradition of the Ch'u state (cf. Pls. 54*a*, 56*a*, 57*a*).

Not far removed in date from the great bells is the mask-cum-ring (p'u-shou) found at Yi Hsien, Hopei (Col. Pl. F), which the excavators

place also in the fifth century B.C. While this magnificent casting, in its combination of snakes, bird and dragons, its relief and ajouré, displays the most picturesque parts of the First Huai style with convincing marks of originality, it retains archaisms absent from the true Huai recension, (cf. the U-shaped lappets on the dragons' backs) and lacks the hook-and-volute, replacing it by a figure resembling the Indian pear. By these archaic traits the *p'u-shou* aligns itself with the Hou-ma *hu* described above. Both these pieces belong to the northern zone, and indicate where one must seek the components blended into the First Huai style of the Honan *ateliers*.

THE THIRD HUAI STYLE

With their strong bias towards extreme geometric pattern, the Honan masters moved irresistibly into cool abstraction from which the trace of recognizable animal form had wholly evaporated. The finest work of this kind was inlaid in silver or gilded bronze foil, but similar designs were adopted in plain casting and for lacquer painting. Painters, rather than metal masters, were perhaps the originators of the late geometric tradition. Three sub-divisions of the Third Huai style can be distinguished. In what appears to be the earliest of them, dating from about the middle of the fourth century B.C., the designs are tightly sprung and avoid obvious symmetry (Pl. 80a). Another large group of pieces has repetitive schemes which tend to symmetry about both vertical and horizontal axes (Pl. 76b). Distinct from both of these groups is the class represented by the bowl of Pl. 75a. The place where this piece was found is not recorded, but it is worthy of note that some other pieces with allied curvilinear geometry were recovered from a noble tomb at Chiang-ling, a Ch'u capital in Hunan. The general effect of the ornament resembles the lines of some skilled animal carvings in wood belonging to the same find. The carvings, at least, seem peculiar to this southern region, and it is possible that the bronze ornament should be seen in the same light, as a more intimate revelation of *Ch'u style* than anything which has been proposed previously. But the bronzes are dated to the fourth or early third century, and so can hardly represent an influence operating in the initial Huai formulation (cf. Burlington House *Catalogue* 1973, nos. 129–131).

TIENIAN STYLE

The kingdom of Tien, occupying the centre of the modern province of Yünnan, was countenanced by the Chinese emperor Wu Ti in 109 B.C., and continued independent for some thirty years before it was absorbed into the Chinese territorial administration. On the hill of Shih-chai-shan near Kunming the necropolis of Tienian kings and nobles was excavated in 1955–60 to yield a rich haul of bronzes of extraordinary artistic merit. Chief among these are some small figurines of animals, rendered in the round or in high relief, with a fidelity to nature surpassing anything of the

kind attempted in contemporary China. A remote contact with the artistic tradition of the nomads of the Central Asian steppes is suggested by the subject of the animal attack (Col. Pl. H(*b*)). This repeats a theme which can be traced westwards, occurring at successively earlier dates, to the art of the Pontic Scyths, and the Assyrian art which lies behind that. The Tienian relation to China is complex, for the Shih-chai-shan tombs contain some objects, such as halberd blades, which attest contact with north China as early as the eighth century B.C., while others indicate a trade, or exchange of gifts, belonging to the second century B.C. But the characteristic work, of which examples are to be seen also in the British Museum, is of quite independent and original inspiration.

ARCHAISM

In a tradition of design so conservative and slow-moving as that of the ritual bronzes, it is difficult in the pre-Han period to make a distinction between the unreflecting long employment of artistic motifs and the deliberate revival of elements of earlier style after they had positively fallen out of use. Regional variation and retardation of the kind which archaeological research now demonstrates may account for the unexpected reappearance of some motifs in mainstream art. The *t'ao-t'ieh* mask associated with the early phase of the Huai style is perhaps explained in this way, and not as an archaistic resuscitation. But an anachronistic collocation of ornament on a single vessel naturally raises a suspicion of deliberate archaism, or in some cases of incompetent modern reproduction. Fifteen years ago two pieces included in the illustrations to this book were accepted without question as products of the tenth and the eighth-seventh, century B.C. respectively (Pls. 37*b* and 50*b*). But the bird-head on the handles of the *kuei* find no convincing context in the art of the early Western Chou, either as to motif (being markedly different from the Chou bird found in other schemes) or as to stylistic treatment. The latter objection is the stronger. During the earlier stage of mediaeval archaism, in the late Northern or early Southern Sung, castings of similar quality were made, and probably the *kuei* should be placed in this category. The unusual rough workmanship of the *hu* in Pl. 50*b* excludes it from the acknowledged archaistic product of the palace foundries of the Sung and later dynasties. Nevertheless evidence of deliberate and misinformed archaism is seen in its strange combination of bird and dragon heads in the interlaced band, with their anachronistic accompaniment of triangular figures at the top, and a tiger mask which would be acceptable either much earlier, or possibly two or three centuries later. The antiquity of the mirror in Pl. 97*b* has also been questioned because of the supposed anachronism of the ram as sole ornament, and the unusual ductus of the outer inscription. It is true that no other instance can be cited from Han mirrors of such use of the seventh of the calendrical animals; but like some others of the twelve, the ram is commonly portrayed in Han art. The script is less defensible, and shows signs of finishing after casting. Even

so neither argument is conclusive for archaism, and the appearance of the metal does not contradict a Han date.

NOTE:
In this preface the now current method of hyphenating the syllables of Chinese place-names is followed. In the main text and select bibliography the syllables are printed separately, with a capital to each.

CHAPTER I

Introduction

T his book describes the artistic bronzes of ancient China from the beginning of bronze-founding in the middle of the second millennium B.C. to the end of the second century A.D. This period includes the Shang, Chou and Han dynasties, and constitutes the first great cycle of Chinese art. It was an age of narrow, tenacious traditions. Its stylized motifs, partly animal and partly abstract, can be traced through a singularly logical development. Towards the middle of the Han dynasty (at about the beginning of the Christian era), a more naturalistic style is introduced, and we then stand on the threshold of a decorative tradition which leads to the familiar art of mediaeval and recent times.

Since no buildings or monumental sculpture remain from ancient time, the bronzes are the chief testimony to the earliest artistic and technological achievements of the Chinese. Some bronze weapons and ornamental pieces, particularly those produced in the fifth–third centuries B.C., rank with the finest metal-work of the ancient world. But it is the ritual vessels which by their beauty and high craft have attracted most attention both in China and abroad, and on them the fame of the Chinese Bronze Age chiefly rests.[1]

The vessels were used in sacrifice to gods and ancestors, and — despite the injunction inscribed on many of them that they were to be treasured in use for ever — they were buried with the dead. All the pieces which survive to-day have been recovered from tombs during the last few centuries. Fortunately for their preservation, the alkaline soil of China is favourable to bronze, turning it to an attractive green or bluish-grey colour, pleasanter to the eyes than the gold-bright metal in its original state. Whether the ancient Chinese, like the Romans, came to appreciate the patina of old bronze for its own sake we cannot say. In recent centuries, before the example of foreign collectors had created a respect for the condition of a piece as it had been preserved in the soil, the Chinese custom was to darken, often to blacken, the surface by rubbing it with wax.

The nineteenth-century collector Juan Yuan[2] characterizes three successive attitudes adopted towards the bronze vessels. Before the Han dynasty they were emblems of privilege and power; from Han to Sung times their recovery from the soil was hailed as a portent; and from the Sung dynasty onwards, freed from superstition, they became the toys of collectors and the quarry of philologists and antiquarians.

The superstition attaching to the vessels in Han times no doubt was the

fruit of the Taoist preoccupation with magic. In the *Lun Hêng* we are told of 9 *ting* tripod vessels said to have been cast by the emperor Yü, founder of the Hsia dynasty, the earliest major division of the traditional chronology. On the possession of these vessels the power of the Chou King over his feudal subordinates was supposed to depend. The *ting* were lost in the final destruction of the Chou house by the ruler of Ch'in in 235 B.C. Shih Huang Ti of Ch'in himself tried to salve the tripods from a river, a pious act portrayed on a stone relief of the Wu Liang tomb in Shantung. Again in 163 B.C. Wen Ti tried to bring the tripods forth from the river by sacrifice. In 116 B.C. Wu Ti changed the title of the regnal period to Yüan Ting (first *ting*) following the presentation of a newly unearthed vessel to the throne; and his successor Hsüan Ti in 63 B.C. promulgated the regnal title Shen Chüeh (sacred libation goblet) when a similar presentation was made.

At the beginning of the Sung dynasty attention was concentrated on the bronze epigraphy, and lexicographers drew fresh material from them. We learn that the Emperor Chen Tsung ordered two scholars to study the inscriptions on a newly discovered vessel, a four-legged *ting*. No interest seems to have been taken in the forms of the vessels themselves before the middle of the eleventh century, when the official Liu Ch'ang is found engaged in studying a local find of bronzes at Yung Hsing in Kansu. A friend of the distinguished man of letters Ou-yang Hsiu and an antiquarian, he was aware that the district to which he had been posted had been near to the centre of government in the early Chou period, and his search for ancient remains led him to eleven bronze vessels which had been unearthed together. He had their inscriptions and pictures of the pieces engraved and distributed rubbings to scholars of his acquaintance. Nevertheless he was chiefly concerned with the ritual significance of the vessels and with identifying the Chou king in whose time they were cast.[3]

The Northern Sung dynasty saw also the first attempt at a broad classification and dating of the vessels. In 1092 appeared Lü Ta-lin's *K'ao Ku T'u* (Pictures for the study of antiquity) in ten volumes, in which 211 pieces of the palace collection and thirty-seven private collections were illustrated by engravings and briefly described. It was followed at an unknown date in the Sung period by a continuation, *Hsü K'ao T'u Lu*. The best known of these manuals, the *Hsüan Ho Po Ku T'u Lu* (The Hsüan Ho Album of Antiquities) was commissioned by the Emperor Hui Tsung from a group of scholars, of whom the chief was probably Huang Ch'ung-jui. It was printed probably early in the Ta Kuei period (1107–1111) and lists 839 pieces in the possession of the insatiable imperial collector. Wang Fu was subsequently ordered to add new acquisitions to the catalogue, this being completed in the 1120's and constituting the revised version, the *Ch'ung Hsiu Po Ku T'u Lu*, in thirty volumes, which together with the *K'ao Ku T'u* now survives only in late editions.

Unfortunately the history of these books robs us in some measure of their value as a record of pieces collected under the Sung dynasty. In the West the available copies of the books are only of the K'ang Hsi period. In successive reprints the printer's blocks were inevitably re-cut and the

quality of the illustrations suffered. Where unusual features appear in a picture, one cannot be sure that they were not introduced in a late, post-Sung edition. Moreover the authenticity of the *Ch'ung Hsiu Po Ku T'u Lu* as a Sung work has been questioned. The second edition, issued in the Chih Ta period (1308–11), was based on a manuscript copy of the Sung printed version, which was no longer extant. It does not seem possible to controvert the suggestion that the Chih Ta edition was compiled *de novo* at that time, and passed off as a reprint of the Sung work. The only surviving Sung editions of the *K'ao Ku T'u* and its continuation are said to have been in the library of the scholar Ch'ien Tseng at the end of the seventeenth century, since when both have been lost.[4]

The *K'ao Ku T'u* proposes to assign the bronze vessels to one of the three dynasties Hsia, Shang and Chou according to specific epigraphical criteria (see p. 82), though it is apparently not intended that these criteria should be regarded as sufficient in themselves for dating the pieces. Indeed only three vessels are attributed tentatively to the Hsia, and only one, more confidently, to the Shang dynasty. The last is a *yu* wine-bucket so dated, it seems, chiefly because it was found at T'an Chia, Yeh prefecture. This is the place called Yin Hsü, the 'Waste of Yin' (Yin being an alternative dynastic title of the Shang) which is recorded in history as the site of a Shang capital and located in north Honan in the vicinity of Anyang. Nine centuries later archaeological excavation was destined to confirm this tradition and archaeologists could still find no better argument for attributing uninscribed vessels to the Shang period than the fact of their finding at Anyang.

The *Hsüan Ho Po Ku T'u Lu* differs from its predecessor by including uninscribed bronze vessels and by a bolder division into dynasties: the Hsia is now omitted, and the Han dynasty is added as the latest category. The vessels are named more consistently, but compared with the cautious approach adopted by Lü Ta-lin, the authors of the *Hsüan Ho* manual appear arbitrary in their distinction between Shang and Chou. A notable advance however is the attention they pay to ornamental motifs: the now familiar names of the chief of them — the *t'ao t'ieh* mask, *k'uei* dragon, and thunder pattern — were adopted in this work. In both these catalogues inscribed vessels are designated by the name of the shape preceded by a personal name or other formula taken from the inscription, and in the *Hsüan Ho* catalogue uninscribed pieces are designated by the name of the principal decorative motif. This practice has been followed by Chinese scholars until the present day.

The study of the ritual bronzes naturally suffered a setback through the loss of the Sung imperial collection — and presumably of many private collections — caused by the invasion of Chin tartars in A.D. 1127 and the move of the emperor to a new capital at Hangchow. It was hardly revived before Ch'ing times, when the emphasis lay more than ever on philology. It was now customary to circulate ink impressions of bronze inscriptions without pictures or descriptions (beyond the titles) of the pieces from which they were taken. Questions of shape and ornament were quite neglected.

INTRODUCTION

As a result many inscriptions are recorded from vessels now lost, and of which no illustrations survive. In 1755 an illustrated catalogue of the collection of the emperor Ch'ien Lung was published by imperial command, the *Hsi Ch'ing Ku Chien*, in forty volumes. Its value is less than that of the Sung works, and among its 1500 items are included many fakes of Ming date. The bronzes were not again illustrated accurately and catalogued critically before the present century, when systematic archaeological research began in China.

The revived interest in ancient epigraphy and bronzes which led to the adoption of scientific archaeological methods can be dated to the last years of the nineteenth century. In 1898 or 1899 thousands of inscribed fragments of tortoise-shell and bone were discovered near the village of Hsiao T'un, a few miles north-west of the town of Anyang in the northern part of Honan province. They came to light either by the collapse of the bank of the river Huan, or through the activities of the local inhabitants who had been secretly supplementing their income by digging for bronze vessels in the area. The drama of the recognition of the bone inscriptions as oracular texts dating from the Shang dynasty has often been recounted.[5] Wang I-jung, a member of the Imperial Academy living in Peking, is said to have been the first to recognize the script of the bone fragments as the earliest form of Chinese writing. Almost simultaneously an antiquarian dealer named Fan Wei-ch'ing and the viceroy and collector Tuan Fang set about collecting the bones which apothecaries had for some time been grinding as a medicine. Wang I-jung committed patriotic suicide when foreign troops entered Peking in 1900. Meanwhile the source of the inscribed bones remained unknown, although they continued to be sought by collectors, among whom were the earliest western students of the subject, F. H. Chalfant and S. Couling.

The scholar Lo Chen-yü finally traced the bones to the vicinity of Hsiao T'un (which he first visited in 1915) and established that the inscribed texts consisted of questions put for an oracular answer which was to be read from cracks produced in bone by heat. For the first time aspects of Shang civilization were illumined by contemporary documents. The questions mainly concern the seasonableness of sacrifice to gods and royal ancestors, the propriety of sacrificial animals, the timeliness of hunting and military expeditions, the weather and the success of crops.

From 1910 onwards the literature on the subject of the oracle bones had vastly multiplied, the interpretation of the sentences being facilitated by volumes of facsimile reproductions published by Lo Chen-yü himself. Lo's initial study of the oracle script was soon followed by Wang Kuo-wei's reconstruction of the genealogy of the Shang Kings and their pre-dynastic ancestors, which vindicated the all but complete accuracy of the list preserved in history. Later Tung Tso-pin used the internal evidence of the oracle sentences to divide them into five periods, and so enhanced the historical significance of the information they contained.[6]

The knowledge of the Shang oracle script provided a new resource for the interpretation of the archaic script used in the bronze inscriptions,

some of the longest and most informative of which are separated by only a few generations from the time of the latest oracle sentences. Equally important was the decision now taken to excavate at the place where the oracle bones had been found. The tradition that the locality outside the village of Hsiao T'un was none other than the Waste of Yin was confirmed by the wealth of building foundations revealed there and by the grandeur of some great tombs discovered a short distance to the west, at Hsi Pei Kang near Hou Chia Chuang. The excavations began in 1927 as the first project of the archaeological section of the newly organized Academia Sinica, and continued season by season until the outbreak of war with Japan brought the work to a stop ten years later. After 1949 the Institute of Archaeology of the Academy of Sciences resumed excavations at Hsiao T'un and on other Shang sites, notably the great tombs near by at Wu Kuan Ts'un (1950) and Ta Ssŭ K'ung Ts'un (1953) and at Hui Hsien, about 100 miles to the south (1950). Still more interesting were the results of excavations around the Honan city of Cheng Chou, thirty miles south of Anyang, where the main effort of this research was concentrated from 1952. Here the remains appear to belong to an earlier phase of Shang history than that represented by the finds made at Anyang.[7]

As a result of these discoveries the main outlines of the material culture of the Shang period were revealed. Interpreted in the light of what is gleaned from the oracle sentences, the excavations suggest that no remains of bronze-age civilization in Central China can be attributed to a widely ruling Hsia dynasty antecedent to the Shang. Archaeology lends its support to the view, already expressed by some historians, that this dynasty, if it ever existed, was not of comparable stature to that of its successors, and that it was perhaps wholly a latter-day fabrication.

The Shang sites around Cheng Chou, of which Erh Li Kung and Pai Chia Chuang were the most productive, are divided into three stages stratigraphically. The typology of pottery and bronzes suggests that all three are earlier than the material recovered at Hsiao T'un, and they may be assigned provisionally to the fifteenth or fourteenth century B.C. The bronze vessels from Cheng Chou, though simpler than the characteristic forms from the northern city, already attest a technological level well in advance of that of the earliest bronze-users in the Near East and the Mediterranean region. It is one of the remarkable features of the Chinese Bronze Age that it does not open with the simple flat axes and daggers which characterize the Early Bronze Age of nearly every region of the West. When the knowledge of bronze-founding reached China it was applied forthwith, it seems, to the manufacture of bronze vessels of advanced design.

Traditional history relates and the oracle inscriptions confirm that Anyang was the Shang capital from the time of the nineteenth king P'an Keng, who is said to have moved there from the east, until the fall of the dynasty. The picture of civilization as it had formed in the Anyang period, from about 1300 to 1027 B.C., is not an unfamiliar one to students of the ancient pre-classical West. The city-state was ruled by a king whose actions

were controlled by a system of oracle-taking, and who could himself function as an augur. It dominated a region extending from Honan to Shensi in the west and probably to the eastern coast, and southwards to the Yangtse. The chief arms were the bow, halberd and fighting chariot. The kings were given splendid funerals, at which human victims were sacrificed in great numbers and treasure was buried. There is slight evidence of a form of feudal subordination of local potentates, and of slavery. The system of writing combined ideographic and phonetic principles in much the same way as the hieroglyphs of the Egyptians. Pillared buildings served as palaces, and artists carved bone, jade and limestone, and designed ornate bronze vessels. From the comparable achievements of the earliest Egyptian and Mesopotamian states, Shang China is distinguished by the excellence of its bronzes, which artistically and technically surpass anything known at a comparable stage of civilization in the West.

The Shang state was overthrown by the armies of Chou invading eastwards from their home in south Shensi and on the Wei river. The capital at Anyang was abandoned. A central area was placed directly under the control of the Chou king and the rest of the territory was divided among princes bound to him by oath in a feudal scheme. The seeds of the later internecine warfare were thus sown. The course of Chinese history until the unification of the empire by Shih Huang Ti of the Ch'in state in 232 B.C. was determined by the rivalries of the feudal states, variously allied as the authority of the king faded. Finally, the scene is dominated by the aggressions of the 'barbarian' state of Ch'u, based in the Yangtse Valley, to which the elements of Chinese civilization — including its bronze art — penetrated in the sixth century B.C. These events led to the disruption of the old artistic unity of the bronze art of Shang and the early Chou reigns. But while local styles now diverge, the uniformly high achievement of the bronze craftsmen is a constant feature of the civilization of the Central Plain wherever it spread.

While the inscriptions of the bronze vessels have been scrutinized in China since Sung times for the light they throw on this history, the development of their ornament was not discussed until quite recent times. The names of the scholars whose writings have laid the foundation of this study in the last thirty years will recur frequently in the following pages. In the east Kuo Mo-jo, T'ang Lan, Jung Keng, Umehara and Mizuno, and in the west Karlgren and Yetts have made the leading contributions to this study.

It has been the custom hitherto, both east and west, to give the age of the bronzes in terms of the dynasties and their subdivisions. In the present book the attempt is made to show all dates in terms of centuries. In order to do so some assumptions must be made and something must be said of the grounds on which the earlier and unconfirmed part of the historical chronology has been reconstructed. The first reliable date in Chinese history, as was recognized by Ssŭ-ma Ch'ien in the second century B.C., is a year corresponding to 841 B.C. Before that the choice lies between the periods of the traditional chronology, which assigns exact reigns to the mytho-

INTRODUCTION

logized rulers at the beginning of the king-list and begins at 2852 B.C.; and a chronology recovered from a variety of historical sources which places the end of the Shang dynasty late in the eleventh century B.C., casting doubt on earlier dates without substituting any exact figures.

The revised dates for the Shang dynasty are based on the chronology given in the Bamboo Books. From the current version of this work (which however is suspected of being edited not earlier than the fifth or sixth century A.D.) come the dates 1558–1050 B.C. Reconstructing the text from quotations of it in other works Wang Kuo-wei arrived at the dates 1523–1027. These figures have been accepted by Ch'en Meng-chia in his recent writings, and, in the west, Karlgren has accepted the year 1027 for the fall of Shang. According to the Bamboo Books 273 years intervened between the accession of P'an Keng, who moved to Hsiao T'un, and the destruction of the last Shang king. This gives 1300 B.C. for the establishment of P'an Keng's capital. The date 1523 B.C. for the beginning of the Shang reign receives some support from other texts as against 1765 B.C. of the orthodox chronology. The period of the Shang settlement at Cheng Chou would thus occupy the fifteenth and fourteenth centuries.

The historian's conventional divisions of the Chou period have little logic to recommend them. The earlier 'Western Chou' period ends in 771 B.C., when the Chou king was compelled to move his capital from Shensi, in the vicinity of Ch'ang An, to a new site near Loyang in Honan. The term 'Eastern Chou' is seldom used, and preference is given to picturesque terms with limits that in part are accidents of historiography. Thus,

Western Chou	1027–771 B.C.
Period of the Spring and Autumn Annals	770–481 B.C.
Period of the Warring States	481–221 B.C.

Besides replacing these confusing terms by dates estimated in centuries, we accept for the purposes of this book the regnal years of the earlier Chou kings as calculated by Ch'en Meng-chia from historical sources and from the evidence of the bronze inscriptions.[8] In the following table these dates are given together with those of the traditional chronology.

	Ch'en	Traditional
Wu Wang	1027–1025	(1122–1115) B.C.
Ch'eng Wang	1024–1005	(1115–1078)
K'ang Wang	1004–967	(1078–1052)
Chao Wang	966–948	(1052–1001)
Mu Wang	947–928	(1001–946)
Kung Wang	927–908	(946–934)
Yi Wang	907–898	(934–909)
Hsiao Wang	897–888	(909–894)
Yi Wang	887–858	(894–878)
Li Wang	857–828	(878–827)
Hsüan Wang	827–782	(827–781)
Yu Wang	781–771	(781–771)

INTRODUCTION

Future research may of course alter the dates prior to 841 B.C., and datings given in this book have to be revised accordingly; but a dating in centuries rather than by the dynasties and their subdivisions affords to the discussion of the subject a gain in order and clarity which is sufficient compensation for this risk. The period covered by the Lu annals *Ch'un-ch'iu* (Spring and Autumn) begins at 722 B.C., but archaeologists generally extend this backwards to join with the end of Western Chou at 770 B.C. Similarly the end of *Ch'un-ch'iu*, 481 B.C., is habitually taken as marking the opening of the Period of the Warring States, although the historically better founded dates 452 B.C. and 403 B.C. are favoured by some writers in east and west. The Peking organizers of the 1973/4 exhibition held in Paris and London chose 475 B.C. Since attribution merely to 'early Warring States' etc., is customary in Chinese archaeological publication, the precise opinion of the excavators is sometimes difficult to divine.

CHAPTER II

The Ritual Vessels

The bronze ritual vessels had a religious and social function. The marks cast on many pieces of Shang date appear to denote persons or clans, and numerous brief inscriptions designate the vessel for use in sacrifice to an ancestor and are sufficient proof that the veneration of ancestors was not confined to royalty. By the end of the Shang period a few inscriptions show that a vessel was given by the king to a meritorious subject. At first these awards seem to have been made only by the king. In the Western Chou period it is clear that they were an essential part of the apparatus of feudal rule. The feudatories copied the royal usage, and from about 900 B.C. bronze vessels were increasingly awarded by the feudal princes at their courts.

In the inscriptions are recorded instances of vessels intended to accompany their owners on journeys, or to be presented as wedding gifts, or cast to record a division of land. That a ritual vessel entered into the ceremony of oath-taking is suggested by the character *meng* (a covenant, to swear), in which an element standing for vessel or utensil is included. The study of the inscriptions reveals also that the vessels might be used in the *hsiang* and *pin* ceremonies for the reception of guests. Perhaps no strict division was made between vessels used ritually and others which served for everyday purposes in rich households. Eventually vessels approximating to the ancient ritual shapes were enshrined by Confucian piety in the traditional ceremonial. They were placed in Confucian and other temples, furnished the great altars at which the emperors performed the seasonal sacrifices, and stood on the tables which served as ancestral altars in private houses. Under the Sung and later dynasties they were copied in porcelain, jade and lacquer, and reduced to a banal rôle in ornament of every kind.

The Record of Rites of the Chou Dynasty, *Chou Li*, and the Record of Rites, *Li Chi*, both compiled from traditional material under the former Han dynasty, have a great deal to say about the ritual vessels and their correct use. So long as writers were preoccupied with the ritual character of the bronzes they have tended to look for a rather strict correlation of shapes and ceremonial functions, and to assume that the rôles allotted to particular vessels in old books had persisted from Shang times. The variation in the range of shapes and in the shapes of single types through the Chou period is enough to disprove both assumptions. The association of

31

different shapes, as observed in grave groups, betrays no striking uniformity. In Shang graves the wine goblets were often buried together. A *ku* with a *chüeh* was the commonest combination though occasionally these are accompanied by wine goblets of other shapes and wine buckets and pourers. The large vessels suited for preparing sacrificial meats, the *ting* and *kuei*, were often buried without wine vessels. After the first few decades of the Chou period the smaller wine vessels ceased to be made.

In the *K'ao Ku T'u*, the vessels are classified as follows:

> Food vessels: For preparing the food: Ting, Li, Hsien.
> For holding the food: Tui, Kuei, Fu.
> Wine vessels: For holding the wine: Yi, Yu, Tsun, Hu, Lei.
> For drinking the wine: Chüeh, Ku.
> Water vessels: For holding the water: P'an.
> For pouring the water: Yi (a character distinct from yi above).

Faced with the problem of identifying the vessels designated in ancient texts with surviving specimens, antiquarians could safely rely on tradition for a large part, but in a minority of cases a doubt remained, and argument turned on the meaning and written form of the vessel names. Much of this discussion is unintelligible without reference to the often very complicated history of the ideographs in question. The names the vessels now bear have various origins. Some are words used in the Shang period, though not necessarily with the stricter meaning given to them in modern times. Others are identifications made in Sung times of vessel names occurring in literature, to varying degrees confirmed from inscriptions on the vessels themselves; and a minority have been inferred or conventionally adopted more recently. The chief corrections made to the *K'ao Ku T'u* list affect *tui*, which as an ideograph and an object, has been shown to be identical with *kuei*; and *yi*, designated wine vessel by the *K'ao Ku T'u*, but now recognized as a term for sacral vessels in general. The *Hsüan Ho Po Ku T'u Lu* admits the latter as a general term but also uses it for a specific type. *Tui* is now applied to a form of late Chou invention and *yi* appears in the modern convention of *fang yi*.

It would be tedious to pursue the history of the nomenclature in detail. The early usage was not strict. Even the name for one of the commonest forms, the *ting*, which is well attested in inscriptions of Shang and later date, appears so frequently qualified by a preceding word, or enters with other elements into a compound character, that it seems to have a broader meaning than the tripod vessel to which we now restrict its use. Conversely, inscriptions on tripods sometimes name the vessel by distinct, uninterpreted ideographs which do not contain the *ting* element at all. On the whole it seems that in Shang times and later the designations of the sacral vessels, apart from special epithets which refer to ritual employment, were not more closely defined than the names of vessels in general. Vessel names occur which are not mentioned in the *K'ao Ku T'u*, especially among the jars and flasks of the later Chou dynasty, now designated mostly *hu*. The

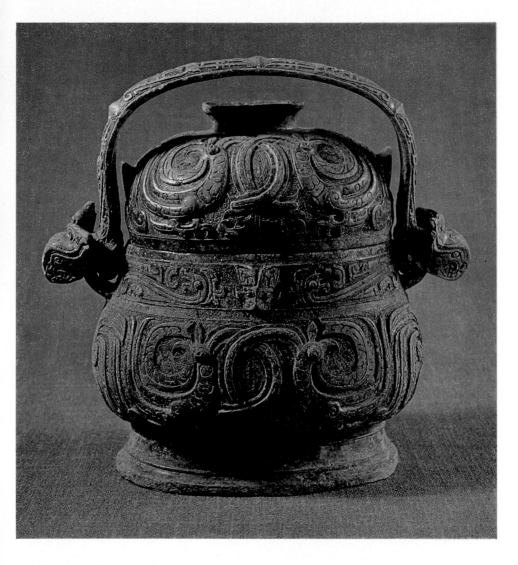

A. Yu. Inscribed by *Kung* with a dedication to use by descendants. Excavated in 1965 at T'un-hsi, Anhui. 11th–early 10th century B.C. Western Chou Dynasty. Ht. (including handle) 9¼ ins.

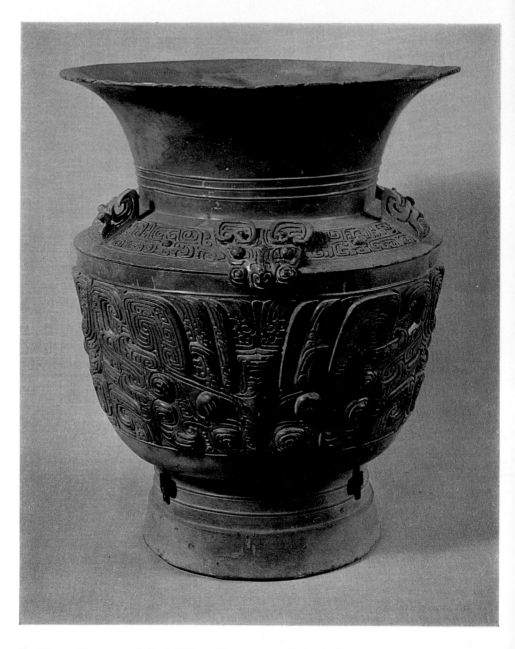

B. Tsun. Excavated in 1957 at Fu-nan, Anhui. 15th–12th century B.C. Shang
Dynasty.
Ht. 18½ ins.

bronzes of the Marquis of Ts'ai from Shou Chou for example, are marked with strangely written and unintelligible names which the excavators take to be dialect words for the vessel forms.

TING

Tripod pottery vessels are known in both the Lung Shan and Yang Shao neolithic cultures and are particularly numerous where these two cultures overlap, in the northern half of Honan province. The simple type consisting of a rounded bowl set on three solid legs is characteristic of the Yang Shao area. The Lung Shan variety, which is the only kind known in the east and north-east of the Central Plain, has the body divided into three lobes in the lower part, the pointed bottom of the lobes forming the legs. Both these tripods survived into Shang times, being made of pottery and bronze and often in shapes intermediate between the two ancestral forms. They are now distinguished respectively as *ting* and *li*, on the lines of the definition given in the late-Chou dictionary, the *Erh Ya*: 'A very large *ting* is called a *nai*; the *ting* with narrowing mouth is called a *ts'ai*; a *ting* with handles on the outside is called a *yi*, when the vessel has hollow legs it is termed *li*.'

These last remarks are not all supported by surviving bronzes and their inscriptions. In this respect they are typical of many definitions given in the ritual works and repeated in dictionaries which drew upon them. *Nai* and *ts'ai* are written with phonetics (yielding these modern readings) combined with the ideograph for *ting*. Both terms occur in Chou bronze inscriptions but they cannot be tied down to vessels of the types indicated here. The distinction seems to apply rather to ritual usage. In some later *ting* the handles are indeed attached to the outer edge of the rim, instead of rising directly from it; but these vessels cannot be linked as a class with a special name. The definition of the *li* is more intelligible as to shape. Still further variants of the *ting* character are found in inscriptions cast on tripod vessels, and sometimes they are preceded by *ssŭ*, i.e. grain or food.

The earliest known type of bronze *ting* is represented by specimens excavated at the site of Pai Chia Chuang at Cheng Chou.[1] They have deep bowls with rounded bottom and three short solid legs, pointed and slightly splayed. Loop handles stand on the rim, which has a shallow flange on the outer edge. In one specimen the body is grooved in the lower part to produce three shallow lobes, similar to the *ting* from Hui Hsien (Pl. 1a), but with somewhat deeper body and shorter legs. It is not certain where the Pai Chia Chuang graves which contained the bronzes should be placed in the Cheng Chou sequence, but they probably belong to the pre-Hsiao T'un period and fall in the fifteenth or fourteenth century. A more elegant version of the early type is seen in the *ting* of Pl. 2b. The distinction between a *ting* with shallow grooves in the body and the *li* with its more pronounced lobes is one only of degree. Karlgren calls the intermediate specimens *li-ting*. Both *li* of emphatic form and grooved *ting* are comparatively rare in the Hsiao T'un period of Shang, although the grooving

reappears in high-legged *ting* in the later eleventh and the tenth century (Pls. 14*b*, 28*a*).

The usual *ting* of later Shang times is round of body, with three column-like legs, a type which persisted into the tenth century (Pls. 13*b*, 14*a*, 15*a*). A few have an expanded mouth, giving an attractive S-curved profile (Pl. 12*c*). The four-legged vessel with rectangular body is a late Shang form, appearing first in the twelfth or more probably the eleventh century. Two famous specimens decorated respectively with a bull and a deer mask were excavated in 1935 from the great cruciform tomb no. 1004 at Hsi Pei Kang. The largest known vessel, the Ssŭ mu wu *ting* excavated recently at Wu Kuan Ts'un near Anyang, is of this form. It weighs about 700 kilogrammes and is 1·73 metres high.[2]

The rectangular *ting* had a short life. It is doubtful if any can be later than the middle of the tenth century. Some rare late-Shang tripods have legs in the form of flat bars representing dragons, birds and even human beings in profile (Pl. 2*a*). A few of these have a circular tray suspended between these legs an inch or two beneath the bottom of the bowl, as if intended for holding burning charcoal which heated the contents.

Tripod vessels of the ancient ritual lineage were made through the whole feudal period, ceasing at the beginning of Han. The chief stages are marked by the appearance, about 900 B.C., of a type with hemispherical bowl (generally shallower than a true hemisphere), and legs which are hipped and hoofed (cabriole legs). This design persisted thereafter. A savagely angular version of it was adopted in the south, in the Ch'u state, about 500 B.C. The elegant covered variety represented by Pl. 60*a* appeared in the north about a century earlier. In the last two centuries of the Chou period the near-spherical type held sway. From the sixth century the *ting* are nearly always provided with lids, although examples of covered *ting* are not lacking from the earliest Chou decades. One version of these last has a ring-foot in the middle of the lid which would make it usable as a dish.[3]

LI

Chinese commentators have not failed to remark that the hollow legs of the *li* would make for more efficient heating of the contents over a fire, although this advantage can hardly have weighed with the neolithic peasants who invented the shape. The *li* is not known outside China and it is a sign of the independence of the Lung Shan neolithic tradition. In Shantung and Hopei, the eastern province and formative centre of this culture, a pottery vessel is found with the three lobes of the body divided almost to the top, producing the shape of goats' dugs. A single bronze version of this so-called *k'uei* survives.[4] It has a tubular spout attached to the fixed domed cover which almost closes the mouth, and so would be classed with the wine-pourers called *ho*. The existence of this piece suggests that the corresponding pottery vessel of the Lung Shan culture survived into the Bronze Age. The decoration of the bronze *k'uei* relates it to the Pai Chia Chuang bronzes and suggests a pre-Hsiao T'un date. Like the Shang jades

which copy forms of the Stone Age, it looks like an archaic shape preserved by the ritual tradition. A famous vessel of square section from a Hsi Pei Kang tomb covered with the elaborate relief ornament of the eleventh century, follows the same general design (Pl. 21b). Hollow-legged vessels of this kind cease with Shang, though ho wine-pourers of the tenth century are still influenced by the li form.

Some vessels in which the three divisions of the body are sufficiently developed to justify the name of li stand on short solid legs, and have handles similar to those found on ting. Early specimens, of the fourteenth and thirteenth centuries, show the tapering, slightly splaying legs which are found on the contemporary ting. The legs are offset from the lobes, in the manner of the later and ornate Shang piece in Pl. 1b. In another kind the curves of the lobes pass smoothly into the legs, and it was this design which was destined to have the longer history. Four such li were recently excavated from tombs at P'u Tu Ts'un near Ch'ang An, close to the site of the ancient Chou capital.[5] Two of them were together with a ho bearing an inscription which is attributed to the reign of Mu Wang, in the later tenth century B.C.

In the li of Pl. 48a the line of the bottom between adjacent legs forms a continuous shallow curve. This so-called 'arched li' occurs among the bronzes of the Kuo state cemetery at Shang Ts'un Ling in Honan, which date between 800 and 650 B.C.[6] Its latest appearance is probably the undecorated specimen from the Ts'ai tomb at Shou Hsien, from the beginning of the fifth century, when it has acquired the heavy outline characteristic of the vessels of the Ch'u state.[7] It is tempting to connect the origin of the arched li specifically with Chou influence, since the earliest representatives of the type come from the heart of the old Chou territory. At Hsiao T'un however the rather similar shape of pottery li and the lower part of hsien suggest that the arched li may have developed in Honan. No arched li of bronze can however be attributed to the Shang sphere or period.

A food-heater of general rectangular outline and plan, which can be traced in sporadic examples from the eighth century into the late Chou period, is also rather inconsequentially classified as a li. In these the section beneath the bowl is closed by walls pierced with wide openings or by hinged doors, and is very suitable for holding a charcoal fire. These oven li are in most cases very ornate, with much plastic ornament in the form of dragons, tigers and monster masks.[8]

HSIEN

The hsien looks like a combination of two vessels, a bowl with expanded mouth set over a li (Pl. 15b). Some pieces have a partition with linear or cruciform perforations fixed at the constricted waist of the container. This was probably the normal arrangement, though the partition, being cast separately, is often missing in the surviving specimens. The hsien is evidently a steamer, and like the ting and li served for cooking the sacrificial

meats. An inscription on the Ch'en Kung Tzǔ *hsien*, cast in the small Honan state of Ch'en and made at least before 478 when Ch'en succumbed to Ch'u, speaks of its being 'for use on campaigns and journeys, for making rice and millet soup'.[9]

The ancient ideographs denote the vessel with the character for *li* combined with another element, which in some cases is the sign for dog to indicate the pronunciation. From early times the character with 'dog' was used (as it still is) with the meaning 'to present'. In defining it the *Shuo Wen* dictionary (A.D. 121) gives an example of the fanciful philology which so often influenced Chinese antiquarians. It says '*hsien* (written with the dog phonetic): a temple dog was called *keng hsien*. Fat ones were used in sacrificial offerings'.

Although no pottery *hsien* in one piece were made in the neolithic period or later, Anderson propounded a likely theory for its origin in pre-Shang time.[10] At Pu Chao Chai in Honan he found a pottery *li* with a ridge on the inside below the mouth, and near it a bowl with perforated bottom. He suggested that the two were designed to stand one over the other, so producing approximately the form of the later *hsien*. Pottery *hsien* consisting of two separate vessels were excavated from a Han grave at Hui Hsien in Honan.[11] The type had survived through two millenia.

Bronze *hsien* were made until the Han period, though by then the *li* shape of the lower portion had been abandoned. From Shang times until the later tenth century B.C. the shape continued unchanged. Specimens in which the upper and lower parts were cast separate, fitting together by a neat rabbeted joint, appear in the ninth century, when they are often four-legged and have a rectangular bowl.[12] Vertical loop handles stand on the lip or are attached on the side a short distance below. Sometimes both parts of the separable vessels are furnished with handles.

The *ting*, *li* and *hsien* were the chief vessels used in preparing the sacrificial food. The five vessels which follow are thought to have held the food after it was cooked.

KUEI

Many of the food-containers called *kuei*, *fu* and *hsü* are named by generic terms in their inscriptions: *tsung yi*, *pao yi*, *tsun yi*, *hsiang yi*, etc., all of which appear to mean merely sacral vessel, though some of them may refer to their use in a particular rite. A minority are named by the terms which are now applied to them. The confusion of names which is found in late Chou texts is understandable and underlines the fact that no regular distinction was made in their ritual employment. Cheng Hsüan in his commentary on the Chou Li (second century A.D.) remarks correctly however (if we judge from the inscriptions) that the *kuei* is round while the *fu* is rectangular. The Sung writers used *tui* for what is now called *kuei*, and *kuei* for the *hsü*, identifications which later scholars have shown to be mistaken.

The *kuei* is a round bowl standing generally (in the earliest specimens

always) on a ring foot, which was an innovation in Shang ceramics and a feature of the wheel-turned bowl which the *kuei* copies. Two early types of the bronze food-bowl are found, one with expanding (but not bulging) profile (Pls. 4*a* and *b*), and the other squatter, with convex profile and two massive handles with animal-head ornaments projecting from the sides (Pl. 43*b*). The second type is notably rare at the Anyang site (if we accept only reports of systematic excavation as evidence of locality) but common a little farther south in Honan, around Loyang, where it has been found included in a number of closed grave groups. The only piece of this kind attributable on the strictest evidence to the immediate vicinity of Hsiao T'un comes from one of the Hsi Pei Kang tombs.[13] Handles and body in this case have the unusually tense profile seen in the Ingram *kuei* (Pl. 43*b*), but the handles lack the appendages and the expanding foot-rim lacks the moulding of the lower edge which is regular on other specimens.

Apparently more characteristic of the Shang capital, for it often appears with the unmistakable late-Shang ornament, is the bowl with expanding profile (Pls. 41*a* and *b*). It may have massive handles similar to those of the squatter *kuei*, or lighter loop-handles like those of Pl. 43*a*, or it may be handle-less. It is on the last form that the ornament is unambiguously of the Anyang style (Pls. 4*a* and *b*). When it has loop-handles or is without handles this type of vessel is distinguished by the name *yü*, as inscribed on a piece excavated at Hsi Pei Kang,[14] and on the bowl of Pl. 43*a*: 'Food *yü* of the Marquis of Yen.'

When the bowls with expanding profile assume handles of the type seen on normal *kuei* they are probably not earlier than the later eleventh century. One piece of this kind was in the tenth-century tomb at P'u Tu Ts'un. The *yü* also belong probably to the later part of the Hsiao T'un period. The *yü* from Jehol and another from Yen Tun Shan in Kiangsu,[15] both peripheral areas of Shang and early Chou civilization, have aberrant styles of ornament. The same is true of two more splendid specimens in the Toledo museum (Pl. 25*b*). It is probable that the *yü* known at Anyang belonged to an eastern tradition, while the *kuei* with massive handles, which flourished after the end of Shang, was adopted farther west in the first instance, and belongs to a distinct Chou tradition.

From the end of the eleventh century, under the new Chou influence, the finest *kuei* become more massive, with elaborate zoomorphic handles, and are often cast in one piece with a square stand almost as high as the depth of the bowl. Some have four handles, and all seem to be designed to carry lids (Pls. 39*a*, *b* and 40*b*). The latter are generally furnished with a ring on top which serves as a foot when the lids are inverted to use as dishes.

Kuei with baroque monster handles and fluted sides, sometimes provided with small feet below the foot-rim, appear in the late ninth (Pl. 48*b*), and continue through the eighth century, without however displacing the pedestalled type. The latest datable representative of the latter comes from the Ts'ai tomb at Shou Hsien, of the early fifth century; though a group of pedestalled *kuei* associated by their inscriptions with the state of Ch'i may be as late or later.[16]

Hsü and Fu

The *hsü* is merely an elongated version of the *kuei* type of Pl. 48*b*, having an oblong bowl with rounded ends. It was introduced towards the end of the ninth century and continued for a few generations. The *fu* (Pl. 56*b*) began in the late ninth century and lasted until the fifth, having been adopted in the Ch'u region. In the *fu* lid and body are virtually identical and reversible.

Tui

The now current attribution of this name to the near spherical vessel shown in Pl. 65*b* seems to be amply justified by a statement quoted in a commentary to the *Erh Ya*: 'Although the *tui* is a container like the *fu* and *kuei*, it differs in being completely round, top and bottom, inside and outside.' It was first made probably in the later sixth century and continued in use until about the middle of the fourth. The strange projections on the sides serve to hold the halves upright as separate vessels.

Tou

Bowls on a high stem are one of the ceramic forms of the Lung Shan neolithic. A similar shape is found among the Shang pots, the bowl-stem becoming gradually higher through the chronological stages revealed by excavations at Cheng Chou. At Anyang *tou* were made of the superior white pottery and decorated with carved ornament. The ideograph used in Shang times to represent the *tou* is readily recognizable, and it is often seen in early Chou bronze inscriptions. It generally has some marks above the bowl representing the cooked grain or the steam rising from it. The earliest *tou* of bronze seems to be one in the Takeuchi Collection which has ornament indicative of the ninth century.[17] A simpler but similar piece excavated at Shang Ts'un Ling may be a century later.[18] In both the bowl has vertical instead of rounded sides and there is a raised cordon at the centre of the thick, concave pillar of the foot.[19]

By 500 B.C. the *tou* was designed with hemispherical bowl and ring handles, covered by a hemispherical lid and set on a slender stem.[20] The lid may have a foot ring, or projections like those of the *tui* serving the same purpose. *Tou* continued to be made until the third century B.C., and were abandoned at the beginning of the Han dynasty.

The vessels used in ritual for preparing and drinking or offering the millet wine begin with an even wider range than the food vessels. On the advent of the Chou dynasty however the more eccentric shapes used by their predecessors, the notoriously bibulous Shang, were rapidly abandoned, and the ritualists were content with various vases, often of slack and unenterprising design.

38

CHÜEH and CHIAO

The strangest vessel shape of all is the *chüeh*, which in graves is often paired with the *ku* goblet. The ideograph now used to represent the *chüeh* occurs in the ritual texts and is defined by the *Shuo Wen* dictionary as a ritual vessel. Although it has not been found in a bronze inscription its form is confirmed by occurrences in oracle texts. The brief inscriptions found on *chüeh* are placed on the small smooth space on the side within the handle, and if they refer to the vessel it is only by one of the generic terms. By the end of the Chou period the ideograph *chüeh* seems to have denoted goblet-like vessels in general; but it had a variant and perhaps original meaning, 'a small bird', and is in fact composed of a bird-like element combined with another signifying 'hand'. This inevitably suggested to the author of the *Shuo Wen* that the ancient goblet had been shaped like a bird, and that the name took its sound from a bird's cry. He transcribes the cry phonetically with characters meaning 'restraint' and 'sufficient', moralizing the name in the spirit of the ritualists and Confucians.

The *Yi Li* names the *chüeh* as the appropriate vessel in thirteen different ceremonials, but we cannot know whether the goblet now termed *chüeh* is the vessel intended. That it should be so is unlikely, because the vessels denoted by the name in recent times ceased to be made some six or seven centuries before the ritual texts were assembled in the form in which they have been transmitted. The ritualists tried to make sense of the apparently unnecessary variety of libation vessels recorded in ancient texts by supposing, for example, that the Hsia used a jade cup, the Shang a bronze *chia* and the Chou a bronze *chüeh*, or that the *chih* was used by honourable persons and the *chia* by the humble; or they suggested a difference of capacity, the *chüeh* holding one measure and the *ku* three. Needless to say the testimony of excavation and of the surviving goblets supports nothing of this. The current application of the terms *chüeh* and *chia* dates from the Sung writers.

The *chüeh* is a cup on three splayed and pointed legs of triangular section (Pls. 10 and 11). The handle on the side, nearly always surmounted by a bovine mask, stands over one of these legs. The projecting parts of the lip are at right angles to the handle. To the left of the handle is a spout with a rounded channel and opposite to it the lip extends outwards and rises to a point. From both sides of the lip at the junction of the spout rise two short columns which generally have stems free of ornament and are surmounted by caps which are oftenest domed and decorated with a whirligig pattern, like those of the *chüeh* illustrated on Pl. 10*b*. The earliest specimens dated by excavation are those from Pai Chia Chuang.[21] They differ from the later Shang type in having a cup with flat base and straight sides, the latter sometimes narrowed in the upper half by a step. The *chüeh* of the Hsiao T'un period has the cup bottom rounded, and the sensitive balance of its taut design, comprehending every part of what appears at first sight an uncompromising shape, is among the most satisfying forms produced in Shang art.

The variations of the *chüeh* shape are insignificant. Some pieces have a column on one side only, or rising from a bridge spanning the spout. A few have a lid decorated at the end with a bovine mask like the heads on the handles of the earlier *kuei*. A few have an almost spherical body and one piece a body of square section. Occasionally figures of birds replace the caps of the columns.

The rarer *chiao* differs from the *chüeh* in lacking the columns over the lip and in having the lip raised either side to points, without the spout. In some unusual examples said to have been found at Anyang the body is divided into three lobes in the manner of the *li* (Pl. 11a).[22] The normal meaning of the character *chiao* is 'horn'. A bronze cup with lid in the shape of a horn was excavated in 1934 at Hsi Pei Kang; but this is a piece without parallel.

The curious shape of the *chüeh* has prompted much speculation on its origin. Li Chi argued that a pottery form preceded the bronze one, but it is difficult to imagine that a potter invented its extraordinary shape. The numerous pottery versions found in Shang tombs, which naturally are simpler, are likely to be substitutes for the bronze vessel. The more summary pottery versions appear to be later on the whole than the more faithful copies. In the pre-Hsiao T'un period pottery *chüeh* are rare and close in shape to the bronze form, though no attempt is made to copy the blade-like legs and the capped columns of the metal goblets.

Kuo Pao-chün suggested that the *chüeh* shape was derived in the first instance from a cup made of an ox horn or a gourd to which two legs had been added to support it in an upright position. This remains the most attractive theory. The columns were an innovation in the bronze model, and Yetts's suggestion that they served for lifting the cup from the fire which heated its contents is very plausible.[23]

CHIA

This word also is often seen in the ritual texts with reference to wine vessels, but it has been attached to the form we now describe only from the Sung period. The *chia* is evidently related in origin to the *chüeh* and it appears with it among the earliest Shang bronzes, those from Pai Chia Chuang (cf. Pl. 3a). The lip regularly has the capped pillars, but no spout. In later Shang forms the *chia* acquires the same tense elegance as the *chüeh*, and is sometimes of considerable size. The splendid pair in the Nedzu collection are 73 cms high. A few pieces with rounded or *li*-like body are known, but the shape seen in Pl. 19a is more typical. The four-legged type is the rarest and probably belongs to the same late-Shang period as the rectangular *ting*, whose design it echoes (Pl. 8). The *chia* was of no less importance than the *ting* and *chüeh* in the Shang ritual. Its ideograph, like that of the *chüeh*, appears in the oracle texts and is easily recognizable as the bronze vessel by the representation of the capped columns at the mouth. Wang Kuo-wei established that the word *san* used in many texts is descended from the ancient *chia* ideograph.

Ku and Chih

Kuo Pao-chün propounded the theory that the imposing goblet termed *ku* (Pls. 20, 22*a*, *b* and *c*) originated from a cup made of two ox horns joined at their points to form bowl and stand. The swelling placed at the centre of the body, where it is always covered with a distinct band of ornament, he explains as a fossil of the joining device. The bottom of the container coincides with this portion of the vessel and the foot is hollow. The early specimens from Pai Chia Chuang and Hui Hsien[24] are stouter and lower-waisted than the developed late-Shang *ku* seen in Pl. 20.

All of them have one or two cruciform perforations in the plain band below the middle zone of ornament. Instead of the hole there is sometimes a depression of the same shape, as if the device in the casting mould which ensured this perforation in the metal had failed in its purpose. The perfection of the rest of the casting in specimens which display this feature makes it unlikely however that it is merely the effect of carelessness. No satisfactory explanation of the cruciform hole or mark has been advanced. It seems unlikely that the bronze-caster should have adopted a method of steadying the inner core of his mould which left so obvious and peculiar a tell-tale mark. Besides, a similar cruciform hole was made in the side of an ivory goblet excavated at Cheng Chou.[25] An intermediate stage in the development of the *ku* is seen in the specimen of Pl. 22*c*; the slenderer profile had been adopted before the standard late-Shang ornament of vertical-blade motifs were added to the sides of the flaring mouth.

The *Shuo Wen* defines the *ku* and *chih* as drinking goblets. The term *chih* is now reserved for a low cup, generally with S-curved sides, sometimes with cover, particularly in the more ornate examples (Pls. 7*a*, 12*a*, *b*, 18*b* and 38). The section may be oval, and the cup always stands on a ring foot. None of the wine vessels so far enumerated was made for long after the fall of the Shang dynasty. The ornament of some of them shows that they continued to be made in the earliest decades of the Chou period. They disappear after about 1000 B.C. Two *chüeh* are included in the group of vessels excavated at P'u Tu Ts'un in Shensi which also included a *kuei* of late tenth-century type; but apart from the possibility that the *chüeh* were already old when it was buried, the excavators' statement that the *chüeh* were not found *in situ* leaves their alleged close association with the *kuei* open to doubt.

Yu

This wine-bucket with swinging handle appears only late in the Shang period and disappears by about 900 B.C. Its characteristic form is seen in Pl. 23*b*, where it has the emphatic ornament of the latest Shang style. The body has an oval section and the handle crosses the narrower width of the vessel. The transfer of the handle to the wider axis, changes in the form of lid and the general profile coincide with decorative schemes which were in vogue at the end of the eleventh and the first half of the tenth century.

The squat form of Pl. 24a marks the final stage of the development.

A group of slenderer *yu* also survive from the Shang into the early Chou period, though they are rarer than the other design (Pls. 24b and c). A *yu* with square body in the Hakuzuru Museum is the finest of these. Vessels with and without handles copying the full form of owls (Pl. 36c), and the monster with victim (or protégé) shown in Pl. 36a served the same purpose. Zoomorphic *yu* belong to the eleventh century at latest.

The current use of the word *yu* to describe the wine-buckets goes back no farther than the Sung antiquarians. The Shang form of the ideograph is known but the shape it suggests corresponds to no surviving vessel of Shang date. It appears to represent the outline of an asymmetric vase, coinciding remarkably well with a flask type of which the surviving examples must be dated much later (Pl. 77a). The earliest of them, judged by its ornament, cannot be placed much before 700 B.C. The only explanation seems to be that the term *yu*, which took an ideographic form based on some vessel made of perishable material of which now no trace survives (the shape would be a tolerable representation of a wine skin), came to be used for wine containers in general. This would account for its use in the early Chou period, e.g. on the Mao Kung *ting* (c. 800 B.C.), when the vessels we now call *yu* were no longer made. Eventually the shape of the ideograph was taken to stand for a specific ritual vessel of ancient times, and it was copied approximately in bronze.

TSUN

This is an ancient generic name for ritual vessels which the Sung cataloguers used for a variety of shapes not easily placed elsewhere in their system. It regularly appears in the formula *tsun yi*, the generic term for a sacrificial vessel, at the end of the dedicatory inscriptions on vessels of various shapes.[26] The current conventional usage groups under it, quite arbitrarily, a certain stout vase and any vessel in the complete shape of an animal which is not already accounted for by the zoomorphic *yu*.

The vase-*tsun*, in its Shang form, is like a thickened *ku* (Pl. 6b); or a wide vessel with flaring mouth and either swelling and sharply shouldered middle part and a high expanding skirt or foot-rim (Pl. 9a, Col. Pl. B), or with S-curved side in the manner of the *chih* (Pl. 40a). None of these was made before the Hsiao T'un period, and the second survives longer, acquiring a square section and heavy ornament in the tenth century.

The zoomorphic *tsun*, which are some of the most attractive works of the eleventh-century bronze-masters, include rams (in the outstanding piece of the British Museum, Col. Pl. C, they are set back to back) and elephants. A horse recently excavated at Mei Hsien in Shensi, and a few birds and rams probably belong to the tenth or ninth century. The terms *hsi tsun* and *hsiang tsun* occurring in the late Chou texts and misunderstood by their commentators are an accurate description of vessels imitating sacrificial animals (*hsi*) and elephants (*hsiang*) in their shapes (Pls. 13a, 25a, 30b, 36).

Hu

This is the least particularized name of all, and is used in modern Chinese for any vase. Pieces which are now classified as *hu* are often named in their inscriptions by one of the general terms for ritual vessel, rarely by the *hu* ideograph. From Shang to Han they vary greatly in design, but broadly constitute a class of tall-shouldered vases with two handles set near the mouth. It is on this metallic shape that the ideograph is based. Shang specimens, which appear to belong to the later part of the dynasty, do not however conform to this prescription; they have usually an approximately pear-shaped body of oval section (Pl. 5). Another kind, falling about the borderline between Shang and Chou, in the late eleventh century, is round in section, and has a tenser profile. Both these early types are distinct by their handles, which take the form of two short, vertical tubes, suited to holding a rope for lifting and suspending.

By about 900 B.C. a heavy, big-bellied *hu* appears, and this type, often of square section, continued into the seventh century (Pls. 52 and 53). A new design, with fully modelled tiger handles and other plastic animal ornament, was introduced in the late sixth or the early fifth century, and made in Ch'u territory (Pls. 54a, b and 55). It is represented by elaborate specimens from the Ts'ai tomb at Shou Hsien and by the two Yü Han Wang *hu* in the Cull collection, for which the date 482 B.C. was argued by Yetts and accepted by Jung Keng in his second treatise on the ritual bronzes. In the north at about the same time the *hu* assume the form seen in the T'ang Shan (Pl. 64b) and Hui Hsien pieces.[27] The chain handle of the latter provided a feature which continued into Han times. The flat flask, *pien hu*, or *ch'ü* (Pl. 67b) was probably not made before 300 B.C. The asymmetric *hu*, which has been mentioned in the discussion of the *yu*, seems not to have been made outside the limits of the sixth and fifth centuries, and the *hu* set on a high foot shown in Pl. 66b is an unparalleled eccentricity.

Lei

This name covers a class of wide vases, generally with curved sides and two handles, which often have free rings hanging from them. One type of the *tsun* is distinguished from them only by its more angular profile. A few *lei* are given this name in their inscriptions, but the word seems to have no strict application. A Shang piece classed under this head (though this variety is often *p'ou*) is shown in Pl. 3b. Here the handles are absent, though a few like vessels are provided with them.

In the pre-Hsiao T'un period a higher vase, with narrow mouth and sharply carinated shoulder, belongs to the same lineage. Tall vessels with bodies of square section, high necks and roof-lids (like those of *fang yi*) are covered with elaborate late Shang ornament. To the later part of the Shang period belong also tall, rounded *lei*, with rings in the handles and another loop near the base which no doubt was used in tipping out the contents.

The contrast in shapes of *lei* between the tenth and early sixth century

may be seen by comparing Pls. 49*b* and 51*a*. Thereafter bulging vases with short vertical necks continued to be made, although they show no close affiliation with the early designs in profile or ornament.

The later *lei* have been variously named *chan*, *fou* and *min* after words occurring in inscriptions cast on them. The ritual texts and the dictionaries refer to the use of these vessels in ritual to hold wine or water.

KUANG and YI

All the vessels shaped like sauce-boats and now distinguished by these names into two classes were known to the Sung cataloguers indiscriminately as *yi*. The division was first made by Wang Kuo-wei. He instanced a number of occurrences of the term *ssŭ kuang* in the Book of Odes. Taking *ssŭ* to mean ox, he defined as *kuang* those vessels which have a lid decorated with a stylized representation of this animal. Some objections have been raised to his theory, chiefly concerning the *ssŭ*, but the name remains in use for the vessels in question since no inscriptions on them give any clue for or against his identification.

The ornament of the earlier *kuang* suggests the Hsiao T'un period of Shang for their manufacture, and chiefly the later part (Pl. 31*b*). A late and degenerate specimen (Pl. 50*a*) was found with the Nieh *kuei* at Yen Tun Shan in Kiangsu,[28] and dated by the inscription on the latter to the reign of Ch'eng Wang or immediately after, at the very end of the eleventh century. The *kuang* is described as a vessel for mixing wine, and the partial division of the body of some into two chambers and the provision of a ladle lends colour to this view (Pl. 31*a*).

The *yi* are so called in some inscriptions appearing on them. A specimen found at Shang Ts'un Ling points to a date for the earliest in the eighth or the early seventh century. The *yi* in the Sedgwick collection (Pl. 49*a*), a near twin of the Shang Ts'un Ling piece, has an inscription referring to a king of the Ch'u state. Since the assumption of the royal title by the Ch'u ruler was a critical political question of the day, the use of it here gives an indication of date. Yetts argued that the *yi* was cast before the Ch'u king's second arrogation of the title, in 704 B.C. (see p. 84).

It thus appears that at least two centuries passed between the abandonment of the *kuang* type of vessel and the introduction of the *yi*, and so it is unlikely that they represent changes in the shape of a vessel of the same ritual lineage.

In the *Tso Chuan* (fourth to third century) there is mention of 'offering the *yi* for washing the hands'. Probably it is correct to associate the *yi* with the *p'an* (see below) as a water vessel used in ritual ablutions. No examples of it date after the fifth century, or possibly the fourth century B.C.

Ho

By this word the *Shuo Wen* dictionary understands only 'to mix flavours', but its appearance in inscriptions on spouted vessels to which the

name is currently applied, proves that the Sung cataloguers were right in their identification of the term. In the shape seen on Pls. 35a and b, with three or four legs, the body lobed or copying the li form, the ho belongs to the later Shang dynasty and the early Chou dynasty, down to about the end of the tenth century. The inscription on the P'u Tu Ts'un piece (Pl. 35b) implies the reign of Mu Wang. The inclusion of a ho with the set of wine vessels from Pao Chi Hsien set of wine vessels in the Metropolitan Museum vouches for its use in the wine offering.

Vessels with tubular spouts can be traced throughout the Chou period, and they often assume quite eccentric shapes, though none so surprising as the ho of the Freer Gallery which has a lid representing a horned human face. One found at Shang Ts'un Ling has a body of oval outline with flattened sides. The old elegance was not recaptured until the fifth century, when the design of the body and legs follows that of some contemporary ting (Pl. 51b). Pourers of this last kind are sometimes distinguished as chiao (a different character from the goblet whose ideograph has the same modern pronunciation).

FANG YI

The fang yi, or square sacral vessel, so called by recent convention, is usually described as a wine holder, but without clear reason. Its purpose is uncertain, but the high quality and rich ornament of the vessels leaves no doubt as to its important ritual rôle. The fang yi too is a late Shang type (Pls. 17, 18a and 33a). The body is rectangular, in the earlier specimens has straight sides leaning slightly outwards, and, later, bulging in a shallow curve. The lid is roof-shaped, surmounted by a knob which repeats its shape. The latest form is seen in a fang yi excavated at Mei Hsien, Shensi, in 1956 which bears an inscription attributed by Kuo Mo-jo to the reign of Yi Wang, at the very end of the tenth century.[29] Here heavy ornamental handles are added on the narrower ends.

P'AN

In the description of the 'ceremonial of the banquet for officials' the Yi Li speaks of the 'attendants preparing the p'an and yi at the entrance of the eastern hall', and from a number of other allusions in the ritual texts we know that both these vessels were used for washing the hands on ceremonial occasions. The p'an is a shallow round basin, on a ring foot in the earlier specimens. One was excavated at Cheng Chou and so is dated before the Hsiao T'un period, but early-looking pieces attributable to the Shang period are rare, and they appear to belong to the end of the dynasty.

A frequent scheme of decoration on the early p'an consists of fish and a large serpentine dragon coiled in the centre of the bowl, both appropriate to a water holder. It is used on a p'an excavated at Shang Ts'un Ling and thus appears to have persisted into the eighth or early seventh century (Pl. 26).[30] From the early Chou period the p'an have loop handles, as seen on

the Nieh Jen *p'an*, whose long inscription concerning the division of territory is referred by Kuo Mo-jo to the reign of Li Wang, towards the middle of the eighth century B.C.[31] In the ninth and eighth centuries they copy the *ting* of the time in having three small feet below the foot-rim. Both foot-rim and tripod *p'an* were made in the south from about 500 B.C., and are often decorated with the fully modelled dragons which were then fashionable for the best bronzes.

CHIEN

Two celebrated examples of this bowl, both including the name *chien* in their inscriptions, belong to the early part of the fifth century (Pls. 59*a* and 60*b*), and one included among the bronzes of the Marquis of Ts'ai from Shou Hsien tallies with them in date. The deeply grooved neck and masked handles with rings are characteristic, but bowls answering closely to this description appear not to have been made before or after the fifth century. Some earlier bowls with more angular profile belong however to the same class. One is of the seventh or eighth century, and another, fitted with a lid, belongs probably to the sixth century. It is possible too that the bowl of Pl. 19*b* of the later eleventh century should be regarded as an antecedent of this type.

The purpose of the *chien* cannot be more closely defined from the ritual books than the other vessels of less specialized form. *Chien* was a name for a washing bowl, and it appears not surprisingly from a passage of the *Chou Li* that it could be used for a variety of purposes: 'In early spring the *chien* are set out . . . warm foods are inspected in them, and . . . wine likewise. In the sacrificial rites an ice *chien* is also supplied.'

Ornament

The impulse which directed the most characteristic art of the Shang period is similar to that which a thousand years later inspired the art of the nomads of inner Asia. Its chief concern is with representing the bodies of real and mythological animals in two-dimensional pattern. It separates and distorts elements of the design, recombines the fragments into new motifs, more or less abstract, and adapts the whole neatly to prescribed areas, such as panels covering the sides of ritual vessels. When the subjects are treated in three-dimensional form the same fantasy is at work, and some of the happiest inventions are seen in vessels which copy the whole animal, with monumental effect, or in the application of animal forms in relief and openwork to the shapes of weapons and other useful objects.

In the bronzes this art is displayed at an advanced stage of development. Neither the material excavated at Shang sites nor the relics of the preceding cultures throw any light on its growth in the earlier stage. Parallels have been drawn between the designs of the bronze art and those painted on neolithic pottery of the north-western tradition, but the latter are almost exclusively geometric and too simple to prove a close connexion. The decorative styles of Shang art were not confined to bronze. Carved white pottery, carved and inlaid wood, ivory and bone have survived with ornament of the same kind. The bronze art is clearly an extension of these other crafts, and it hardly takes an independent path before the last few decades of the Shang period. The extravagant plastic effects which appear at this time seem to be the inventions of the bronze-caster, and exploit the special potentialities of metal.

Before this liberating step was taken the bronzes faithfully reproduced the motifs and style of ornament which had been developed in the carving of softer materials. The fact that this ornament was carved, and not moulded, determined the character of its reproduction in metal. In the sharp angles which separate the surfaces of the ornament the trace of the carver's knife survives and the clarity and loving precision of the designs are in keeping with this ancestry. The decline of these qualities in the late eleventh century B.C. marks a changed and more independent status of the bronze craft, and heralds a new tradition.

The predominance of strange and sophisticated shapes and patterns in most of the products of Shang art that have come down to us tends to

47

obscure the gift for realistic animal portraiture which the artists of the Shang and early Chou period undoubtedly possessed. The creators of the later animal art of the Asiatic steppes worked in a comparable idiom of convention and abstraction, but a feeling for organic form was nonetheless fundamental to their stylizations. Both they and their predecessors of the eleventh century B.C. would on occasion portray in bronze a real animal with fidelity and insight.

The realistic animal art of Shang appears in the small jade amulets, which include silhouettes of birds, hares and other animals. A sympathetic eye has observed the ibex-heads and horse-heads which provided the models for the pommels of certain bronze knives (Pl. 83a), which can be approximately paralleled in the near-contemporary remains of the bronze age of south Siberia. These are one of the few links which join the narrowly circumscribed world of Shang art with a broader tradition. The lively profiles of horses of the steppe race which figure in some emblems cast on the vessels (e.g. a *ting* in the Seligman Collection) are free from the prevailing conventional distortion. Such realism is however rare in the bronze ornament. A striking example of it is seen on a vessel made about a generation after the fall of Shang, in the naturalistic deer with back-looking heads which are placed on the lid and neck of the Mo Tzǔ *yu*.[1] The exotic note of naturalism in this case is probably a deliberate departure from custom. The inscription on the vessel commemorates a royal hunt and the gift of three deer from the king to the Prince of Mo. The prince bears a name which is applied in the Book of Odes to a tribe of the north-east region.[2] Some centuries later, in the mid-Chou period, a distinct and near-naturalistic style in the representation of men and animals (as seen on the 'hunting *hu*', cf. p. 68 below) appears to be localized in approximately the same area, the territory of the state of Yen. The naturalistic animals of the Mo Tzǔ *yu* are perhaps an allusion to a style recognized as peculiar to the north-east, the region of the modern province of Hopei. Sophistication of this order would not be alien to the bronze art.

In the rhinoceros *tsun* of the Brundage collection (Pl. 25a), which falls also on the borderline between the Shang and Chou traditions, a similar naturalism is displayed in three-dimensional form.[3] This piece too is exceptional. The normal zoomorphic vessels of Shang and early Chou time are in the main highly conventionalized, but in the best works the stereotyped elements are combined skilfully with the real form and a natural unity is not altogether lost. The owl vessels, with the birds' wings replaced by snakes and the feathers turned into scales, are some of the most notable inventions in this vein. They retain a vitality despite the strange adjuncts. The owl evidently had a place in Shang mythology. In late Chou times it was associated with the Yellow Emperor, to whom it was thought to have been sacrificed in ancient times.

The ability to impart a powerful illusion of life to extremely altered animal forms vanished towards the end of the eleventh century. It was not recaptured in the bronze art till some four centuries later, when it reappeared in a changed context of artistic convention. Its disappearance

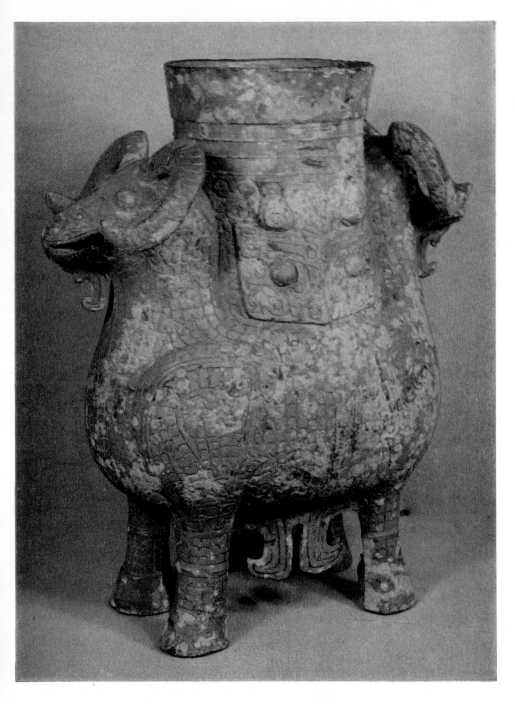

C. Double-ram tsun. 12th–11th century B.C. Shang Dynasty.
Ht. 17 ins. British Museum.

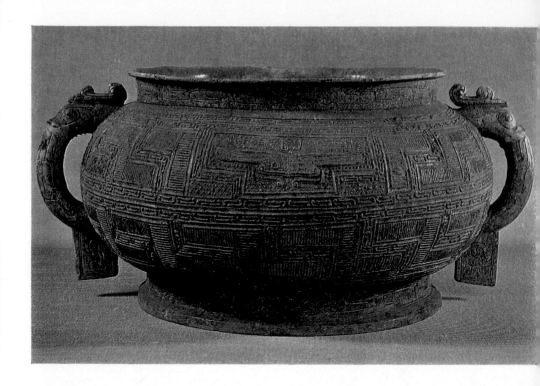

D. Kuei. Excavated in 1966 at T'un-hsi, Anhui. 10th century B.C. Western Chou
Dynasty.
Ht. 7¾ ins.

has been attributed to the loss of interest in high relief ornament occasioned by a decline in casting technique;[4] but changes in the artistic impulse and in the conventions of ritual seem to have led to the abandonment of the fine zoomorphic castings some time before bronze technique fell to the poorer average level characteristic of the later part of the Western Chou period.

In the portrayal of the human figure the Shang artists were less successful, achieving only a gauche convention of inexpressive face and a perfunctory modelling of the body (Pl. 36a). Here too they anticipate a prejudice of the later nomad art, in which the human body is rarely represented, and then only under civilized influence. The face seen on the Cernuschi *tsun* is repeated on the legs of a *ting* in the Pillsbury collection, and on a larger scale but with no greater interest, it forms the entire lid of a *ho* in the Freer Gallery. On a four-legged *ting* recently recovered in China human masks some six inches in diameter occupy each side of the vessel, and have more normal features. As a replacement of the usual animal mask figuring in chief in the ornament, these human faces are unique. An equally rare introduction of a human face in an ornamental scheme is found on the handles of the huge Ssǔ Mu Wu *ting*, where it is flanked by gaping monsters in the manner of the 'Daniel in the Lions' Den' motif of the Dark Age art of Europe.[5] The same gaping monster heads without the human mask cover the handles of the *ting* illustrated on Pl. 12c.

Recognizable, though conventionalized, animals which recur in the Shang schemes are tiger, snake, elephant and cicada. But much more frequent than any of these is the monster mask called *t'ao t'ieh* (Pl. 7b, etc.), on which nearly all the varieties of continuous ornament are centred. The name in its present acceptance means glutton, but its original meaning, whether a real or mythological animal, is beyond any sure conjecture. The *t'ao t'ieh* is first mentioned in literature in the *Tso Chuan* (fourth to third century B.C.) as an epithet applied to a bad man of legend for his covetousness. He is associated with three other undesirables and all four are said to have been sent forth by Shun, the minister of the legendary emperor Yao, as guardians of the four quarters of heaven to 'ward off evil monsters'. If this was treatment meted out to a god banished by the lords of Shang in favour of their own cults, as mythological parallels might suggest, it is not improbable that such a creature should have remained in Shang religious iconography as a guardian and admonitory genius. The *t'ao t'ieh* invaded Shang art from the earliest time of which we have any knowledge, but there is no mention of it in Shang inscriptions either on bronze or bone.

The *Lü Shih Ch'un Ch'iu* (third century B.C.) speaks of the *t'ao t'ieh* portrayed on the '*ting* of the Chou dynasty' as a monster possessing only a head (for that was how it seemed to be represented) which 'tried to devour men but did not succeed in swallowing them, suffering the harm in its own body'. It adds that it symbolizes retribution. This idea was not necessarily attached to it in Shang times. Influenced by the theory that the *t'ao t'ieh* was an apotropaeic genius, or that the form of a real animal must underlie the transmogrifications of the mask seen on the bronzes, occidental writers

have suggested various fierce originals for it, from Hirth's 'great mastiff of Tibet' and Rostovtseff's 'horned lion-griffin of Persian art' to Yetts's storm-god and Karlgren's 'dragon's head conveying the idea of fecundity'. Florence Waterbury sees in it a tiger mask and regards it as at once apotropaeic and auspicious ('for all the symbolic animals of Shang are auspicious') and Creel favoured the ox-mask as the original inspiration.

Bovine and feline masks constitute the two main divisions of the varieties of t'ao t'ieh. Even the bovine masks take on some ferocity, with changing shapes of horns and with fangs and claws borrowed from the feline version (Pl. 5). The employment of a mask with bovine features was appropriate on vessels which served at rites in which the ox was a frequent sacrificial victim. It is not unusual in ancient ritual for the slaughtered animal to be represented on the instruments of the sacrifice. The identifiable rams and deer, probably even the owls of the bronzes allude to the victims. The connexion is made explicit on two ting, with deer and ox masks, excavated at Hsi Pei Kang, for these are marked inside with the ideographs denoting the animals represented in the ornament.

Behind the diverse forms of t'ao t'ieh lay both an appalling tiger-like monster intended to avert evil and the face of the ox or ram offered to the gods and ancestral spirits whose aid was invoked. The cicada as a symbol of the rebirth of the great ancestors into a spirit world and the snake as an emblem of the underworld are readily intelligible. To seek a more explicit meaning in the decorative schemes of the bronzes would probably be to misrepresent the nature of the art. By the time we make acquaintance with Shang art the iconography has largely divested itself of concern for literal communication. Within the limits of a tyrannical convention, inherited no doubt from a distant past, the artist uses his imagination freely in the pursuit of artistic effect. Even a degree of playfulness may be detected at times, as when dragons standing on their tails serve as the legs of a tripod, or when an ideograph is included between the horns of a mask as part of the design (Pls. 2a and 28a).

Not all the masks which are termed t'ao t'ieh were elaborated in pattern. The forms which brood over the lobes of the lower section of the hsien (Pl. 15b) and regularly cover the sides of bells (Pl. 68b), have a simple and fairly constant outline, and the monsters formed on the lids of kuang (Pls. 31a and b) show little variation. The small feline mask placed at the centre of a band of abstract pattern (Pls. 42a and b) suffers no change in this scheme. These masks of firm outline appear on vessels belonging to the later Shang period. From the beginning of the Shang dynasty however the dominant motif was a changeable and less natural t'ao t'ieh which could serve as the nucleus of a linear pattern.

The lower jaw of the t'ao t'ieh is missing, with rare exceptions, of which the mask on the ting in Pl. 29a is the most notable. Fangs are set in the upper jaw and the eyes are generally raised above the level of the rest of the design. There are horns at the top of the head, mostly arched, but they may be angular, turned up or spiralled like a ram's, and often ears are added near the eyes. In coherent versions, such as that seen in Pl. 15a,

lateral extensions from the mask represent a body, doubled for symmetry, and beneath them appear the clawed feet. The centre of the face is often formed by one of the vertical flanges which are common on the sides of vessels in the later Shang period. Considerable variation was allowable in the arrangement of these elements. Two of the most interesting are those in which parts of the design are turned into independent creatures. The horns may be changed to dragons (Pl. 17), and the lateral extensions of the mask turned into dragons standing on their noses (Pls. 14*b*, 27*a*).

The dragon found thus closely associated with the *t'ao t'ieh* are the only animals in the Shang repertoire which appear to correspond to the dragon ubiquitous in all later Chinese mythology. They were identified in Sung times with the *k'uei*, a mythological creature mentioned in pre-Han texts and connected with rain-making. The belief that it had only one leg agrees with its representation in Shang ornament, for it is there always seen in side-view, with a single paw visible, an upturned nose and jaws usually agape. On the *ting* of Pls. 14*b* and 27*a* the *k'uei* are separated from the mask, but their appearance is little different from the shape given to the bodies of some *t'ao t'ieh*. The *k'uei* seems to have arisen merely out of the decorative treatment of the lateral extension of the mask. This impression is reinforced when we find that some masks are so drawn that each half either side of the nose ridge forms a perfect *k'uei* (Pl. 28*b*). One theory suggests that the mask itself was arrived at by confronting two dragons; but since an independent *k'uei* motif is absent from the ornament of the earliest vessels (those found at Cheng Chou, on which *t'ao t'ieh* and their linear derivatives are the only ornament), this explanation seems improbable. The isolation of the *k'uei* motif from the mask design evidently took place in the Hsiao T'un period. It could eventually form the legs of *ting* (Pl. 2*a*) and figure alone in bands of ornament (Pl. 30*a*).

The bronze vessels excavated at Cheng Chou, belonging to the fifteenth or fourteenth century B.C. and the earliest so far discovered, are decorated with figured bands in sharp relief at the neck and sometimes on the sides. The *t'ao t'ieh* is repeated at least twice in a band and placed at the centre of tightly scrolled and hooked lines. The linear fantasy is quite in the spirit of the more developed motifs of later Shang times. The bands are edged with rows of small circles or with a squared double spiral like a key-fret. The design is cast either as a thin raised line or in broader flat surfaces. The former style is exemplified by the *ting* from Hui Hsien (Pl. 1*a*), where the rendering is more primitive than that seen on any vessels attributed to either Cheng Chou or Hsiao T'un, and the latter is that of the *chia* illustrated on Pl. 3*a*. By about 1400 B.C. the technological and artistic prerequisites of the full Shang style were already present.

For the history of Shang art during the Hsiao T'un period, a space of almost three centuries, we lack objective data such as a clear stratification of the excavated deposits might have afforded. The ground at the place was so much disturbed that the excavators were unable to relate their finds satisfactorily even to such stratigraphic features as they observed. The great tombs situated in the vicinity of the capital had mostly been

plundered of their contents, and those at Hsi Pei Kang which still held bronzes could not be related to Hsiao T'un or to each other by technical data. Criteria for the comparative dating of the ritual bronzes have therefore been sought in the development of their ornament. Without great difficulty a logical sequence can be argued in the use of different linear and plastic treatments of the stock motifs. If we were to believe, as Bachhofer does of the complex styles of the later eleventh century, that 'one style reigned supreme at any one time',[6] the art of Shang could be fitted to a chronological frame reaching from the fourteenth to the end of the eleventh century. But there are indications that diverse styles were practised simultaneously; and once a decorative scheme was associated with a vessel type it tended to be reproduced so long as the vessel was made.

Of local stylistic divergences in the Shang period we still know very little. We can only guess at the extent of external influences which reached Hsiao T'un from the western region, the home of the Chou tribes, before the invasion and defeat of the Shang by the Chou in 1027 B.C. The comparative age of different ornamental styles can be suggested only on broad lines, and no strict line can be drawn to separate the styles of the latest years of Shang rule from those which appear about the time of the Chou victory. The main trend in the development of the bronze ornament after 1300, the date provisionally assigned to the Shang occupation of their new capital at Hsiao T'un, was the increase of the decorated area until it covered the whole surface of the vessels. One method was to elaborate the adjuncts of the t'ao t'ieh in linear schemes to produce the almost uniform surface seen in the lei of Pl. 3b. Here the mask, saving the eyes, has been dissolved almost to anonymity. Another method was to fill the spaces between the clearly outlined figures with small, slightly squared spirals — the lei wen or thunder pattern of the Sung antiquarians, so called from its chance resemblance to an ideograph (Pl. 7b). The lines of schemes in the latter style are finer, and witness to an important advance in the technique of casting. The effect of the minute reticulation of the bronze surface was further enhanced in some pieces by an inlay of black or dark red paste, the original nature of which cannot be determined by chemical analysis.[7]

The overall decoration seems at first to have favoured rounded vessel forms, and the strongly carinated and stepped shapes represented by the chüeh, chia and lei of Cheng Chou were abandoned. The smooth profiles suited to the graphic designs might have a new elegance or a less attractive slumped outline, as the examples of Pls. 7b and 3b demonstrate. The expansion of the single available motif, the t'ao t'ieh, led to its dismemberment and the revaluation of suggestive fragments. Thus arose the k'uei, which in the hu of Pl. 7b has moved from its natural place at the side of the mask to do duty as its horns. The k'uei could conveniently be used to fill the narrower bands at the neck and foot of vessels. On this hu it appears in three varieties: beaked at the neck, with bottle-shaped horns (a feature possibly suggested by the blunted and capped horns of sacrificial oxen) at the foot, and reduced to a barely identifiable eyed figure on the central zone. It was probably at this stage that the other animals, cicadas,

birds and snakes, were admitted to the range of permissible ornament.

A later stage in the development of the bronze art of Hsiao T'un is marked by the appearance of plastic effects in over-all schemes. Both the coherent *t'ao t'ieh* and the dismembered version are raised a little above the background, which is invariably filled with *lei wen* (Pls. 4*a*, 5 and 7*a*, etc.). The raised parts are covered either with the same small spirals (Pl. 14*a*) or, more frequently, with the spurred and tendril-like scrolls (Pl. 15*a*) which are an elaboration of the thunder pattern. The plain relief seen in the *ting* of Pl. 28*a* is comparatively rare. With this plastic manner are introduced heavy vertical flanges which separate symmetrical panels of ornament. These flanges probably originated in a device adopted by the bronze-caster to adjust the sections of the mould from which the vessel was cast. They strengthened the design of the vessel literally and aesthetically. The flanges are seldom plain (as in Pl. 28*b*), being as a rule notched with horizontal or T-shaped grooves (Pl. 15*a*), which recall similar marks engraved on the edges of the jade *tsung* of the same age. They are present as often on vessels of curved side as on the straight-sided *fang yi*, and are hardly ever omitted from vessels decorated in relief.

Vessels decorated with flat ornament have been found together with others bearing relief designs, as in the great cruciform tomb no. 1400 at Hsi Pei Kang; and occasionally the combination of flat and raised ornament on the same piece, as on the *chia* of Pl. 8, is proof that the two manners were used contemporaneously. Nevertheless the relief style represents the direction of change. The growth of plastic elements eventually produced ornament which freed itself from the panelled schemes altogether, and projected horns and ears and monster-head handles to the point of dominating the structure and profiles of the vessels. The Nezu *ho* (Pl. 21*b*), the Sedgwick *chih* (Pl. 18*b*), and the *yu* of the Victoria and Albert Museum are typical of this extravagant style. It is understandable that some art historians see in this change an illustration of the passage of a classical into a baroque style.

The exact dating of this development remains problematic. In part at least it is motifs of Shang ancestry which take part in it, yet hitherto no pieces of this kind have been described from the excavations at Hsiao T'un and Hsi Pei Kang. It is even debatable whether the high plastic style belonged in the first place to the Shang period, for it is akin to styles which flourished in the early decades of Chou. The bronzes with extravagant relief ornament in Shang style are best attributed to the later eleventh century, and the question whether they date before or after the defeat of Shang left open for the present.

Karlgren has given a detailed analysis of the motifs of the bronze ornament in the Shang and early Chou periods, beginning with a paper published in 1936. He sets out from epigraphical premises, using the inscribed figures termed *ya-hsing, hsi tzŭ sun* and *chü* (cf. p. 80 below) to establish a series of vessels of Shang date.[8] He shows that these signs never occur in inscriptions which from the rest of their contents can be proved to belong to the Chou period. So regular is the separation of the two types of

inscription that Karlgren regarded those containing the critical signs as unquestionably of Shang time, and he concluded that such inscriptions ceased to be cast on the ritual vessels from the very morrow of the Chou victory in 1027 B.C.

This conclusion, despite the statistical argument, has not gone unquestioned. It rests on the assumption that the Shang tradition of rite and epigraphy could not survive the Chou conquest at all without being affected by the new practice, in which the old formulas were abandoned and replaced by others appertaining to a new ceremonial and including allusions to recent political events. But it is not implausible, and indeed it is probable, that the new and old traditions, as far as the form of inscriptions is concerned, continued independently and contemporaneously for a short time. The replacement of the reputedly degenerate institutions of Shang by those of the sainted Chou kings need not have been so sudden or universal as in later times Confucius and his disciples supposed it to be. The view Karlgren himself reached on the survival of elements of Shang art into Chou times by no means supports the theory of a sudden suppression of the Shang tradition. Karlgren's thesis of the three epigraphical criteria cannot perhaps be substantiated or refuted until more is known, from systematic excavation, of late eleventh-century tombs and dwelling sites in which bronzes and the traces of bronze-founding are preserved.

Karlgren lists a stock of ornamental motifs, still in use in the earliest Chou period, which represent the survival of elements of the Shang style. He assigns them to a transitional phase which he calls Yin-Chou, dated from 1027 to c. 900 B.C. His terminology is used for the most part in the following attempt to estimate the duration of various motifs within this period.

As typical of the Shang shapes Karlgren lists rectangular *ting*, *chüeh*, *ku*, *kuang*, *li-ting*, *yu* and *fang yi*. None of these can be dated after the end of the tenth century B.C., and the first four cease perhaps half a century earlier. Among the structural features of Karlgren's list the use of legs in the form of animals (Pl. 2a) and flanges with straight or T-shaped grooves (Pls. 7a and 15a) do not appear on vessels which can be dated to Ch'eng Wang's reign and are not combined with schemes of ornament which are datable by inscription or analogy to this period. These appear to be characteristic features of the Hsiao T'un workshops. Their equivalent in the first decades of Chou are the hooked flanges seen on the *fang yi* of the Freer Gallery (Pl. 33a).

Vertical ribbing of the vessel's sides, as seen in a *chih* of Shang date (Pl. 12a), appear on *kuei* of Chou style (Pls. 40b and 43b) belonging to the late eleventh century, and on these vessels can be traced at least as late as the end of the tenth century. The plain cylindrical legs (Pl. 13b) characteristic of Shang *ting* were seldom made after c. 1000 B.C., being replaced first by the leg with mask, which seems to be a late-Shang invention (Pl. 9b), and increasingly after 1000 B.C. by legs of cabriole shape, with or without masks (Pl. 47a). As a decoration of the legs the mask replaced the more typical and earlier Shang convention of a pendent triangular figure (Pl.

54

15a). The related 'blade' pattern much used in the Shang schemes, generally placed above or below a band of ornament in the neck of vessels, is also very rare on bronzes of the early decades of Chou, and thereafter falls out of use.

Much of the conventional animal ornament of the Shang was still in use after the fall of their city, but often with considerable changes of design. The late-Shang bovine mask of the form customary on *hsien* (Pl. 15b) continued into the tenth century. A large feline *t'ao t'ieh* persists in the ornament of the first three or four decades of the Chou period, and rarely appears thereafter, but it differs from the Shang version by the closer unity of the design. The lateral extensions are mostly given up, and with them the suggestion of the combination of confronted *k'uei*, or the addition of vertical *k'uei* at the sides. The pattern of the divided and spread *t'ao t'ieh*, such as is seen on the handle-less *kuei* of Pl. 4a, appears not to survive the events of 1027, for it cannot be associated with an inscription of Chou date or other stylistic features of the post-Shang period.[9]

Characteristic Shang forms are the beaked and gaping varieties of the dragon (Pls. 12c and 13a), the latter particularly when it wears the bottle-shaped horns (a feature exclusively of Shang date), to which must be added the abstraction of the *k'uei* figure seen on the *ting* of Pl. 13b. The winged, feathered and turning dragons (Pls. 30a, 16 and 41b) are all associated with styles of decoration belonging to the end of the eleventh century which seem to have no connexion with the Hsiao T'un products. The dragon type displayed on the *ting* of Pl. 9b, with its somewhat rectangular head, simple curved back and single pointed foot is one of the final variations of the motif. It is present on a Chou vessel included in one of the sets unearthed at Pao Chi Hsien in Shensi, in the ancient Chou territory (cf. p. 58) and is common on bronze chariot fittings found in Honan. In the latter instance it gives a hint that the chariot itself was not introduced into the Shang territory until late in the reign of the Shang kings, when the Chou confederacy lying to the west was already a power in the land, and one advantageously placed for horse-raising.

The bird-like dragon decorating the British Museum's *ting* (Pl. 44a) is a rare and late variant. It recurs on a vessel of the Pao Chi Hsien find, and so may with some reason be thought peculiar to a Chou style and native to the ancestral Chou region. The same may be said of the twisted dragon shown on Pl. 46b. Whereas the other forms of *k'uei* seem not to have survived long if at all after the end of the eleventh century, the twisted dragon can be traced, sometimes in geometricized abstractions, until the late eighth or early seventh century. At this time it is still the basis of a design on a *ting* excavated at the cemetery of the Kuo state at Shang Ts'un Ling in Honan.[10] The last three dragon types, all of them referable to the Chou territory through the Pao Chi Hsien bronzes, take us outside the Shang tradition of Hsiao T'un altogether. They are not closely connected with the most characteristic Shang forms, whose design seemed to arise naturally from a fanciful treatment of the Shang *t'ao t'ieh*. The Shang annexed the representation of this mythological creature to the mask pattern, whereas

in the Chou homeland, where the *k'uei* was probably no less familiar in fable, an independent convention was adopted for it.

The motif called by Karlgren 'animal triple band' (Pl. 41*a*) is developed from the *t'ao t'ieh* as it is found on the early Shang vessels from Cheng Chou. The addition of a 'body' on either side of the mask and the re-interpretation of these extensions as vertical dragons was a device confined to the large masks which occupied the main field of the ornament. When the mask was confined to a comparatively narrow band its extensions took the form of long scrolled and hooked lines which even in the Cheng Chou pieces show a tendency to be arranged in three horizontal segments.[11] Many of the vessels excavated at Hsi Pei Kang have this band of orna-ment, differing from the earlier version mainly by its greater compactness, regularity and clear separation of the segments. A final stage in the history of this motif was reached when, in the later eleventh century, the *t'ao t'ieh* mask was replaced by a small bovine or feline mask raised considerably higher than the rest of the band. This scheme seems not to have survived for more than a few decades in the Chou period, and was then superseded by a band in which the mask is flanked by a bird motif.

The minor geometric motifs used on the Shang bronzes, filling in the background, more sparsely covering the main motifs and filling the bands at foot and neck of vessels, can all be shown to have survived for an indeterminate but relatively short period after the Chou conquest. The abandonment of these patterns, particularly where they merely cover the ground, is a notable feature of vessels bearing schemes of ornament typical of the early Chou styles. By the beginning of the tenth century they seem to have been discontinued. Close-set bosses (Pl. 4*b*) are a late-Shang invention. They appear in grotesque size on the Shensi *kuei* of Pl. 21*c*. They are used on rectangular *ting* of the reign of K'ang Wang, but seem to have been discarded from the middle of the tenth century; and the lozenge pattern with which they are combined on Pl. 4*b* ended even earlier. The *lei-wen* ground and the tendril-like figures on the main elements of the design continue sporadically into the tenth century. The spiral-filled band on the other hand (Pl. 12*a*) was allied to vessel shapes produced in Hsiao T'un, and was discontinued somewhat earlier. The whirligig roundel used on the neck of the Malcolm *kuei* (Pl. 40*b*) appears already on vessels from Cheng Chou, and so has an ancient history (cf. Pl. 3*a*), while the 'square with crescents' appearing with it is probably a late-Shang invention. Both are used on a pedestal *kuei* (Ko Po *kuei*) dated by its inscription to the reign of Kung Wang, at the end of the tenth century.[12]

The art of Shang as known from Cheng Chou and Hsiao T'un shows the coherent development natural in a local tradition. Pieces in its charac-teristic style are hardly known outside the north and centre of Honan province. The course of history implies that bronze metallurgy was known in the Chou territory even before the defeat of Shang, but it has not so far been possible to prove that any bronzes unearthed there antedate this event. We may assume too that the mythological and artistic heritage of the Chou people was akin to those of the inhabitants of the Central Plain.

The impact of the Chou iconographic ideas, as expressed in bronze, upon the Shang tradition, might well result in just the modification of dragon and monster mask conventions which occurred in the decades around 1000 B.C. The explanation of these changes as the irruption into the Central Plain of a distinct though allied artistic tradition is much preferable to the view, often expressed hitherto, that they mark only the degeneration of Shang art now fallen into the hands of barbarians. The time at the end of the eleventh century in which the new Chou and the old Shang elements are confronted, and in part intermingle, may be called transitional; although, since the Honan tradition was then being modified by influences reaching it from without, the term is not quite appropriate.

The earliest bronze vessel of the independent Chou style which is datable by its inscription is the T'ien Wu *kuei*, with which Kuo Mo-jo begins his corpus of bronze inscriptions of the Chou period.[13] It records a royal rite in which T'ien Wang assisted the king. The mention of Wen, the predecessor of the first Chou dynastic ruler Wu, suggests that the vessel was cast at the very beginning of the Chou reign, probably in the time of Wu himself. Ch'en Meng-chia would therefore date it between 1027 and 1025 B.C. Another phrase bears the interpretation (though it is disputed) that the dead king's blessing is prayed for in the task of 'ending the rites of Yin (i.e. Shang)'. Sun Tso-yün has recently argued from this that the *kuei* was cast before the defeat of the Shang ruler.[14] He stresses the sophistication of the wording of the inscription as proof of the developed literacy of the Chou even before their advance to the east brought them into contact with Shang culture. The *kuei* is of the four-handled type set on a square podium. The sides of the bowl are decorated with the design seen on the *kuei* of the former Ingram collection (Pl. 45a): confronted gaping monsters with large spiralled tails which fall outside all the permutations of the Shang *t'ao t'ieh* and *k'uei* dragons. These are interpreted in a moulded relief which is equally alien to the Anyang style. The same ornament is repeated on the sides of the base.

A similar *kuei* in the Buckingham collection decorated with confronted monsters on the bowl,[15] adds two motifs which become characteristic of Chou ornament in the transitional period: a bird-like creature with reverted head and frills of 'feathers' along both sides of the body (a variant of which is seen on the *yü* of Pl. 43a), and heavy hooked flanges resembling those of the *fang yi* of Pl. 33a. All these features are peculiar to Chou work, and their origin, whether in bronze or in softer carved material, must lie in the pre-conquest period, and so be contemporary with the later history of Shang art at Anyang. The Buckingham and the Ingram *kuei* display in the band of ornament around the foot a type of dragon which is occasionally found in Shang schemes (cf. Pl. 13a), but only on vessels which seem to belong to the end of the Shang reign, and, unlike the majority of the Shang ornament, have no antecedents in the earlier bronzes. Whether they belong to the common ground of Shang and Chou art or mark an influence reaching Anyang from the Chou centre lying to the west is at present uncertain. On the heads of the birds depicted on the

base of the Buckingham *kuei* is a crest which over the birds of the *kuei* in Pl. 44*b* has been reinterpreted as dragons of similar shape.

Nothing is recorded of the find-places of the *kuei* we have discussed, though the early date inferred for the T'ien Wu *kuei* suggests that this piece is not likely to have been made in the Shang sphere of Honan. Another group of vessels of the late eleventh century, quite distinct from Shang work, was found in Pao Chi Hsien in Shensi province, in old Chou territory not far from the Chou capital, Tsung Chou.[16] These consist of two sets, recovered from tombs respectively in 1901 and 1910, of which the first was acquired intact by the Metropolitan Museum. The second set was dispersed, but an old photograph recently studied by Umehara has confirmed its existence and made possible the identification of some of the pieces in the American collections to which they were added. Each set stood on a rectangular bronze table of a kind not so far found elsewhere. Through the location of this find and the consistent style of the decoration one may attribute to the independent Chou tradition a style and a number of motifs which occur on other bronzes of the transitional period.

The most striking feature of the Pao Chi vessels is the extravagance of the ornament. The *yu* of Pl. 21*a* (itself an unlocated find) is virtually identical with the two *yu* of the Metropolitan set. The grotesque masks at the base of the handle, the spiky profile of flanges and the weight these impart to the whole design are a far cry from the tense lines and close-knit schemes of the Shang vessels. The ornament of the sides consists entirely of birds, the theme which in the course of the transitional period was gradually to replace *k'uei* dragons, and in its turn was to be eventually transmuted into abstract pattern. The most savage exaggeration of all is seen in the *kuei* of the Freer Gallery (Pl. 21*c*), which Umehara has identified with the vessel half-hidden on the back row of the vessels of the dispersed set. Around the foot are dragons of the kind found on the Buckingham *kuei*. The bovine masks, which are unlike any masks used on Honan bronzes of Shang date, resemble those found on chariot fittings of the early Chou period. This awkward combination of low relief, engraved ornament and uncomfortable projections, is happily unique among the surviving bronzes.

The elongated dragons which decorate the stands of the Pao Chi sets are of the twisted type (Pl. 46*b*), or of the kind with curved back and single hook-like foot. The *kuei* of Pl. 32, which is also identified by Umehara as one of the pieces of the Pao Chi Hsien group, is decorated in an idiom unknown among the excavated finds of Honan. The same mannerism — the rows of quill-like projections added to the main lines of the figure — is seen in Pls. 33*b* and 43*a* infecting more elaborate motifs of Chou origin. It is noticeable also in the Chou versions of decorative schemes which lie closer to those of the Shang tradition, for example, in the treatment of the *t'ao t'ieh* on the sides of the square *ting* in Pl. 27. The projections serve the same purpose of extending the motifs as do the scrolled development and dismemberment of the Shang figures, replacing the powerful Shang scheme by a less impressive, almost playful movement.

Casual invention has taken the place of the earnest logic of the Shang draughtsman. This mannerism is seen in its most pleasing form in the Freer *fang yi* (Pl. 33a), on which hooked flanges set on a bulging profile epitomize the slightly inert dignity which was the ideal from the late eleventh century. This style has left its mark also on some details of the mask on the chariot-pole fitting of Pl. 34a.

The mannered treatment of the *t'ao t'ieh* was not the only one used at the opening of the Chou period. The style seen in the masks of the pedestal *kuei* of Pl. 37a was contemporary with it and resembles the late Shang design more closely, but the detailed treatment distinguishes it no less from the Shang masks. The addition of small masks (one is of the Shensi kind) over the nose of each large mask; the placing of birds in the foot band either side of a figure deriving from the middle section of the *t'ao t'ieh* design; and the eccentric treatment of the vertical *k'uei* dragons flanking the lower mask, are all innovations of a new style.

The grotesque and mannered styles are grouped by Bachhofer under his 'ornate style'.[17] This he regarded as a late expression of Shang art merely influenced by the taste of the Chou patrons after the conquest. He saw in a family of vessels of elegant form and restrained ornament a reaction from this exuberance, calling it a 'severe style', assigning to it a short *floruit* in the reign of Ch'eng Wang. It is seen in perfection in the *yu* of the Victoria and Albert Museum (Pl. 16). But the theory of a universal stylistic change in favour of simplicity is indefensible in the light of the many and varied vessels which can be attributed by inscription and analogy to the last quarter of the eleventh century. The 'severe' vessels may be the work of a single foundry or locality, but so far it has not been possible to prove this for them any more than for the vessels in other Chou styles.

The shape of the Victoria and Albert *yu* is close to that of another found in excavations at Hsi Pei Kang, and to that of Pl. 23a. It was adopted in Honan under the Shang. The 'feathered dragons' of the Victoria and Albert Museum's *yu* and the manner of rendering by a smooth, rounded line are however alien to the Shang style, though the effect is suggested by the treatment of the design on the Shang *tsun* of Pl. 6b. The same gentle line is used on the Hsing Hou *kuei* (Pl. 39a) and on the *ku* of Pl. 22a, in these instances on a smooth ground, which is a Chou innovation of the early decades of the dynasty. The dragons around the foot of the *kuei* are also of the feathered kind. Although it shares the rounded rendering of its linear pattern with other vessels, the Hsing Hou *kuei* is in other respects unique. The beauty of its proportions and the graceful sweep of the ornament make it one of the most attractive vessels attributed to the opening of the Chou era.

A group of bronzes unearthed together near Loyang in Honan province (i.e. near the site of the eastern Chou capital established at the time of the conquest) proves that vessels decorated in the mannered style were contemporary with those with the rounded relief. They are linked by their

inscriptions, the breveted officer Nieh Ling being mentioned on five of the vessels and one Ch'en Ch'en on another three.[18] The style of the Freer Gallery's *fang yi* (Pl. 33a) which comes from this set, is closely matched by a square-bodied, heavily flanged *tsun*. A *yu* akin to the piece of Pl. 33b and a round-bodied *tsun* are decorated with the rounded relief line seen on the Hsing Hou *kuei*, and have the same rare conventionalized elephant as the principal motif. All of these vessels may be the products of the same foundry, and their burial at the Chou capital suggests that they were made expressly for the royal court.

One piece of the Nieh Ling group, the *ho* in the Freer Gallery (Pl. 35a), is stylistically apart, being decorated with a rare variety *t'ao t'ieh* dissolved among *lei wen*. This scheme stands in much the same relationship to the corresponding schemes of Shang tradition and date as do the *t'ao t'ieh* of the mannered style. Both use the same basic motifs to strikingly different effect. It is in the light of such pieces, rather than the Shensi bronzes of the Pao Chi family, that a continuation of the Anyang workshop tradition into the Chou period can best be argued. But here too the contrast of feeling between the Shang and Chou versions of the related themes is strong evidence for the independence of the Chou craft.

A group of vessels excavated in 1954 at Yen Tun Shan in Tan T'u Hsien, Kiangsu province (the place farthest from the centre of Chou power at which bronzes of the early decades of the dynasty have been recovered) includes a *kuei* on a high round foot bearing an inscription which names Nieh, Marquis of Ch'ien, enfeoffing him in the territory of Yi.[19] This Nieh, it is thought, may be the same personage as the Nieh Ling of the Loyang bronzes, but the style of *kuei* with which he is associated here is quite different from these. The foot band has beaked dragons in rounded relief line on a plain ground, and the body is covered with an enlarged version of the whirligig and back-looking dragons seen in the upper register of the ornament of the *kuei* of Pl. 41b. The four vessels which accompanied Nieh's *kuei* are distinctly rustic in appearance, with birds, twisted dragons and incoherent bands of pattern apparently derived from the feathered dragons; the last are so compact that they suggest an interlaced design, although the crossings of interlacery are not represented.

The rougher vessels of the Yen Tun Shan find seem to represent the work of a provincial centre where decorative designs of the Chou type were employed. It is interesting that it includes an example of the *yü*, a deep bowl with bent handles. This shape is known in the late Shang period at Hsi Pei Kang, and does not occur among the early Chou vessels which can be attributed to Honan or Shensi. Another *yü*, inscribed with the name of the Marquis of Yen (Pl. 43a), was excavated at Hai Tao Ying Tzǔ Ts'un in Ling Yüan Hsien in the north-east province of Liao ning.[20] It is decorated in the mannered style of the early decades of the Chou dynasty, with a motif similar to the twin bird-dragons used on some of the Nieh Ling bronzes. The Ling Yüan group, like the Yen Tun Shan group, includes pieces decorated in the metropolitan Chou style with others of provincial shape and ornament.[21]

ORNAMENT

Of numerous motifs adopted in the transitional period, the bird was to have the longest history, in the course of which it underwent graphic transmutations similar to those suffered by the Shang *t'ao t'ieh* and *k'uei*. The Shang bird, a late addition to the Shang repertoire, is usually the comparatively naturalistic creature seen on Mrs Sedgwick's *fang yi* (Pl. 18*a*). On the bowl of Pl. 19*b* the design is extended by the long scrolled tail, which is separated from the body of the bird. This version is not found on bronzes excavated from the Anyang sites, and it remains doubtful whether it was used in central China before 1027 B.C. Yet this bowl, unique both in shape and the arrangement of its ornament, fits better into the varied context of the Shang vessels of the Hsi Pei Kang group than with the narrower range of early Chou vessel forms.

The large bird with elaborate tail and crest, a Chou motif first seen in the Pao Chi bronzes, figures in schemes of the mannered style in strange conventions, which in details may approach the dragon designs. On other vessels of the late eleventh century the large birds are closer to Shang (Pl. 38); but comparison with the Fu-feng *yu* (Col. Pl. A) suggests an original Chou connexion, despite the absence of interlace in Honan. A similar design may cover the entire sides of the squat Chou version of the *yu*, seen in Pl. 24*a*. In the band patterns the bird was substituted for dragon figures, and it accompanies a *t'ao t'ieh* in a neck-band which appears on *ting* throughout the tenth century. It might displace the conservative decoration of the *chüeh*, as on the rare specimen of Pl. 10*a*, which can hardly date after 1000 B.C.

In the form of fully modelled handles of *kuei* the bird is much rarer, and in this instance is combined with decoration consisting entirely of bird pattern. *Kuei* handles with the bird's head as the principal feature belong probably to the middle of the tenth century at the earliest. They are used on the *kuei* of Pl. 37*b** and on another, which is ascribed by its inscription to the reign of Mu Wang.[22] But the zoomorphic handles of earlier Chou date, such as those of the T'ien Wu *kuei* and the Pao Chi *kuei*, combine the monster head with a bird figure or with wings and claws on the lower part of the handle. Bird's claws on the square appendage below the handle were the usual prescription (Pls. 42*a*, *b* and 43*b*).

The alteration of the bird figures of the narrow zones of ornament into more or less abstract motifs began probably as early as the opening of the tenth century. The beginning of this process appears on the *yu* of Pl. 24*a* and the *ho* of Pl. 35*b*. The inscription cast on the latter mentions Mu Wang.[23] The roughly squared linear figures rotating in opposite directions about a central eye are the deformed remains of the bird with its tail and crest. This figure, rather than any abstraction of the dragon, lies behind the pattern at the neck of the *ting* and *kuei* in Pls. 46*a*, 47*a* and 48*b*. The same idea appears in the decoration of some harness trappings of the western Chou period (Pl. 82*a*).

Between the later tenth century and the earlier seventh century languid versions of the traditional vessels were the rule, alongside a few novel variants. The ornament is on the whole inferior in vitality and execution to

* See the comment on this piece in the Preface to the Second Edition, p. 21.

that of the transitional and earlier time. The shallow *ting* which swells towards the base (Pl. 46b) dates from about the middle of the tenth century, and by about 900 B.C. the bowls generally approach the shape of a hemisphere and stand on cabriole legs (Pls. 46a and 47a). On them the bird-derived figure, often looking like two G's laid on their side on either side of an eye, is sometimes combined with a simple imbricated pattern on the sides of the vessel. The broad, flat band used for the scales is usually divided by one or two grooves running along the centre. Such rendering of ornament in broad bands, with little relief, persisted from the tenth to about the beginning of the seventh century. The famous Silver Island *ting* is one of the most elegant pieces in this style, and the Mao Kung *ting*, equally famous for its long inscription, shows it at its most jejune, being decorated with bands of alternating smaller and larger D-shaped figures, the final attenuation of the bird. Both of these vessels have been attributed through their inscriptions to the reign of Hsüan Wang, in the late ninth and early eighth centuries.[24] The ribbon-band style was followed at the feudal courts in the later part of the Western Chou period, and examples of it can be referred by their inscriptions to states stretching along the Yellow River valley from Shensi to Jehol and Shantung.[25]

Probably the change which began to overtake the whole tradition of Chinese bronze ornament in the seventh century is connected with influences emanating from the north-west. The barbarian inroads which had compelled the king to move his seat to Loyang in 771 B.C. were carried into north Honan in the following century. Subsequently the effect of contact with peoples of inner Asia is manifest in borrowings of weapons and horse-trappings. But the first sign of the new artistic trend cannot be attributed to foreign influences with any certainty. Nothing is yet known of the culture of the Jung and Ti barbarians of the north-west. The artistic ideas their descendants are later found possessed of are likely to have come with traded goods from settled communities of north-west China.

The introduction of interlacery into the schemes of ornament heralds the new age. Hitherto the bronze patterns, however complex and however near they come to suggesting the effect of interlacery, stop short of it as if deliberately. Three groups of bronze vessels illustrate the new principle of design in an early stage: one is a series of vessels linked together by their inscriptions and the other two groups comprise vessels excavated from richly furnished graves at Hsin Cheng and Shang Ts'un Ling in Honan province.

The bronzes associated through their inscriptions[26] include a *ting* decorated with the wave pattern seen on the *hu* of Pl. 52; an *yi* which closely resembles that illustrated on Pl. 49a; a *hu* equally close to the piece of Pl. 53, and two *kuei* so closely reproducing the shape, decoration and inscription of the piece in Pl. 48b that one must assume the latter to have belonged to one set with them. The inscriptions begin with the phrase 'the third year of the king', and there has been argument as to the king who is meant. The archivist (*shih*) Sung is charged with the duty of supervising a new palace, and in this Kuo Mo-jo finds grounds for ascribing the bronze to

the reign of Mu Wang (947–928 B.C.). Karlgren rejects this view and places the vessels merely in the second half of the Western Chou period, i.e. after 900 B.C. Bachhofer and others take the date to be the third year of Hsüan Wang, 825 B.C. By their style, the vessels seem to fit better in the context of the late ninth than the late tenth century.[27] The P'u Tu Ts'un bronzes of Mu Wang's time (Pls. 35b and 49b) are closer to a transitional style and the stylization of their bird figure has dissolved less far than the equivalent motif appearing on some of the Sung pieces. Moreover the wave pattern of the Sung *ting* is repeated on some *fu*, a vessel shape which does not occur with decoration in tenth century style.

The Sung wave pattern makes its appearance fully formed, without antecedents of bird or dragon affinities. In breadth of manner it answers to the prevailing trend of ribbon-band ornament of middle Chou date, but its relief has a new movement. The careful moulding of the concave line and the confident race of the design around the body of the vessel is a great improvement over the slack meander of the ribbon-band schemes. The casting technique is much superior. The handles of the *kuei* of Pl. 40b compare well with the best Shang work. Similar though less finely rendered monsters adorn the handles of the covered *kuei* of Pl. 48b, which exemplifies the other style represented by vessels in the Sung group. Here the conventionalized bird motif and the lappets around the foot are taken from the common stock. *Kuei* approximating to this form are dated by allusions in their inscriptions, at the earliest, to the last decade of the tenth century.[28] Sometimes *kuei* with the same rilled sides are otherwise unadorned (Pl. 47b). Vessels of this kind have often a slightly elongated body, and are accordingly termed *hsü*. The *hsü* and *fu* shapes seem to have been adopted about the time of Hsüan Wang.

The Sung *hu*, with its twin of Pl. 53, is in its context strikingly original. The decoration of the neck is allied to the wave pattern, and the foot has the deformed bird, but the design of intertwined snakes which covers the main field is unparalleled. It is an original treatment of the interlaced flat bands of contemporary vessels. The excellent casting of the relief is not matched among other Chou bronzes of like date. The *yi* linked by inscription to the Sung group and the analogous piece of Pl. 49a further indicate the late ninth-century date of these vessels, for such pieces are not found with ornament of an earlier type, or with inscriptions referring them to an earlier time.

Two important cemetery sites of middle Chou date have been excavated, near Hsin Cheng and Shang Ts'un Ling, both in Honan province. The latter is the more informative as regards dating, since it covers a shorter period of time.[29] One of the *ting* recovered there is inscribed as belonging to 'Tzǔ Tso of the Chi family of Kuo'. If the princely Chi of the Kuo state flourished when this piece was buried, we may date it before 655 B.C., when Kuo was annexed by the state of Chin. The capital of Kuo, though not closely located, is thought to have lain in the vicinity of the Shang Ts'un Ling site, and the style of the excavated bronzes as a whole supports the excavators' suggestion that the bulk of the tombs belong to the period of

Kuo's independence. The upper limit for the date of these tombs must reach well into the eighth century B.C., though the absence of any of the distinctive late ninth-century types of vessel shapes and ornament suggests that it does not go so far back as 800.

Many of the Shang Ts'un Ling vessels are banal mid-Chou *ting* with cabriole legs and the degenerate bird and twisted dragon set in bands. A coarse expansion of the same motif sometimes covers the sides. A new shape is the *li* with arched legs (cf. Pl. 48*a*), and with this is associated an ornamental scheme which was destined to have an interesting history in the following two centuries. This is a double band bent in a square meander, terminating in a head which is half griffin, half dragon, and usually with more or less explicit clawed feet below. On the *li* two such figures are placed side by side with the heads facing outwards. On a small bowl the necks of the serpentine dragons are intertwined. The germ of interlaced pattern, the diversification of linear pattern with dragon and bird heads which dispense with any further suggestion of animal anatomy, and the combination of these with some simple spiral and triangular figures, so as to produce schemes of repeating units, mark the beginning of a fresh cycle in the history of bronze ornament, which ends only with the advent of the naturalistic art of the Han period.

Another innovation in the repertoire of ornament at Shang Ts'un Ling is a stylized tiger, drawn in profile, with a head little different from that of the griffin-dragon. The feet are shown as a single curved claw disproportionately large; on shoulder and haunch are prominent spirals and the coat is marked by chevrons. All these features recur constantly in the tigers which are common in bronze from about the beginning of the sixth century, on bronze ornaments and harness mounts as much as in the decoration of vessels. The same convention is later found in the art of the nomads of the northern steppes.

Hsin Cheng lies 140 miles east of Shan Ts'un Ling. Tombs cleared there in 1923 produced great numbers of bronze vessels, of which more than a hundred have been reproduced.[30] The site covers a longer period of time than the tombs of Shang Ts'un Ling. Again the absence of ornament allied to that of the Sung group suggests an upper limit of *c.* 800 B.C., and the absence of any of the degenerate bird motifs is perhaps good reason for placing the earliest of the Hsin Cheng finds in the later eighth century, rather later than the earliest tombs of the Shang Ts'un Ling cemetery. The motifs which appear at both sites are designed with greater refinement at Hsin Cheng. At the latter site the serpentine dragons interlace freely and elegantly, not only in the scheme of the arched *li*, but in continuous pattern covering the sides of other vessels. The twisted dragon, which occurs on only a few pieces, is made to resemble them, with a head at either end. A number of the Hsin Cheng bronzes could be set in sequence to show how the theme of the interlaced dragons is gradually reduced in scale, at one point producing the design seen on the *lei* of Pl. 51*a*, in which the eye of the dragon appears at the crossings of the ribbons as well as in its proper place. It is eventually compressed into a small rectangular unit which is repeated

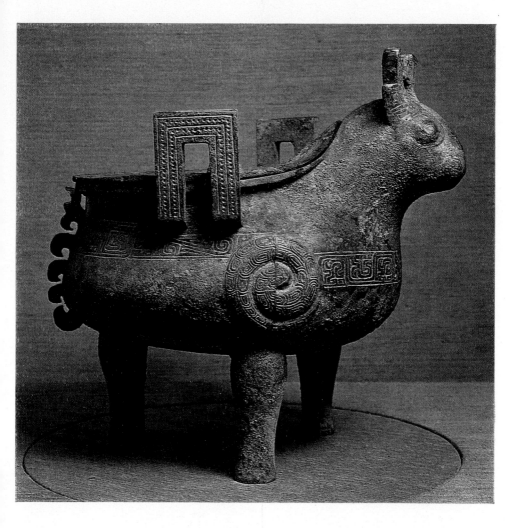

E. Zoomorphic ting. Excavated in 1959 at Shu-ch'eng, Anhui. 7th or early 6th century B.C.
Ht. 10¾ ins.

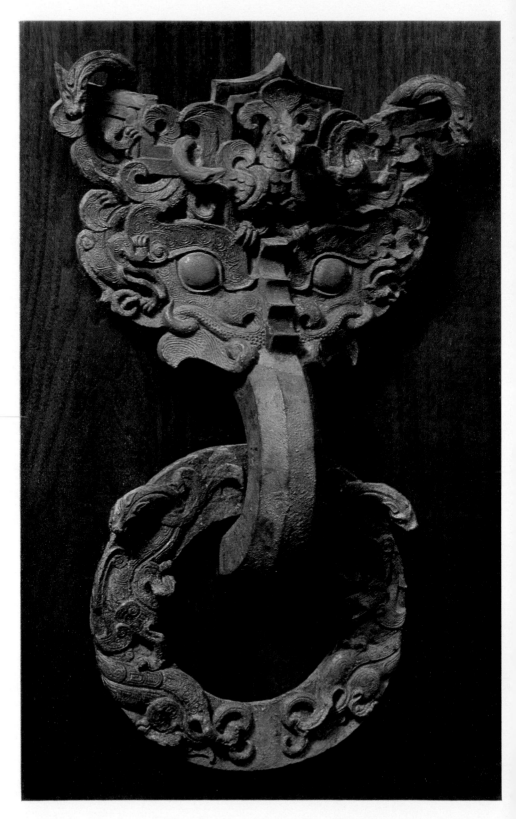

F. Mask and ring from a tomb door. Excavated in 1966 at Yi-hsien, Hopei. 5th century B.C.
Ht. 23⅞ ins.

in regular vertical and horizontal rows to cover the whole surface. Further reductions may be seen on the vessels of Pls. 57*a* and *b*, and the motif used of the *fu* of the Buckingham Collection (Pl. 56*b*) has reached almost the limit of compression. The catalogue describes it as 'vermiculated pattern based on the cloud scroll', but the fuller form from which it derives has no suggestion of atmosphere: the dragon as a winged creature inhabiting the upper air was a conception of Han times.

In the course of this process of reduction the strong effect of interlacery gives way to mere enrichment of surface, in which the shape of the figure hardly matters. A technical change occurs also. In making the casting mould, or the wax model if this was the method used, the larger versions of the motif received their final modelling by hand, even supposing that some mechanical device was used to rough out the repeats of the pattern. When the design had been reduced to small, tight units these were impressed from a stamp. This method marks the most important break with technical tradition which had occurred thus far in the history of the bronze art, and it remained the chief technique until metallic inlays were adopted in the fourth century B.C. In Shang and early Chou times stamp-work is unknown and even the repetitive frieze of bird motifs of the Middle Chou period seems to have been freshly modelled for each operation. With the adoption of the stamp some of the old vitality is lost, and precision is everything.

A *lei*, the only piece of its kind among the Hsin Cheng vessels, with near-spherical body and four handles in the shape of a pair of interlocked dragons in openwork modelled in the round, displays some minor graphic features which point forward to the 'Huai style', the art of the region around the lower Yangtse. The upper part of the *lei* is covered with a very free pattern of intertwining snakes whose bodies are covered with close chevrons. The spaces between the snakes are filled with small headless worms branching into spurs and brief spirals, and the whole is bounded by narrow raised cordons grooved to represent a rope-twist. This scheme is reproduced approximately in the lower panel of the bell of Pl. 69*c*. The suggestion of twisted and plaited cords and the straight and curved chevrons of the animals' bodies are a feature common in the later nomadic art. It has been thought that even in the eighth century, to which the Hsin Cheng vessel in question must belong, they reflect an influence from peoples of the northern steppes; but no sufficiently early evidence can be produced from this region in support of this theory. When some centuries later a connexion is perceptible between the art of the steppes and that of China, influences were more probably passing the other way, from China outwards.

In the Hsin Cheng group four tall *hu* are of forms unknown from earlier times. Two are of the type illustrated in Pl. 54*b*; the others are covered with a broad pattern of intertwining snakes and have lids with double rows of petals surmounted by more or less naturalistic figures of cranes. These shapes approximate to that of a *hu* found at Shang Ts'un Ling which is decorated with the ribbon dragons of the eighth-century type, but

E

the loading of the Hsin Cheng *hu* with large tigers as handles and feet is something new. The tigers have the clawed feet, spiralled joints and curled noses seen on the example described from Shang Ts'un Ling, and they set a convention which persisted until Han times. The taste for extravagant ornament, turning the vessel into a mere vehicle for large plastic effect, thus appears again after an interval of more than two centuries. Both in early Chou times and at the time of the Hsin Cheng vessels the influence of a north-western tradition is at work.

Before we describe the art known to the West, since Karlbeck's collecting, as the Huai style, which appears to be a development of tendencies present in the Hsin Cheng bronzes, there are two distinct stylistic groups of the northern region which claim attention. One of these is exemplified by a find of bronze vessels made in 1923 at the village of Li Yü in north Shansi province.[31] In shapes and ornament the vessels are a homogeneous group, but the lack of inscriptions or association with other more closely datable objects leaves the question of their date obscure. The style is ideally represented by the covered bowls of Pls. 60a, 61a and 65a, which are typical Li Yü modifications of the traditional vessel shapes. The extravagant ornament and emphatic articulation of the late Hsin Cheng bronzes nowhere appear. Quiet forms and refined flat pattern, as fresh as engraved work, strike an entirely new note. The quality of the casting surpasses anything produced since the end of the transitional period.

In the animal figures, with the exception of a few masks such as those on the handles of the Freer bowl (Pl. 65a), the Li Yü artists rejected the conventions which were introduced at Hsin Cheng and Shang Ts'un Ling, and modelled ducks, sheep and buffalo with charming naturalism. The tapir of Pl. 79c, which is typical of Li Yü modelling, makes a concession to convention in its curled nose and the spiral figures on shoulders and haunches, but the figure has a vitality beyond the stylized tigers.

In adapting the ideas of sixth-century pattern the Li Yü artists chose elements which are only adumbrated at Hsin Cheng. The treatment of the ducks of the Freer bowl, with scales, repeated spirals on the wings and fine granulation, is typical of the ornament on animal figures. The tapir has bands filled with a rope-twist pattern, or with another design which is even more characteristic of the style: to rectangles formed of adjacent triangles, such as are found in the background of some Hsin Cheng themes, tight spirals were added at either end, so producing the precursor of the 'hook and volute' motif which is ubiquitous in the art of the late Chou period. This spiral-and-triangle unit fills the ribbons of the interlaced dragons which figure in chief on the sides of the vessels.

The interlaced pattern is varied by overlapping the ears and snouts of the heads on to the bands, by adding scrolled spurs to the main line or inserting separate curving elements. The design seen on the Freer bowl (Pl. 65a) still betrays its relation to the earlier dragon meanders. In the version on the *ting* of Pl. 61a this connexion is less obvious, and the monster heads are omitted. On the *ting* of Pl. 60a the heads have been reinterpreted as ram masks seen in front view and there is a concern,

hitherto not noticeable, to reduce parts of the design to symmetry (Fig. 1). A division of the ornament into paired units, each symmetrical about a vertical axis, characterizes a later stage in the development of the ornament, and anticipates the heraldic arrangement of symmetrical figures which governs schemes used at the end of the Chou period.

Proof that bronzes of the Li Yü style were actually manufactured in Shansi is furnished by a vast number (over 1000) of fragments of pottery casting moulds excavated at Hou Ma, in the south of the province, in the K'uai river valley. A group of bronzes with ornament of the Li Yü kind come from a tomb at Fen Shui Ling near Ch'ang Chih in south-west Shansi.[32] The interlaced pattern of a *ting* and a *chien* included in these is of the variety, probably the latest version, which includes full-face ram masks. No piece here or in the Li Yü find is inscribed. The style cannot

Fig. 1. Ink impression of the ornament on the *ting* of Pl. 60*a*.

have been created much before the mid-sixth century. It probably flourished for a few generations, and was abandoned by 500 B.C. or shortly after. It was confined to the north side of the Yellow River, spreading probably only a short distance from Shansi. The covered *ting* of Pl. 61*a* is said to have been excavated in Hui Hsien in Honan province. Its ornament is close to that of the Shansi pieces, while that of the *yi* and bowl of Pl. 63 and even of the *tou* of Pl. 61*b* are related to it. Scrolled openwork such as covers the spout of the *yi* is not found in any of the pieces from the Shansi sites, but comparable pierced designs appear at Hsin Cheng as the crests of tigers and later they are not uncommon in small bronze ornaments.

Bronzes which represent an eastern variant of the Li Yü style, and combine it with a striking exotic element, were recently excavated at Chia Ko Chuang near T'ang Shan Shih in Hopei province.[33] Here some twenty graves contained material of the late Chou period, including the *tui* of Pl. 65*b*, the *hu* of Pl. 64*b* and the tripod *yi* in Pl. 62*b*. The subdivision

of the Li Yü type of interlaced band into separate symmetrical units is now complete, some of the shapes suggesting a misunderstood version of the ram-head which was taken into the Li Yü scheme. The remarkable and unparalleled *yi*, unique by its comparatively fully-fashioned animal shape, is covered with the scales and chevrons of the new convention. The pear-shaped *hu* with vertical ring foot and a pair of ring handles is one of the earliest representatives of a vessel shape which suffered little change from the fifth century until Han times. The imitation of a rope sling is an early feature, which appears on the piece found at T'ang Shan (Pl. 64*b*).

The panels of this *hu* are filled with hunting scenes, the figures cast con-cave and filled with a black substance. Some of the animals have curved feet and spiralled joints, but there the resemblance to the commoner con-vention ends. The huntsmen and their prey are drawn in a stylized realism which falls quite out of the context of the rest of Chou art and recalls the art of primitive hunting peoples in remote parts of Asia and in Africa. Among the hunted animals the boar, deer and birds look real, but a phoenix is fanciful, and the elephant probably no less so, for this animal has not existed wild in China since prehistoric times. The huntsmen hold spears and are accompanied by dogs.

A number of these 'hunting *hu*' are preserved in collections.[34] They are decorated with equally animated scenes, though unlike the T'ang Shan piece these are generally rendered in relief. One such, in the Kunstindustri-museum in Copenhagen (Pl. 70*a*), is among the finest of them. It bears a hint of archaism in the twisted dragon motif which decorates the foot, while the heraldic disposition of the phoenixes at the neck attune better with the schemes of the fourth century. The *kuei* of the Ingram collection is a rare example of the hunting ornament applied to a vessel other than the *hu*. The mythological animals represented on other bronzes from T'ang Shan are depicted in concave line, and follow the style of tigers and dragons seen on the Hsin Cheng pieces and even more commonly on the bronzes of the later Huai style.

Since the bronzes from T'ang Shan are related by their ornament both to the Li Yü style and the succeeding Huai style, they must fall, at the limit, between the middle of the sixth and the end of the fifth centuries. Probably they were made about 500 B.C. They show points of comparison with the tigers which decorate the Cull *hu* of 482 B.C. (Pl. 55).[35] The hunt-ing *hu* in this find is the only example of these vessels which has been located by excavation and is associated with other bronzes. The modern province of Hopei lay formerly in the territory of the Yen state. A *hu* decorated with dragons like some of those used at T'ang Shan is inscribed with the record of a sacrifice performed at a place in Hopei.[36] The style of the hunting scenes is so much at variance with the normal canons of the feudal art that one may suspect an exotic influence. The figurative art of the Yen state may owe something to the art of barbarian hunters inhabit-ing the forested region lying to the north-east, a pendant to the nomad's art which formed in the north-west.

Abundant finds of bronze vessels, weapons and ornaments made in

tombs in the vicinity of Shou Hsien in the Huai river valley in Anhui, acquainted us some thirty years ago with the art of a region regarded by the central Chinese of the pre-Han period as barbarian land to which Chinese culture had not completely penetrated. The excavation of a great tomb at the same place in 1955 gave a full record of another bronze treasure.[37] In this case inscriptions on some of the vessels give grounds for inferring a date. Shou Hsien, situated on the Huai river near its confluence with the Yangtse, was an important city of the state of Wu, and continued to flourish after the defeat of Wu by the state of Yüeh in 473 B.C. and its later annexation by Ch'u. Already in 493 B.C. the neighbouring small principality of Ts'ai had been overrun by a Ch'u army, and a Marquis Chao of Ts'ai had then taken refuge in Wu. The Marquis of Ts'ai whose name appears on many of the bronzes excavated in 1955 is believed to be this individual or a near successor, the title being recognized until 447, when Ts'ai was finally destroyed. Thus contents of the tomb are probably to be dated within a generation more or less of 493 B.C.

The state of Ch'u was established early in the seventh century B.C., but there is no reason to believe that fine bronze casting was practised within its borders before, at the earliest, the end of the sixth century*. Its territory, which included the north of Hunan province and an indeterminate region stretching southwards, was initially unacquainted with the feudal civilization and advanced arts of the Chou confederacy. The unusual taste and the newly acquired technical skill of the redoubtable southern neighbours of the silken princes of Chou are epitomized in the *ting* shape they adopted (Pl. 56*a*). This form was characteristic of the Ch'u region in the fifth century, and as a whole is foreign to any northern style, although some details of the composition come from that quarter. The dragon protomes which adorn the sides, with large square crests on the reverted head and a body formed of spiralled segments, answers to the animal known at Hsin Cheng and T'ang Shan, but the form of the vessel itself has been redesigned, and, one might add, with little success. The pedestal *kuei* (Pl. 57*a*), the *fu* (cf. Pl. 56*b*) and the *tui* are closer to the northern tradition. The *hu* (Pl. 54*a*) so closely resembles the specimens recovered at Hsin Cheng that they seem to be the product of one workshop. Indeed the Hsin Cheng pieces may have been imported from the south, for they fit better in the context of the Ts'ai treasure.

The Ts'ai bronzes follow the same trend as those of the north in adopting small continuous ornament which has no structural character, and in seeking larger plastic effects. The extravagance and often fortuitous air of the projecting parts is however apt to look barbarous in contrast with the better integrated designs of Li Yü and T'ang Shan. The motifs used in the continuous pattern continue so naturally from the sequence of development observed at Hsin Cheng that a close contact of the makers of the two groups must be assumed. Since there can hardly be any question of

* The account of Huai style which follows should be read together with the further comment included in the Preface to the Second Edition, pp. 19–20.

artistic bronze-work in the Yangtse valley much before 500 B.C., a migration of bronze-workers from the north, or perhaps their capture by the invading Ch'u armies, was no doubt a preliminary to the sudden rise of sophisticated metallurgy in the Yangtse region at the end of the sixth or early in the fifth century. The styles which were adopted in bronze vessels and ornaments were a development of the work of the northern centres, perhaps influenced in a minor degree by a local artistic tradition which had hitherto been expressed in perishable materials.[38]

The unit of design on the pedestal *kuei* of Pl. 57*a*, like that on the *fu* of the same plate (inscribed '*fu* of a prince of Ch'u'), is the squared dragon interlacery impressed by stamps which is known on vessels found farther north. The bands at the base of the *ting* and the *lei* (Pls. 56*a* and 59*b*) are filled with a minute figure formed of a spiral raised to a wart to which is attached a slightly curled, feather-like wing. This motif was called by Orvar Karlbeck 'abundant hooks and volutes'.[39] It is the hallmark of the Huai style. Parts of the *hu* and the *lei* are covered with a feebler pattern which arose when the crossings of interlacery were neglected and care for its lucid structure abandoned.

The hooks and volutes of the Shou Hsien bronzes may have arisen in the first place as an enlivening quirk given to broad interlaced pattern, not unlike the Li Yü schemes, such as adorns the Chih Chün Tzŭ *chien* of Pl. 60*b*. But examples on this large scale are rare. Normally the hooks and volutes fill the field without conforming to any larger pattern. They enrich the surface much as do the small interlaced units, but with greater effect. The last degeneration of the interlaced unit, a meaningless square figure with a wart added, can be seen on the *hu* of Pl. 76*a* (the piece so mysteriously and unconvincingly recorded as found in excavations at the Dane John in Canterbury in 1876). The 'teeming hooks and volutes' covering the flask of Pl. 67*b*, and furnishing the ground ornament of the majority of Shou Hsien mirrors (Pls. 90*b* and 91*b*, Fig. 2), recapture the life which the dragons have lost. A comparable use of spiral figures, peaked to points and sharp edges above the general level of the design, is found in the bronze art of Celtic Britain.

There is nothing to suggest that the hook-and-volute motif was evolved in material other than bronze. Its shape is natural to carving in the negative, and its existence an argument for the use of negative moulds, whether for direct casting or for the *cire perdue* process. In particular, the hooks and volutes could not be produced by stamps, and this preserved Huai art from the routine degeneration observable in earlier styles. In the fourth century B.C. the motif was adopted by jade carvers, in the revival which raised their craft to the level of a great lapidary art.

Other features of the Huai style appear also as a selection of ornamental ideas in vogue with Ch'u's northern neighbours. These are the rope and plait patterns, the spiral convention in the drawing of animals, and the use of granulation, circles and parallel strokes on their bodies, all of which are to be found in the work of the near-contemporary northern centres. They constitute an element of the style which was inherited in various degrees

by the nomad artists of the Ordos region and the steppes. Blade-shaped figures, whorled circles, scaled snakes and animals and monster masks, all of which strangely echo elements of the Shang style, relate Huai art to the broadest Chinese tradition. Tempting as it is to see in the Shou Hsien bronzes the manifestation in bronze of elements of a purely local artistic tradition, an analysis of the constituent elements of the art forbids this, and proves, not unexpectedly, its great debt to the north.

The Freer Gallery *chien* (Pl. 60*b*) instanced above as a pointer to the origin of the hook-and-volute mannerism, was discovered at Hui Hsien, Honan province, in 1938.[40] The Chih Chün Tzŭ of the inscription may be

Fig. 2. Ink impression of a Shou Hsien mirror.
4th–3rd century B.C. Diameter $3\frac{7}{8}$ ins. British Museum.

connected with a princely family of the state of Chin, in the territory of the modern Shansi province, whose head was killed in 473 B.C. The style is close to that of the Cull *hu* (Pl. 55) which bears an inscription suggesting a date for its manufacture near to 482 B.C. (see p. 86), the year when Chin and Wu concluded a pact of mutual assistance.[41] Fu Chai, a ruler of Wu, is named in the inscription of the *chien* of Pl. 59*a* and dates it to about the same time. Unfortunately this information gives no clue to the place of manufacture of the Cull *hu*, unless it is the inference that the Han Wang of the inscription was, as Yetts thought, an alternate name for the king of

Wu. In the troubles arising from the aggression of the Ch'u state that Wu and Chin were facing, the king of Wu may have been the suppliant party. Han Wang 'presented the bronze metal'. In the convention of the epigraphy this may mean that he had the vessel cast in his own territory, which was within the sphere of Huai art.

While the accomplished use made of the hook-and-volute motif on these two vessels suggests that it must have originated before 500 B.C., there are no dated pieces through which to trace its history into the preceding sixth century. After the fifth century it seems no longer to have been used in broad interlacery of the kind related to the Li Yü style, and a uniform surface of small raised volutes was the all but universal decoration of vessels, weapons, mirrors and other ornamental bronzes produced in the Huai tradition (Pls. 58 and 67*b*). The flat figure in concave line filling the bands of the Cull *hu* and the Freer *chien* — a spiral joined to a triangle — which they share with the Li Yü vessels, is not found on the bronzes from the Ts'ai tomb at Shou Hsien, and is absent from the majority of Huai bronzes of the fifth century. The same figure is used later as continuous ground pattern on mirrors of the northern group (see p. 85 ff.) and it is the point of departure for the geometric style of the fourth century.

In the fifth century ornament of Huai style was applied with great success to the bronze bells (*chung*) which were often buried in tombs in complete sets of thirteen, graded in size to sound the notes of a musical scale (Pls. 68*a* and 69). The bells are clapper-less and intended to be struck on the outside. They were hung mouth-downwards, in contrast to the earliest bells, of late Shang date (Pl. 68*b*), which were evidently intended to be mounted mouth-upwards. The latter type ceased to be made when the Shang state fell. Bells of the Chou tradition can be traced to the tenth century through the piece found in the tomb at P'u Tu Ts'un,[42] which has rows of nipples on the sides for striking. Bells of the eighth and seventh centuries found at Shang Ts'un Ling have smooth sides decorated with a broad, flat figure based on a coiled serpent-dragon. The nipples of the bell illustrated on Pl. 69*b*, its handle and the handle of the bell of Pl. 69*c*, are in the older style.

The sides of the fifth-century bells are covered with ornament of the Huai kind, the hooks and volutes filling the spaces between the nipples. The broader field below them displays a symmetrical composite scheme suggesting a monster mask flanked by dragons or entwining snakes, often with their limbs raised sharply in the hooks and spirals of the prevailing convention (cf. Pls. 68*a*, 69*b* and *c*). Equal ingenuity was expended in the design of openwork handles built of confronted dragons or tigers.

The Huai style lasted through the fifth century and into the fourth. In the fourth century its characteristic motifs were replaced by others of more geometric character, in the design of which the ruler and compass take a greater part than hitherto, and whose appearance coincides with the adoption of inlays. Two trends are distinguishable. In one, the units of the pattern are arranged symmetrically about a vertical or diagonal axis. They are drawn in straight lines with spiral ends, continuous with

wider scrolled elements. The broader effect is of bands of adjacent or intersecting triangles or lozenges, and the whole makes a static pattern (Pl. 76*b*, Fig. 3). The other new convention preserves better the energy of the older Huai style, although it has no close connexion with its motifs. These patterns follow the new fashion of symmetrical arrangement either within the unit or between a pair of figures. Their main lines take broad sweeps, with a lively movement akin to that of the scrolled animals of the

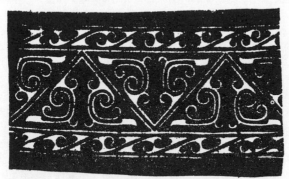

Fig. 3. Ink impression of the ornament of a bell.
Late 4th–3rd century B.C. British Museum.

earlier ornament. The chief figure is a pacing winged dragon, with a feline head, or, oftener, the head of a bird of prey. The body of the dragon is never reduced to a quite abstract figure. Where it approaches an abstraction of interlaced and scrolled lines, the head and the fling of the dragon's limbs are still perceptible. This style is better recorded in the decoration of small bronzes, weapons and chariot parts and on mirrors, than on bronze vessels (Pls. 80*a*, 80*c*, 83*b* and Fig. 4). The two geometric styles were not

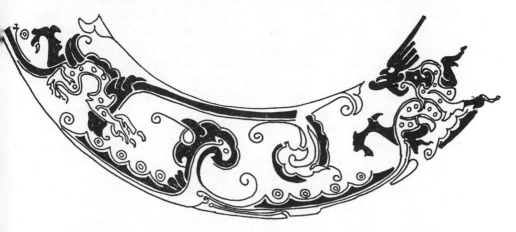

Fig. 4. Design inlaid with gold and silver on a bronze ring (the black parts representing gold. 3rd century B.C. Collection of the Hon. and Mrs Robert Woods Bliss. Width of the drawn segment about 5 inches.

73

exclusive. Some pieces with curved dragon elements have also bands of the more rectilinear geometric abstractions. Nor can geographical limits be set. Both types of design occur in Honan and in the Ch'u territory, although broadly the heraldic style appears to have been favoured in Central China, where it is well represented in the great treasure of Chin Ts'un. The freer manner, being more akin to designs found on mirrors of the Shou Chou family, may represent the southern tradition. In both variants of the geometric style the pattern is most often rendered by inlay in the bronze.

Gold and silver were applied without previous preparation in the casting. A scoring made in the bronze with a sharp point was sufficient to hold a thread of the precious metal, which even in fine lines was supplied as foil, and never wire. The use of foil encouraged (if it did not prompt) the draughtsman to combine fine line and broader bands in his design, with sudden change from one to the other. The foil was attached over the broader bands merely by scorings at the edges which may be slightly undercut. It is common to find pieces (particularly belt-hooks and ornaments from weapons) in which the exposed bronze surface has corroded away below the level of the inlay, so that this is left standing proud (Col. Pl. G).

Frequently in belt-hooks and sometimes in vessels stone inlay was combined with precious metal (Pls. 66b and 76b). Turquoise and, more rarely, malachite were laid in cells ready cast in the bronze. The stone seems not to have been very securely fastened, and through the decay of the adhesive most of it has been lost from surviving pieces. In the fourth century copper was sometimes inlaid to show red against the yellower hue of the bronze. Small dragon silhouettes in copper are found on some fourth-century hu, and more commonly pendant triangles of copper inlay adorn the lip, as seen in the flask of Pl. 67b. One singular bowl in the Victoria and Albert Museum is decorated with copper dragons filling perforations in the bronze wall. To the same enterprising time belong weapons — swords, ko and spearheads — decorated with mottling and figures such as the stars on the British Museum spearhead. It is not known how the pattern was produced on its metal surface. Possibly the marks have been accentuated in the patina acquired by the bronze during burial. This *tour de force* of metalcraft may have been an achievement of the Ch'u foundries, for a large number of weapons decorated in this manner were recently excavated near Ch'ang Sha in Hunan.[43] The inscription inlaid with gold on the spearhead, composed in the ornate 'bird script' and decipherable with difficulty, appears to read: 'King Chou Shao of [Yüeh?]. May he himself [ever?] use it' (Fig. 8).

The taste for inlay which produced the best metalwork of the third century B.C. terminated the tradition of finely cast ornament which had persisted through a thousand years. Few inlaid vessels can be dated after the end of the third century B.C. During the earlier Han period, in the second and first centuries B.C., inlay was gradually abandoned even in smaller bronzes. In vessels the only traditional motif still retained is a t'ao

t'ieh mask of Huai style, which serves as escutcheon to the ring handles (Pl. 77*b*) and reproduces the handles fixed to wooden coffins (Pl. 88*a*). The *hu* and other shapes of flask are the usual forms, and they are often left unadorned (Pls. 71*a* and *b*). Incised decoration consisting of simple geometric figures in bands and of birds and other animals (Pl. 75*b*) was practised in earlier Han times, and gilding was introduced in the same period both for vessels and ornamental bronzes.

Some of the earliest gilded bronze is found among the belt-hooks. A few, gilded specimens of the early (fourth or third-century) class of small hooks with Huai-type ornament are known (cf. Pl. 86*a*), and in these the gold seems to be poorly secured on the bronze. In the larger belt-hooks of the third and second centuries B.C. a superior quality of burnished gilding is common (Pl. 86*b*) and is nearly always found on the belt-hooks decorated in the 'chip-carved' style, adopted at the beginning of the Han period, which copy a style of wood-carving (Pl. 87*a*). Vessels are parcel-gilt (Pls. 73, 74*c*) or decorated with gilding of two colours, reddish and yellow, following the lightly engraved lines of 'cloud scrolls' (Pls. 73 and 78*b*). Feet of gilded bronze in the shape of bears were added to wooden and lacquered vessels, and often survive apart.

The outstanding achievements of Han metalwork are not to be sought among these vessels however, but belong rather to the realistic animal bronzes, such as the lamp of Pl. 84*a*, the inlaid leopards from Man-ch'eng (Col. Pl. H*a*), and the belt-hooks of Pls. 80*b* and 87*d*; and to the bronze mirrors. These last are described in the last chapter of this book.

CHAPTER IV

Inscriptions on the Vessels

Inscriptions were first cast on the bronze vessels of the Shang period in the latter part of the dynasty. No inscriptions are found on the pieces recovered at Cheng Chou nor on the more primitive vessels from An-yang which are presumed to belong to the earlier period of the site. At all times, from Shang to the end of Chou, inscribed vessels are a minority, but we may assume that the religious and political purposes the inscriptions record belong equally to the unmarked pieces buried in the tombs.

A passage in the *Li Chi* describes grandiloquently the intention of the inscriptions as it was understood in late Chou and Han times, when Confucian piety had hallowed the institutions of Chou: 'The inscriptions on *ting* record the name of the person who had them composed, and they do so in order to extol the merits of his ancestors and to declare them to later generations. All our forbears had their virtues and faults. The inscriptions record the former, for they are motivated by the filial piety of their descendants. Such filial piety is found only in persons of high moral character. The inscriptions publish to the whole Empire the virtue, incorruptible zeal, meritorious services, official rewards and the fame of ancestors.'

Inscriptions which answer explicitly to this definition are not however found before the Western Chou period, when the political rôle of the vessels is clear. Records of a royal gift cast on vessels of shape and ornament characteristic of the Shang dynasty are very rare, and doubt remains whether this custom had been adopted before the advent of the Chou. It is possible that the Shang kings made official gifts of bronze vessels towards the end of their reign, when the feudal relations which provide the context for them can be demonstrated to some extent from the oracle sentences.

The normal Shang inscriptions, in which there is no mention of award, are brief formulas, and often consist of no more than a single ideograph or emblem. They show a mixture of characters, some belonging to the ideographs of the ordinary script, but of nobler and better balanced form, and others which are more obviously representational. The latter may represent an older stage of the writing, prior to the forms of the bone inscriptions, in which they are not used. On the bronzes they often appear alone; if they are combined with further characters of the normal kind, they usually stand a little apart, and always at the beginning or end of the inscription. They are believed to be mainly personal or clan emblems. The

76

characters are cast on the inside of the vessels, on the bottom or near the edge; or, in the case of the *chüeh* and *chia*, on a space left clear for the purpose behind the handle.

At their best the characters are beautifully drawn, their rather unpromising elements delicately shaped and arranged, with a skill all the more notable for the lack of any tendency to geometric or symmetrical form, even to the extent to which this is present in the Han and modern scripts. They are crisply cast, preserving something of the character of brush-writing which we have reason to believe was already practised in Shang times. The inscriptions were carved on a die in intaglio, and, in preparing the casting mould, transferred to the clay or wax so as to produce in the bronze an even, concave line with vertical edges. A few inscriptions appear in raised lines (e.g. Fig. 5 (7)), but such departures from the normal process are exceptional.

The dedicatory inscriptions of Shang and early Chou date are worded conventionally and abbreviated, so that their interpretation presents problems even when the characters have been identified with their equivalents in the modern script. The meaning of many of the characters used is unknown or debatable, even when their graphic equivalents in the modern script can be deduced. This is particularly true of the earlier inscriptions; and while the gist of the longer texts of Chou date may be clear, details are often in doubt. Attempts at connected translation are beset with difficulties peculiar to each case. In the following pages only the general purport of the inscriptions is discussed, with illustrations taken mostly from bronzes illustrated in the plates.

A formula in use towards the end of the Shang period dedicating a vessel for sacrifice to the spirit of an ancestor consisted of the following elements, which are marked in Fig. 5 (1):

1. The name of the maker of the vessel, usually a single ideograph, sometimes a pair (Fig. 5 (1) (*a*)).
2. 'Made (for)' (*b*).
3. The ancestor indicated by a ritual title, the word '*fu*' ('father') (*c*) followed by a calendar symbol (*d*).
4. Designation of the vessel: '*tsun yi*' (*f*, *g*) 'sacral vessel', which is often preceded by '*pao*' (*e*), qualifying it as 'precious' or 'to be preserved'.

Yi is the generic term for a ritual vessel and *tsun* seems to do no more than qualify it in the same sense. In the ritual name of the ancestor the character following '*fu*' is taken from the series of ten symbols (the 'ten stems') which were used in the Shang calendar to mark the days. Combined with another series of twelve symbols (the 'twelve branches') these signs recorded the sixty-day cycle of the Shang and Chou calendar. They are the same as those used from Han times to the present day to record the sixty-year cycle of traditional Chinese dating. In Shang times the ancestor to whom the vessel is dedicated appears to have had sacrifice offered to him on the day corresponding to the symbol of the inscription, on one of the days of a ten-day 'week'.

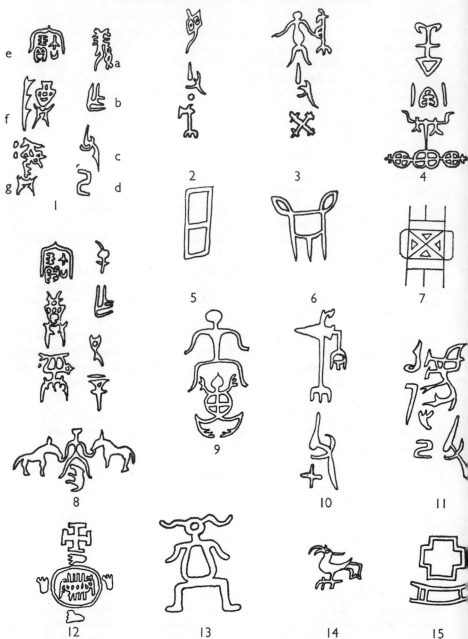

Fig. 5. Inscriptions cast on ritual bronzes of the Shang period:
1. vase-*tsun*, J. P. F. Menten; 2. *chih*, Pl. 18*b*; 3. *yu*, Mrs
Christian R. Holmes; 4. *ku*, Lord Cunliffe; 5. *yu*, Pl. 30*a*; 7. *ho*,
Mrs B. Z. Seligman; 8. *yu*, Detroit Institute of Arts; 9. *chia*,
after Jung Keng; 10. *ting*, Pl. 27*a*; 11. elephant-*tsun*, Pl. 30*b*;
12. *yu*, Cernuschi Museum; 13. *fang yi*, Pl. 18*a*; 14. *li*, after
Jung Keng; 15. *fang yi*, Pl. 17.

In connexion with this dedicatory formula, the characters believed to be personal or clan emblems occur most frequently added at the end. More rarely they replace the characters of more normal script type (though even these are often not interpretable) which begin the inscription as the subject of the verb 'made'. The emblematic characters vary from fairly naturalistic figures of animals to more schematic versions and abstract shapes distinguishable from script ideographs mainly by their stiffer outlines. Sometimes the formula is reduced merely to the naming ideograph or emblem followed by the ritual name of the ancestor; examples occur of this name alone, and even more frequently the mark is only an emblematic character. All the inscriptions shown in Fig. 5, except (1) and (8), illustrate these briefer dedications or emblems of the dedicator. Many of the emblems portray birds and animals with a naturalism unusual in Shang art. A figure suggesting horse-taming or horse-breeding follows the fuller formula in Fig. 5 (8). The *ting* of Pl. 1 is marked with a creature resembling a scorpion.

Human figures occur in a variety of attitudes, full-face with arms and legs spread, or in profile, wielding bow, halberd or shield, carrying in yoke-fashion loads of cowrie shells which represent money, or kneeling singly or in pairs near altars and vessels in a sacrificial rite, as on the *ku* of Pl. 22*a* where this figure occupies the first place in the fuller formula. Other instances suggest that the emblematic character denotes a type of sacrifice rather than the identity of the dedicator. For example, the figure of *ting* marked on the *yu* of Pl. 21*a* (oddly at variance with the shape of vessel on which it appears) seems improbable as a personal designation; and a frequent and varied group of signs point to human sacrifice. In the latter the human figure is usually headless. On the *ho* of Pl. 35*a* the mark of a human foot appears over the severed neck (Fig. 6 (6)); elsewhere the picture of an axe of a kind well known from surviving specimens (Pl. 83*c*) is placed over the body. These signs recall beheaded human victims buried in the royal tombs of Shang. On the bronze vessels they may refer to this form of sacrifice, or perhaps, as a personal emblem, to military prowess, since prisoners of war may have provided the victims at the funeral holocausts.

Another symbol frequent on Shang vessels is the rectangular frame with recessed corners which encloses emblematic characters in the examples illustrated in Fig. 6 (1) and (2). This is the *ya-hsing* ('ya shape') so called from its resemblance to a character of the later script denoting 'inferiority'. Various interpretations have been proposed for this figure, none of them conclusive. Its outline suggests the plan of a cruciform Shang tomb, and it might thus symbolize the cult of the dead and the nether powers.[1] It also approximates to the shape, seen from above, of the ritual jade *tsung*, as it was made in Shang and Chou times and placed in tombs. The resemblance is here rather remote however, since the *ya-hsing* fails to reproduce the circle within a square which suggests the heaven-earth symbol of the *tsung*. The shape has been compared to the ground plan of a fort,[2] and also interpreted ideographically in the sense of the *ya* character, that is, to mean abominable, ghostly, relating to the dead.

The *ya-hsing* is found in another simpler form, more like a stumpy cross, when it may enclose, or (unlike the elaborate form) be placed alongside other ideographs in the manner of other emblematic characters, as in *fang yi* of Pl. 17 (Fig. 5 (15)). It is not certain that this form is to be regarded as only a variant of the other. The *ya-hsing* with the peculiarly shaped corners is recorded many times containing the figure seen in Fig. 6 (2), which may represent an ancestral spirit receiving the sacrifice contained in a vessel. If an explanation of the shape is sought in the paraphernalia of sacrifice, it may be surmised that it gives the outline of a ritual pen in which the sacrificial animal was confined before it was slaughtered.

In other instances the *ya-hsing* of elaborate shape contains emblematic characters of the kind thought to be personal emblems when they occur with a dedicatory formula. The example illustrated in Fig. 6 (1) may enclose such a personal mark, though here it could be interpreted as representing the sacrificial animal enclosed in its pen. The marks around the head, to hazard another guess, suggest trees or bushes. The strange animal seems not to belong to a domestic species. From the oracle bones we know that hunted game might be offered in the rite. But whatever the symbolic origin of the *ya-hsing*, it is likely that it was used perfunctorily to frame personal or clan names in the manner of the Egyptian cartouche. The characters which occur inside or alongside the *ya-hsing* in inscriptions are of the same types, ideographs or emblems, as appear with the dedicatory formulas in positions which suggest names. There are instances of the same character placed inside the *ya-hsing* in one inscription and outside in another. The inscription of the *kuei* of Pl. 4b (Fig. 6 (7)) is also recorded from another bronze with the character enclosed.

The above remarks suggest the lines which have been followed in speculation on the meaning of the more enigmatic of the Shang bronze inscriptions. There remain three other marks of equally obscure meaning which occur fairly frequently. The composition shown in Fig. 6 (3), was transcribed in Sung times by the current characters *hsi tzŭ sun*, that is, literally, 'divide son(s) grandson(s)', although the meaning intended was not further elucidated. Wang Kuo-wei interpreted this figure as the conventional representation of sacrifice to ancestors, the smaller figure being the *shih*, the impersonator of the dead man at the ceremony, and the larger the person offering the sacrifice. The uppermost sign has been interpreted on ideographic grounds as an altar table. Kuo Mo-jo regards this symbol, like the other emblematic characters, as the mark of a clan. He applies a similar reasoning to the recurrent composition seen in Fig. 5 (9), explained earlier as 'sons and grandsons', which he transcribes as 'heavenly tortoise', *t'ien kuei*. He quotes a passage from the *Chou Yü*: 'My clan-name comes from the Heavenly Tortoise'.

Opinion on the meaning of both these symbols has varied widely and no conclusive interpretation has been reached. The *hsi tzŭ sun* especially has tempted to speculation, in which Dr Bulling's theory of tree worship — the splitting symbolizing the opening of a 'cosmic womb' — is the latest and most hazardous.[3] The characters shown at Fig. 6 (4) and (5) have both

80

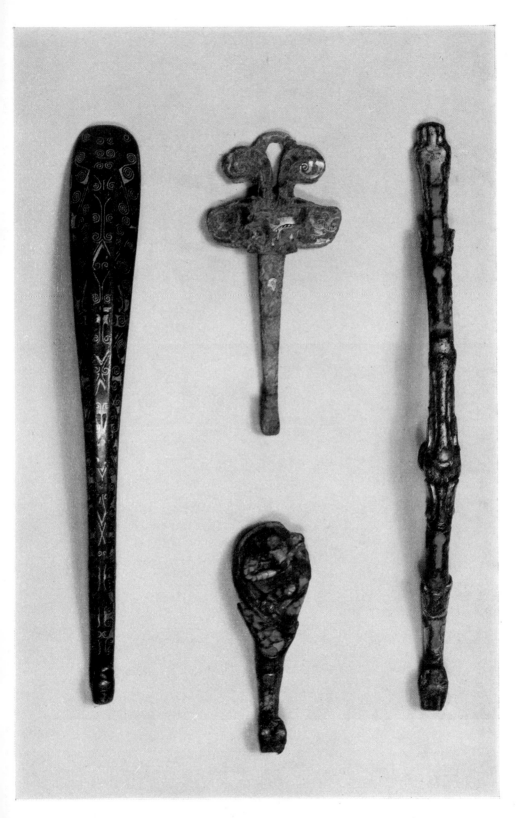

G. Belthooks inlaid with gold and turquoise. 4th–3rd century B.C.
Length of the right-hand hook 7 ins. Formerly in the collection of Lord Cunliffe.

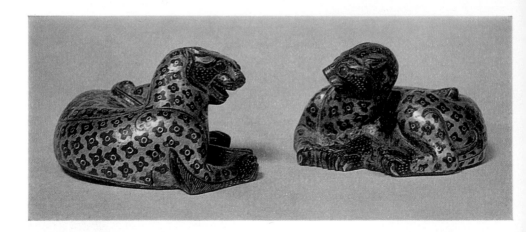

H(a). Parcel-gilt figures of leopards, inlaid with silver, the eyes of agate. Found in 1968 in the tomb of the princess Tou Wan at Man-ch'eng, Hopei. Late 2nd century B.C.
Ht. 1⅜ ins.

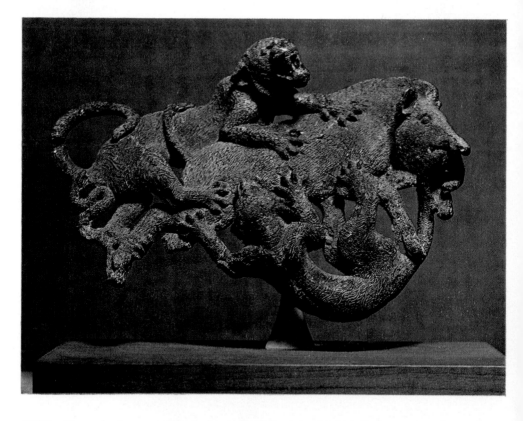

H(b). Bronze plaque with traces of gilding in high relief representing a boar attacked by two leopards, one of which a snake is biting. Excavated in 1955–60 from tomb no. 3 at the necropolis of the kings of the Tien kingdom in Yünnan. 2nd or early 1st century B.C.
Length 6¾ ins.

been conventionally equated since Sung times with the modern *chü*, raise, hence to offer in sacrifice. No proof of this meaning has been proffered, then or later.

Features of the inscriptions discussed above and of some rare longer inscriptions have been adduced as evidence of the Shang date of the bronzes on which they appear. The use Karlgren made of the *ya-hsing*, *hsi*

Fig. 6. Inscriptions cast on ritual bronzes of the Shang period. 1. *tou*, Museum of Eastern Art, Oxford; 2. *kuei*, after Jung Keng; 3. *yu*, after Jung Keng; 4. *tsun*, after Jung Keng; 5. *yu*, after Jung Keng; 6. *ho*, Pl. 35*a*; 7. *kuei*, Pl. 4*b*.

tzŭ sun and *chü* was mentioned above, and doubt expressed of the implied view that the Shang customs, religious and epigraphical, which they reflect, ceased at the moment of the Shang defeat and the destruction of the capital at Anyang in 1027 B.C. This assumption smacks somewhat of the dynastic mystique of the earlier Chinese historians, and still remains to be proved. Western archaeologists have learned to be sceptical of 'destruction theories'. But, apart from the supposed suddenness of the change, it is

F

clear that the epigraphical criteria chosen by scholars from the Sung dynasty until the present time as pointers to the Shang date of inscriptions are in the main valid, whatever exceptions to the date-line at 1027 may be forthcoming in the future.

In the *K'ao Ku T'u* the Hsiang Kuei *yu* is attributed to the Shang period primarily by reason of its provenance (see p. 17 above), but also on other grounds: (*a*) the use in the inscription of the term *ssŭ* (a sacrifice) to designate the year of the King's reign; (*b*) the inferred royal succession from elder to younger brother, which was a Shang custom; and (*c*) the use of the calendar symbol *kuei* (the last of the ten stems) to designate the dead elder brother to whom the *yu* is dedicated.[4] The last two arguments are based on the Shang king list preserved in history, in which many kings bear names composed with one of the calendar symbols. At the beginning of the present century Lo Chen-yü accepted such use of the ten stems in posthumous titles as proof of the Shang date of inscriptions and added as a further criterion the use of the 'pictorial characters' which we have called emblematic.[5] He was not dogmatic in his conclusions, allowing that these practices might extend upwards into the Hsia dynasty and downwards into the early decades of Chou rule.

Another method of determining the Shang date of bronze inscriptions is comparison with the formulas of the oracle sentences. Unfortunately there are so few inscriptions on surviving bronzes which lend themselves to this comparison that the results are of limited interest. The inscriptions in question are records of royal gifts which anticipate the all but regular form of the longer inscriptions of the early Chou period. Wang Kuo-wei, in studying parallels of oracle sentences with the phraseology of the earliest historical text, represented by the oldest parts of the Shu Ching, singled out the method of recording the date as the salient distinctive feature of the Shang convention as compared with that of Chou times.[6] The Shang custom was to start with the symbols of the sixty-day calendar cycle, and to end with the regnal date: 'such and such a month, the king's such and such a year'. This inverts the order year-month-day which was followed from the beginning of the Chou dynasty and has been customary ever since. The word used as equivalent for year is *ssŭ*, or sacrifice, the appearance of which, as noted above, was accepted by Lü Ta-lin as evidence of Shang date.

These points are exemplified in the following inscription from a *chiao* in the Sumitomo collection:[7]

'The day *Keng Ch'en*. The King in the Eastern Hall. The king advanced. The *tsai* [an official] *Hu* followed him. He [the King] presented five strings of cowries. He [*Hu*] using these caused to be made the sacral vessel [*tsun yi*] of his ancestor *Fu Ting*. In the 6th month, the 25th year [*ssŭ*] of the King [here an emblem].'

In 1928 Ma Heng added further epigraphical criteria for deciding the Shang date of an inscription: (1) the mention of sacrifice to a female ancestor, ritually designated *pi*; (2) the appearance of two characters standing for particular sacrifices and prefixed to the word day; (3) and of

the phrase 'campaign against the inhabitant of the marches (*fang*)' apparently intended to distinguish the year in question.[8]

Among the brief inscriptions cast on vessels in the early reigns of Chou some can be found which follow the Shang convention closely. That on the *kuei* of Pl. 42*a*, which we date to the end of the eleventh century, reads 'Made for Father Yi a precious sacral vessel'. The name of the maker is not given, and at the end is placed the *chü* character (Fig. 6 (4)) followed by a scorpion-like emblem. The most perfunctory abbreviations, simply 'made a sacral vessel', without any mention of names, occur in the western Chou period, apparently from the early years of the dynasty, and are used on the *kuei* of Pls. 37*b* and 39*b*. Such marks as the '*Yü* of the Duke of K'ang', on the bowl illustrated in Pl. 25*b*, leave us in doubt whether the duke was author of the vessel or recipient of the sacrifice.

Fig. 7. The inscription on the *ting* of Pl. 47*a*.
Width about 3 ins.

The *kuang* of Pl. 31*a*, which must date to about 1000 B.C. introduces a new phrase at the end: 'Shou Kung made this sacral vessel for father Hsin, *may it be preserved for ever*'. From the early ninth century B.C. the formula 'may sons and grandsons [i.e. descendants] preserve it for ever' often concluded the inscription, as on the *ting* (Pl. 47*a*, Fig. 7), in which the dedicator of the vessel insists on his authorship but does not name an ancestor:[9]

'In the 8th month, 1st quarter, on the day *keng shen*, I, Ts'ai Shu, *myself* made this [] *ting*. May my sons and grandsons for a myriad years, without limit, treasure it and use it.'

The *hu* of Pl. 52, which was made by 'Shih Wang, younger son of the *T'ai Shih* [a great official]' has the same stereotyped wording but, more

83

sensibly, it would seem, omits the 'without limit'. Two similar inscriptions from pieces illustrated in this book relate to the state of Ch'u:

The Ch'u Tzǔ *Fu* (Pl. 57*b*):[10]
'In the 8th month, the 1st quarter, day *keng shen*. Huan the Prince of Ch'u caused to be cast this cooking *fu*. May his sons and grandsons forever preserve it.'

The Ch'u Huan *Yi* (Pl. 49*a*):
'In the king's first month, 1st quarter, day *keng wu*, Hsiung of Ch'u ordered the casting of this *yi*. For a myriad years may sons and grandsons perpetually use it for sacrifice.'

The first of these, it will be noticed, has the same date as the preceding inscription: in the middle Chou period certain calendar days were chosen by preference for the dedication of a vessel. The inscription on the second piece is cast with the characters individually inverted, with a single exception. It is of special interest as one of the rare examples of a record of the Ch'u State in which the king referred to appears to be the Chou ruler. In 887 B.C. and again in 704 B.C. this ruler of Ch'u usurped the title of king, which amounted to a declaration of independence from control by the house of Chou. Yetts believed that the *yi* is to be dated before 704 B.C.[11] The style of decoration is in the metropolitan Chou tradition of the eighth century. There is no sign that artistic bronzes were being cast in the Ch'u territory at this early date.

The longer inscriptions found on bronze vessels of Chou date are for the most part concerned with official ceremonial and political occasions. Whereas the majority of Shang inscriptions and those of Chou date discussed above suggest that the bronzes were cast as an act of piety, the typical longer inscriptions advertise honours conferred on the person responsible for the casting of the bronze. The king or feudal prince awards noble rank or high office, which the recipient records on his bronze along with the gifts in kind which were presented to him at the ceremony. The form of such records is hardly less stereotyped than that of the brief inscriptions, whether they emanate from the Chou king or from a feudal prince. The former mostly fall in the western Chou period, before 771 B.C.

Fig. 8. Inscription inlaid in gold on a spearhead. 4th century B.C. British Museum.

Although the reigning king is not named, allusions to antecedent rulers

and other persons sometimes make it possible to assign a bronze to a king's reign. The inscription often opens with a date in the full form, used after Shang, the year of the reign, month, quarter of the month and the day denoted by the cyclical symbols. Thus an inscription and the vessel on which it is cast may sometimes be dated to a year, which after 841 B.C. is exact, and before that accurate within the limits of the reconstructed chronology. Through persons named in the inscriptions undated vessels may link with others inscribed with dates, and so be approximately dated also. Rather rarely reference to a historical event gives a clue. Apart from dates, personal, geographical and tribal names and ritual matters, the inscriptions inform us on a variety of interesting subjects, which have been studied in the light of historical and literary texts. Ranks of nobility, official appointments, the different classes of servitors and slaves are among these. We learn that the bronzes might be intended as wedding gifts, for use on journeys and on social occasions 'to put guests at ease'. The lists of gifts include weapons, chariots, horses, cloths of various materials, garments, banners.[12]

An example of an inscription cast to record the performance of ritual — and the personal glory flowing from attendance thereat — is furnished by the *ho* of Pl. 35*b*, here translated from the text as established by Ch'en Meng-chia.[13]

'3rd month, first quarter, day *ting hai*, King Mu, being in *Hsia Yü*, offered the sweet wine, and Ching Po the Great Ritualist responded with the Shê rite; and King Mu offered the *mieh* rite to Chang Fu. Then [the King] came to Ching Po's place, and Ching Po was great in respect and failed in nothing. Chang Fu performed the *mieh li* rite, and made bold to wish for the great prosperity of the Son of Heaven. To commemorate these occasions he had this sacral vessel made.'

The major affairs of the state, as the *Tso Chuan* says, depended on 'sacrifice and armament'.[14]

An elaborate text of some five centuries later cast on the bell of Pl. 69*c*, is also concerned with ritual, couched in a more personal and boastful vein. We give it here as translated by Yetts.[15] Some of the wording is obscure and the translator called his version tentative:

'On the 1st day of the King's first month, day *ting hai*, I, Ch'i of the State of Lü, grandson of Duke Yi and son of the Earl of Lü, having served the prince diligently in restoring peace by warlike prowess, have made of dark and fine bronze these bells: eight large of full tone [for sacrificial rites to ancestors] and four small of lesser tone [for invoking the spirits]. Proudly, proudly the posts and bars [of the bell racks] rear the dragon heads. Now their casting is completed, and the big bells, when suspended, shall harmonize their notes with tinklings of the sonorous jades and beats upon the alligator-skin drums. I dare not exalt myself; but to my ancestors I shall make filial offerings accompanied with music from these bells, whereby to implore the bushy eyebrows of old age. May generations and generations of my descendants continue to use and treasure them.'

Inscriptions of the first decades of the Chou dynasty speak in laudatory phrases of King Wu as Emperor of the Shang, and sometimes, though rarely, allude more specifically to military campaigns. In this respect the most notable piece among recent finds is the *Nieh Kuei* excavated in 1955 in Ling Yüan Hsien, Jehol province.[16] The inscription records a fief granted to Nieh, speaking of Ch'eng Wang's 'subjugation of Shang' (this must refer to his crushing of a Shang rebellion which history recounts) and of his 'visiting the eastern region'. This text corroborates the historical tradition of a campaign by Ch'eng Wang which extended the Chou power to the east coast. The name of the territory so acquired, *Yi*, and its constitution as a fief, are facts new to history.

In general however the historical allusions incorporated in the inscriptions are of a less precise kind, and where they serve to date a bronze, the reliability of the inference hinges on the historical text to which they can be related. Such a case is the famous inscription of the pair of *hu* in the Cull collection (Pl. 55), which has been discussed at length by Yetts.[17]

'At Huang Ch'ih the Prince (or King) of Han was aided by Chao Meng. With the bronze bestowed by the Prince of Han this vessel has been cast for sacrificial offerings. Yü.'

In 482 B.C. a conference was held at Huang Ch'ih near K'ai-feng in Honan province, at which Fu Ch'ai, King of the South-eastern State of Wu, assembled other feudal princes and demanded the presidency of the existing inter-state treaty, and a treaty of mutual protection was concluded between Wu and the Northern Chin state. The plenipotentiary from Chin was Chao Yang, and with this person Yetts proposed to identify the Chao Meng of the inscription, and possibly the Yü (a name) at the end, though this could be a son or descendant of Chao Meng. It is likely that 'Prince of Han' is an alternative title of Fu Ch'ai. Set in this context, the vessel would appear to have been cast after 482 B.C., and possibly before 473 B.C., when Fu Ch'ai committed suicide and his state was extinguished by its neighbour Yüeh. According to Jung Keng the *hu* were discovered at Hui Hsien in Honan.

The longest and most circumstantial inscriptions, belonging nearly all to the earlier part of the Western Chou, are those detailing ceremonial awards. The long text of the Ling *fang yi* of Pl. 33*a*, so admirably translated by Wenley[18] begins:

'Now in the 8th moon, on the day *chia shen*, the King commanded Ming Pao, son of the Duke of Chou, to take charge of the Three Ministries and the Four Directions [i.e. departments having to do with internal and external affairs], and to receive the Chief Ministers.'

Thereafter follow other orders issued by the King, the Duke of Chou, Ming Pao and Nieh. Sacrificial wine, metal and a small ox are bestowed by 'Duke Ming' (i.e. Ming Pao) on T'ai (or K'ung?) Shih and on Nieh with the command to perform certain rites, and they are enjoined 'to be on the left and on the right, to be colleagues, and also to serve with loyalty'. It is the 'Annalist Ling', i.e. Nieh, who extols the Duke's bounty and designates a vessel for use in sacrifice to his (own) father Ting.

The inscription on the *p'an* of Pl. 26*c* includes a typical list of gifts: The text edited by Kuo Mo-jo translates as follows:[19]

'The first month, 3rd quarter, day *yi wei*. The King was in Chou [i.e. his capital]. Chou Shih [an official] honoured Shou Kung with appointment to office. Shou Kung assisted Chou Shih in performing the *lo* rite with great splendour. Chou Shih bestowed on him a roll of silk; five carpets of grass cloth; two curtains of grass cloth; a horse; three coverings of felt; three pairs of shoes of twisted hemp; three strings of jades. Shou Kung extolled Chou Shih's gifts, and commemorated the occasion by making a sacral vessel for his ancestor yi. May his descendants forever without decline treasure it in use for sacrifice.'

In the inscription of the Hsing Kou *kuei* (Pl. 39*a*, Fig. 9) some crucial characters have been variously interpreted. It is characteristic of the difficulties which beset the translation of the early Chou inscriptions that the first character of the passage recording the wording of the brevet should have been read as Hsia, the personal name of the Marquis of Hsing, and as an aberrant graph of a word *chieh* which can be argued to be equivalent to 'bestow'. The first meaning was adopted by Yetts in his long discussion of the inscription. The second was proposed more recently by Ch'en Meng-chia, and appears to be preferable because it eases the grammar by the addition of a verb.[20] The opening section is specially interesting for its reference to the donation of persons, though the status of these retainers is obscure:

'In the third month the King issued his command to Jung and the Inner Minister, namely 'We bestow on the Marquis of Hsing, for his services, subjects of three classes, the men of Chou, the men of Chung, the men of Yung. [The Marquis] saluted and bowed his head to the ground, praising the Son of Heaven.'

The inscription concludes with the Marquis's reply, couched in conventional formulas, mostly of balanced four-character phrases. The part most reliably translatable reads '. . . Ti will never withdraw the rule from the house of Chou. Mindful of my ancestors, I dare not be found wanting'. Ti was the high god of Shang, and it was held that the power which had withdrawn the mandate to rule from the Shang emperors and so determined their downfall had conferred it on their conquerors. The inscription ends with the words 'a record was made of the King's command, and a ritual vessel was made for [use in sacrifice to] the Duke of Chou'.

The ceremonial awards which symbolized the political bond between the Chou king and the feudal princes were repeated at the feudal courts, and many inscriptions, particularly among those cast between the later tenth century and the eighth century, record honours bestowed by the feudal rulers. The royal ceremony of Chou was naturally the more elaborate, and in the late eleventh and early tenth centuries at least seems to have been conducted by the King in person. The wording of the bronze records shows however that the pronouncement of the award was made later by the King's ministers in his presence. The inscription on the Sung *kuei* (Pl. 48*b*) describes, in a typical fashion, how the King, being in his capital, came to

his great hall and assumed his place, which would face south.[21] With him are his high officers, one of whom he instructs to read out the brevet. Another officer has introduced the recipient of the reward through the gate and placed him in the middle of the court. Sung is charged with the

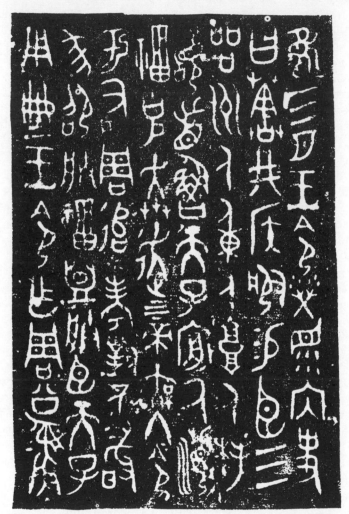

Fig. 9. The inscription on the Hsing Hou *kuei* (Pl. 39a).
Width of the panel 3¼ ins.

government of the Ch'eng Chou, apparently the city near the modern Loyang which the Chou king made his capital in 771 B.C. His gifts include fine garments, a banner and a harness bridle. He received the brevet and fastened it to his belt before departing. In return he presented a jade sceptre (*chang*), praised the King, and declared his own filial piety and loyalty.

CHAPTER V

Mirrors

With some rare and early exceptions Chinese bronze mirrors are thin discs, decorated with cast ornament in low relief on the back. At the centre of the back is placed a loop for attaching the cord which served to hold them. The edge is thickened and, in the majority of types, separated from the ornament by a broad concave band. The mirror-makers of the Han period modified the traditional design by substituting a pierced dome for the suspension loop in the heavier mirrors, and by giving a slightly convex curve to the reflecting surface, which had hitherto been quite flat. This necessitated a heavier rim, which was more generously moulded and decorated with ornament separated from the general scheme.

In the earlier centuries of their history the mirrors were decorated with patterns related to, but seldom identical with, those which were used on bronze vessels. The early schemes made use of a small range of motifs, and the mythological purport of the figures and animals is no more explicit than that of the ornament which appears on vessels and other bronzes of the late Chou period. In the Han dynasty however the mirror backs were made the vehicle for representations of cosmographical ideas and of animal and human personages of mythology which we are better able to explain. The decoration of mirrors now becomes an important source of knowledge on this subject, illustrating and even adding to information preserved in literature. The inscriptions which were cast on mirrors in the later Han dynasty and in the following century sometimes allude to the mythological theme of the ornament, and even throw light on the process of manufacture. In the second and third centuries the ornament is often in high relief, and the skill of the casting equals the best of ancient times.

In all the particulars enumerated above the Chinese mirrors differ from those of the ancient western world. These were discs with handles attached at the edge, and any decoration of the back is engraved or simulates engraving in the casting. It has often been surmised that the mirror was adopted by the Chinese from the nomads of the Asiatic steppes. Its first appearance seemed to fall about the middle of the sixth century B.C., when it might be surmised that innovations in the styles of bronze ornament reflect an influence from abroad. But in recent years evidence has come to light which suggests that mirrors were made in China in earlier times. A bronze disc with a loop handle in the manner of the later mirrors (though

larger in proportion) was among the objects recovered from the Shang tombs at Hsi Pei Kang.[1] The back is decorated with a pattern differing from the usual Shang ornament, consisting of 'an outer circle, filled with the dragon or snake design, and an inner space filled with a kind of textile pattern'. The disc is slightly convex on the plain side. It is claimed that it served as a mirror; and the alternative explanation, that it was the lid of a vessel, is discounted on the grounds that no such vessel was included in the small grave with it, and that in general no such lids are found among Chinese bronzes. It can be urged against it that rather similar objects of pottery were found in a tomb at the same site, and that the convex surface need not imply a mirror since all later mirrors before Han were flat.

Less doubt attaches to three mirrors recovered from two graves at the late Western Chou site at Shang Ts'un Ling in Honan.[2] Like the disputed Shang specimen, these are approximately $2\frac{1}{2}$ ins in diameter and have similar loop handles which cover a space of about three-quarters of an inch on the back; but they are flat, and two specimens have a slight turned-back thickening of the edge which anticipates the standard treatment in the later Chou period. One mirror, which carries two parallel loops set close together, is decorated on the back with naïve drawings of animals cast in thin raised line, two tigers, a deer and a bird. Another had been wrapped in cloth, of which fragments adhered, in this case removing any suspicion that the object had served as the cover of a jar. The lower date of the Kuo state cemetery at Shang Ts'un Ling is inferred as 655 B.C. (see p. 55 above), and the mirrors may be presumed to belong to the eighth or early seventh century. We may note in passing that the bronze mirrors of the Tagar culture of the Yenesei region of Southern Siberia do not support the theory of a foreign origin for the Chinese mirror. Here plain mirrors with a central knob seem not to be earlier than the fifth century B.C., and they more probably copy than provide the Chinese idea. A later type having a zoomorphic handle projecting from the edge, unlike any Chinese mirror, was the nomads' own invention.

References to mirrors in literature suggest that a custom of wearing them slung from the girdle had been adopted by the seventh century B.C., a date which supports the evidence of the Shang Ts'un Ling find indicating that mirrors were being made even before the rise of the late Chou bronze styles with which their history is so closely linked. Nevertheless specimens datable by their ornament before 500 B.C. are rare. The mirror seems not to have become a common article of grave furniture before the late fourth century. Only one piece was found in recent excavations of many middle and late Chou tombs at Loyang in Honan, and none was included in the large group of bronzes recovered from the tomb of the Marquis of Ts'ai at Shou Hsien.

The earliest mirrors which survive in appreciable numbers are decorated in high relief with dragons, either a circle of four complete animals with compact curved limbs, or a continuous interlaced pattern of ribbon-like dragons (Pl. 90a). The granulated and spiral figures which cover their bodies follow the convention which prevails in other bronzes of the period.

The background of the design, when it is allowed to appear, is decorated with a coarse version of the *lei-wen* pattern. The small fluted loop at the centre may be surrounded by a plain area or a band of spiral figures, and in one example the central pattern is formed of petals, anticipating a design frequent in the fourth and third centuries.[3] A constant characteristic of these early specimens is a comparatively broad flat rim, plain, or decorated with a pattern of rope-twist or a chain of cowrie-shell figures. They belong probably to the sixth century. The decoration of mirror backs in fairly high relief was abandoned in the following century and was not revived until late Han times.

A still rarer early group is of a form which had no sequel after the adoption of the standard types: the mirror back is cast separately, usually in the form of a compact mass of squirming serpentine dragons in openwork (the piece in Pl. 88*b* may have been applied to a mirror), or a flat openwork pattern derived from the interlaced figures of the sixth century. A few of these mirrors are square, a shape which recurs in some rare fourth-century specimens and not thereafter among the ancient mirrors.

The development of the decoration at first followed the trend which was invading the bronze art as a whole. On the mirror excavated at Chung Chou Lu at Loyang, which preserves the archaic band of cowries at the rim, the dragon pattern is reduced in scale and already transmuted into a version of the continuous hook and volute motif which is the hallmark of the Huai style.[4] The weapons and other bronzes buried with this mirror indicate a date in the fifth century. A pattern composed of two extremely stylized *t'ao t'ieh* masks, each covering one half of the field and designed in hooked and spiral figures akin to the Huai convention, decorates mirrors of which specimens are recorded from Chin Ts'un at Loyang. The date of these can hardly fall later than the middle of the fifth century. Together with the other early types they belong to the metropolitan tradition which antedates the rise of the bronze industry of the Ch'u state in the Huai valley.

A much more numerous class is represented by mirrors on which the decoration is essentially a continuous close pattern of hooks and volutes (Fig. 2). Unlike the Shang Ts'un Ling mirror, on which the figures are arranged somewhat irregularly and in approximate circles corresponding to the round field, the hooks and volutes of these mirrors are laid in vertical and horizontal lines continuously to the rim, which cuts across the outer units (Pls. 90*b* and 91). Other motifs, when they are present, are placed over this continuous ground. Finds of these mirrors have been most frequent at Shou Hsien and other places in the Huai valley, and they are designated the Shou Hsien type. Like other bronzes of the Huai style they are not however confined to the central region of the Ch'u state. Many specimens have been excavated from tombs at Ch'ang Sha in Hunan and some are reported from sites in Honan. A stone mould for casting a mirror of the Shou Hsien type found at the capital of the Yen state, Hsia Tu in Hopei, shows that these mirrors might be cast outside the Ch'u sphere.[5] The Shou Hsien mirrors of this class continued to be made until about the

middle of the third century. Their beginnings must be looked for in the fifth century, but the lack of excavated specimens associated with other bronzes of better datable types makes it impossible to define this date more closely at present. The absence of mirrors from the early fifth-century tomb of the Marquis of Ts'ai has already been mentioned.

Within the Shou Hsien series the use of plain flat rims vouches for an early date. They are found on mirrors on which the spread of hook and volute pattern is the only decoration. Karlgren believes that mirrors of this type were made both in Honan and in the Shou Hsien region, and that only mirrors representing later developments of the ornament were exclusively manufactured in the south. These mirrors generally have a square or circular plain band around the loop. When the flat rim was replaced, as soon happened, by a concave rim rising to a more or less sharp edge at the periphery, the central band was given the same hollow profile (Pl. 91b). The flat rims are probably confined to the fifth century. Thereafter the dating of the mirrors can be surmised, as Karlgren has done in his analytical study, from the logical development of the decorative schemes.

An early elaboration of the ornament was the addition of four pointed petals springing from the square or circular band at the centre. From this moment the rims are always concave, with a few variants of the moulding (Pl. 91b). The quatrefoil figure may appear repeated four or more times around the central one (Pl. 91a). Single petals are placed on thin striated stalks extending from the centre or from the rim, or attached directly to the rim. A broad rectangular pattern formed of the striated stalks may spring from the tips of the inner petals, running to the edge or terminating in further petals.

The surface of the petals is generally concave, with a central ridge, variations of the petal design, of larger size and having some elaboration in line, being confined to mirrors which fall early in the series. The centre of the quatrefoils placed beyond the centre of the mirror is concave, circular and plain. The strangest variant of the petal motif is the inexplicable motif called a flail by Karlgren, a club-shaped figure springing from a stalk (which is generally a smooth groove) bent at right angles. The flails connect with leaves or quatrefoils and point in the same direction to give a whirligig effect to the design. On the distinguished mirror of Pl. 92a the flails spring from studs of turquoise. Such inlay is rarely met with.

Petals and quatrefoils are often combined with a T-shaped motif of broad concave bands, sometimes flanked with narrow grooves, as seen in Pl. 92a, which extend inwards from the rim. This motif, as Karlgren pointed out, appears to have been suggested by an element of the lozenge-shaped background pattern of the Loyang mirrors which will be described presently. It indicates that the early mirrors of the Shou Hsien and Loyang families were approximately contemporary. The lozenge patterns are borrowed from woven designs. The T-figure resembles the ideograph for 'mountain' and its popularity was perhaps owed to an auspicious association, for the definition of the word by the *Shuo Wen* dictionary reads: 'Mountain stands for good order; meaning that it suitably scatters the

humours and produces the myriad things of creation.' The T-figures vary from three to six in number, and appear combined with all the varieties of the petal figures. Their execution is identical with that of the zigzag patterns forming broad linked lozenges which replace them on other mirrors and make still clearer their origin in textile pattern.

The adoption of quatrefoils, lozenges and T-figures established the independence of the mirror decoration from the styles prevalent on vessels and other bronzes. None of the new motifs was however the invention of the mirror-maker. The quatrefoil appears on a few bronze objects of late Chou date and on roof tiles of the early Han period. It must correspond to what Han writers call the 'flower pattern', and Komai suggests that it was an open water-lily.[6] Its frequency on the Shou Hsien mirrors points to an origin in the south. Karlgren proposes to date the mirrors according to the increasing complexity of the decorative schemes: 'mirrors with slanting Ts only and those with small and modest quatrefoils are to be placed in the earlier part of the fourth century, those with "stalks" and outer petals in the latter part of the fourth century, and those with "flails", extra sets of petals in the interstices, and peripheral quatrefoils in the first half of the third century'.[7]

Animal figures also were superimposed on the hook and volute grounds of the Shou Hsien mirrors. These are sometimes birds (cf. Pl. 93a) combined with petal figures, but oftener they are dragons or bear-like or monkey-like quadrupeds of an unprecedented kind, drawn with the vigour of fresh invention. The animals are usually four in number, drawn in thin raised lines, the area of the bodies being left plain (Pl. 91c). Their long tails curve strongly behind them and often are clutched by the paw of the following animal. In some pieces their bodies are abstracted into an unrecognizable pattern of no less energetic movement. These mirrors answer to one of the Loyang types, although the execution is very different. Probably they fall near the end of the Shou Hsien series, at the end of the fourth century, and in the first half of the third century B.C.

The family of Shou Hsien mirrors stands in contrast to a contemporary group which represents the fashion of metropolitan China as opposed to that of the Ch'u state. The recorded finds of 'Loyang mirrors' are mainly in Honan province, particularly near Loyang itself, K'ai Feng and Cheng Chou. While a few examples of the Shou Hsien type have been found in the northern region, the Loyang mirrors appear not to have travelled beyond the limits of the Central Plain. The salient feature of the northern group is the lively invention of their dragon and dragon-derived figures (Fig. 10). They are clearly distinct in style from the animal designs which were adapted to the Ch'u mirrors, and cannot be closely paralleled among animal designs found on other classes of bronzes. The hook and volute ground of the Shou Hsien series is never found combined with figures characteristic of the Loyang group; and the latter offers no examples of the early flat rim, or the cowrie shells and t'ao t'ieh design of the archaic mirrors. For these reasons it appears that the mirrors of the distinctive Loyang series were not made before the end of the fifth century B.C., and

probably not before 400. Their manufacture ceased before the beginning of the Han period, a fact not disproved by the rare examples which have occurred in second-century graves.[8]

The rim of the Loyang mirrors is either concave like that of the standard Shou Hsien form, or presents a plain flat surface scalloped on the inner edge into inward-facing arcs, generally twelve to sixteen in number (Pl. 94a). The loop is small and usually ribbed, as on the southern mirrors, and is surrounded by a concave circular or square band, or by a flat star-shaped figure which is raised to the level of the relief of the principal motifs. This central feature receives greater elaboration than the corresponding part of the Shou Hsien designs, being enlarged by petals or lanceolate shapes sometimes clearly representing a lotus bud.

Fig. 10. Ink-impression of the design on a mirror of the Loyang type. 3rd century B.C. Diameter 5⅝ ins. British Museum.

The background to the principal motifs consists of lines and dots in low relief, forming continuous pattern of four main kinds:

(a) A rhombic fret of T-figures, the bands of the fret being filled with triangles or spirals and the rest with dots (Pl. 95).
(b) Zigzag bands defining lozenges, the bands filled by a line of dots and the rest with spirals and triangles.
(c) Spirals and granulation in triangular or lozenge-shaped units defined by thin lines (Pl. 94a).
(d) Continuous pattern formed of repeated units of spiral and triangle (Pl. 98a and b).

Karlgren divided the Loyang mirrors into four classes, one of which he attributes to the fourth and the rest to the third century B.C. He showed conclusively that none of them was in fashion after the beginning of the Han period. His earliest group has background pattern of the first two varieties. The animals on the field, three or four in number, are usually recognizable as leaping dragons. Their heads look back and their tails are often extended, with scrolled and fork-like additions, to give the whole figure a shape approximating to a letter S. The central knot of the body may be reduced to scrollery or to a rhomboid fret, but the whirligig of fly-ing limbs remains, and the head is that of a dragon with a long nose (Pl. 95). The arguments for dating this subdivision of the Loyang series

to the fourth century are slender. One is the coincidence of the T-figure fret with the recurrent T-motif of Shou Hsien, and another that some features are logical antecedents of forms which must belong to the third century. But the presumption is no doubt correct, if for no other reason, because it is improbable that no mirrors were made in Honan at a time when so many were being produced in the south.

The group of Loyang mirrors which must broadly span the third century show features which are enlargements or modifications of the initial motifs. In some the central quatrefoil increases in size to occupy the most prominent position in the field. In others the dragon head is replaced by the head of a bird of prey, and the dragon's body tends to incorporate a geometric figure — a lozenge with zigzag sides — which repeats an element of the original background pattern. The last only occurs with bird-headed dragons, or with creatures more explicitly bird-like, having long plumed tails. In some instances petals and quatrefoils adopted into the ornament hint at borrowings from the Shou Hsien schemes.

The variation of the design of centres and rims does not correspond significantly with the chronological succession suggested by the treatment of the main motifs. The interlocked Ts and lozenges of the background pattern continue through the fourth and third centuries; but the continuous ground of spirals and triangles (i.e. without lines of Ts or lozenges) appears only in the third century. It survives as the latest of these patterns into the second century B.C., when it is combined with new principal patterns.

The next development of the mirror decoration was the adoption of a continuous band of scrolled pattern formed of more or less abstract versions of the dragon motif. The lozenge figure and the Loyang mirrors which have come to be attached to a dragon or incorporated as part of its body is now often as important to the scheme as the animal form itself. These motifs and the animals fill the field of the ornament with their curves, which are now increasingly embellished at the ends and on the sides with spirals, spurs and petals (Pl. 96a). These details preserve the broken line and sharp changes of direction which gave the Loyang designs their energy but are now of less account in the main movement of the design. The latter has a more pedestrian regard for symmetry and equal spacing. The dragon foundation of the figures is barely apparent at first sight. When the creatures' heads are explicitly drawn, which is not always the case, they are feline rather than bird-like in the style of the later Loyang type.

The scrolled pattern, its execution in broad relief, and the lozenge-and-spiral or volute-and-triangle diaper of the background all appear to be borrowings from the mirrors of the Loyang group. Mirrors with scrolled dragon pattern have been found in Honan, but the greater number of recorded finds are in the Shou Hsien region and at Ch'ang Sha in Honan. The type may therefore be a southern invention, a style evolved in the Ch'u territory in succession to the mirrors with hook-and-volute grounds. The rims are concave, in the Shou Hsien tradition, and the central band (with

an exception noted below) round and concave. A feature found on many of the dragon-scroll mirrors, and very rarely present in earlier Shou Hsien specimens, is a zone filled with parallel striations encircling the central smooth band. More rarely a similar hachured band is placed next to the rim.

Fig. 11. Ink-impression of the design on a dragon-scroll mirror. 3rd century B.C. Diameter 5½ ins. British Museum.

Distinctions can be made in the dragon-scroll mirrors which appear to mark a difference of age. One group has the principal pattern raised in flat relief, which is variegated in its broader parts by small engraved curls and circles (Pls. 98a and b). In another group these main features are drawn in double or treble lines, with small dimples at the centre of scrolled

Fig. 12. Ink-impression of the design on the mirror of Pl. 96a.

appendages; or if the relief is flat it is divided by a concave line running along the centre (Pl. 96a, Figs. 11, 12). The mirrors with thread-like or grooved relief bands appear to be on the whole the later of the two groups. Their background pattern is regularly of volutes and triangles, while the mirrors with flat, unlined bands in the dragons make use also of the lozenges, spirals and granulation of the old Loyang tradition. The decora-

tion with thread-like relief is often overcrowded, as if it were a degeneration of the earlier design. Schemes of this kind are occasionally combined with motifs normally belonging to mirrors which as a whole date after the dragon-scroll mirrors, notably the TLV motif, which was introduced towards the middle of the second century B.C. Dragon scrolls in double line may even be found on inscribed mirrors, the presence of the inscription suggesting that they are not much earlier than about 100 B.C., when the practice of inscribing mirrors began. The inscriptions are placed in a central band, and the independent decoration which this band sometimes encloses, and occasionally an animal mask which replaces the three-grooved loop of long tradition, are other signs of late date, bringing the history of the dragon-scroll mirrors perhaps even into the beginning of the first century B.C. The overloading of the scroll seen in some examples of the mirrors with thread-like relief is partly the effect of multiplying the curled projections along the main lines of the motif. The resulting design recalls patterns used in textiles of the first century B.C. A motif resembling a stylized tree, projecting from the central band and dividing the main scrollery into four sections, is an elaborate version of the distinctive theme of the Ts'ao-yeh mirrors of the first century B.C., and further corroborates the dating of the dragon-scroll mirrors with thread-relief (Pl. 98b).

The comparison of the two types of dragon-scroll mirrors suggests that one, the mirrors with thread-relief, in the main succeeded the other and flourished in the second century B.C. The earlier type probably does not extend far into the third century. Karlgren places its inception at about 250 B.C., and suggests that it replaced mirrors of the old Shou Hsien tradition when this city became the capital of the Ch'u state in 241 B.C. Unfortunately the many third and second-century graves recently excavated have not contained mirrors in numbers sufficient to corroborate this attractive theory. Both types of dragon-scroll mirrors have been found in Han tombs of the second century B.C.[9]

A number of mirror types related to the dragon-scroll family and plainer or inferior in decoration are attributed to the second century B.C. Some of these are merely coarse versions of the dragon-scroll mirrors, with a simpler scroll, generally in a wider band, and lacking the balance and spiral finesses of the prototype. In these the background is filled with spirals, or with groups of parallel strokes made prominent by their large size and rough execution. The connexion of these degenerate mirrors with new mirror types of the first century B.C. is revealed by their borrowings from the latter of nipples, usually four, placed equidistant in the main field, square centre bands with inscription, the 'trees' of the *ts'ao yeh* type, the TLV pattern, etc. Gradually the remnants of the dragon scroll recede into the background among the strokes and spirals. One class of these mirrors displays a design which is peculiar to them: a plain concave circle running through the middle of the field, punctuated at four points by plain nipples or by nipples set at the centre of quatrefoils (Pl. 93c). Another variant has a large star with four to eight points formed of inward facing arcs of concave bands (Pl. 92b). The ground is either of plain spirals and triangles

(Pl. 99c) or of a combination of these with elements of dragon-derived scrollery which has undergone a fresh degree of spiralling and peaking at the curves (Pl. 92b). The star may also rest on a ground of the volute-and-triangle diaper alone. The rims, centre-bands and loops are of the traditional Shou Hsien kinds.

The division between the late Chou tradition of mirror making and the new Han tradition falls towards the end of the second century B.C. Although there are instances of mirrors of the old and new fashions found together in tombs, the overlap revealed in this way is less than might be expected.

In China as in other countries superstitious beliefs attached to mirrors from the earliest times. Figurative allusions to mirrors in the works of the philosophers imply the basic notion: that the mirror reflected true forms and could be used to detect illusions which might deceive the senses. A passage in the sayings of Pao P'u Tzŭ, a book compiled in the fourth century A.D., makes explicit an idea which Taoist adepts had held for centuries past:

'The essences of the ancient things of creation are all capable of assuming human shape and can deceive men's eyes by the illusion; and often they put mankind to the test. However, they are unable to change their true form in a mirror. Therefore when the Taoist masters of ancient times entered the mountains, they all hung at their backs a mirror measuring nine ts'un or more in diameter.'[10]

This superstition supplied a reason for placing mirrors in graves, for by discriminating spirits they could help the dead on their journey. Taoist lore did not however influence the choice of ornament for mirrors before the first century B.C., and when it appears it is allusions to cosmological and astronomical ideas and to the Taoist paradise and its gods which are chosen, and rarely portraits of the less seemly creatures known from some tomb finds. The inscriptions cast on the mirrors follow the new fashion. In the early first century B.C. they are merely short laudatory phrases or wishes for prosperity, or speak of the brilliance of the mirror's reflection. With the adoption of the cosmological conventions of ornament the inscriptions come to include references to the symbols of the heavens, to the Taoist high gods Hsi Wang Mu and Tung Wang Kung, and to processes of manufacture and other matters.

The earliest cosmological theme found on the mirrors is the strange device called the TLV pattern. This gets its convenient name from the shapes of marks set at fixed places in the field of the decoration, on the sides of the central square and on the inner edge of the rim flange. Its origin and exact intention have not been conclusively explained. Yetts argued that Ts, Ls and Vs were the marks of a sun dial. But he allowed objections to this theory; and the technical assumptions that must be made are not very plausible. Cammann interpreted the scheme as a cosmo-logical diagram in keeping with so much of other mirror decoration and with the symbolism of the remaining decoration of the TLV mirrors, and

drew a parallel between it and the Tibetan Buddhist Mandala. Komai and L. S. Yang find proof that the TLV scheme was close to if not identical with the board of a game called *liu po*. This interpretation need not conflict with the cosmological one, and on the mirrors the cosmological symbolism of the diagram is undeniable.[11]

The Ts of the TLV scheme stand at the middle of the four sides of the central square, which must symbolize the earth (Fig. 13). Each horizontal

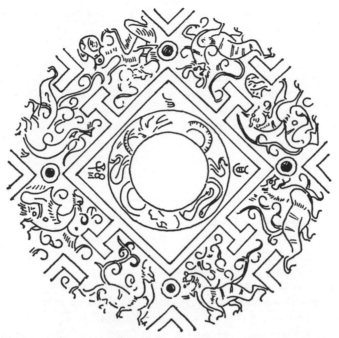

Fig. 13. The decoration of a TLV mirror. The animals in the frieze include the bird, tiger and dragon of the southern, western and eastern quarters, a three-legged toad and other quadrupeds, and a Feathered Man. The figures around the central boss and two characters of the inscription are obscured by corrosion. Late 1st century B.C. Diameter of the decorated field $4\frac{1}{4}$ ins. British Museum.

of a T lies parallel to the leg of an L protruding from the outer edge of the main field, the outer edge of the world. Vs placed on this perimeter are placed pointing to the corners of the square. The TLV symbols were not at first accompanied by the rows of nipples, animal and human figures which afterwards are almost invariably combined with it. They appear on one mirror type with dragon scrolls on a ground of volute-and-triangle diaper which derives from the second-century class of dragon-scroll mirrors (Pl. 96b). TLV mirrors of this class cannot be much later than the mirrors they copy in some respects, and must belong at the latest to the first decades of the first century B.C. In the course of the first half of this century (some

would say about 100 B.C.) the diaper grounds of the Shou Hsien tradition were finally abandoned, giving way to smooth grounds; or, in the case of mirrors with the TLV device, to an agglomeration of small figures executed in thin raised threads and in flowing lines which have no hint of the geometric precision of the earlier style. The winged animals and monsters and feathered immortals are depicted in movement, often amid clouds represented by scrolled lines surrounding them.

The most elaborate mirrors with TLV pattern belong to the reign of Wang Mang, who usurped power in 9 B.C. and was displaced by the founder of the later house of Han in A.D. 23. Like the Han emperor Wu Ti before him, Wang Mang is credited with a lively interest in astronomy and in the Taoist lore, magic and alchemy then inseparable in the study of the heavens. The inscriptions of a number of TLV mirrors open with Hsin, the dynastic name assumed by Wang Mang, and praise the metal: 'Hsin has good copper'. They sometimes specify that it came from Tan Yang or Hsü Chou. The former is equivalent to the modern Yi Ch'eng in Anhui, and the latter is located in Kiangsu, still under the same name. The inscriptions often refer to the submission of the 'barbarians of the four directions', state that 'the people are given rest' and 'the empire' restored.

Taking these set phrases in their literal sense Karlgren has argued that they cannot have been adopted during the reign of Wang Mang, whose government was proving ineffectual against the barbarians of the northern frontier. He thinks these parts of the inscription had by Wang Mang's time become a mere convention, and that they were probably composed near the beginning of the first century B.C., when Chinese arms under Wu Ti were notably successful. The TLV mirrors of this class would then extend over the whole of the first century B.C. More recently Dr Bulling on the other hand proposes to connect these ostensibly political remarks rather with allegorical plays, citing a late Chou and Han rite entitled 'The Pacification of the Four Barbarians'. The 'Barbarians have submitted' of the mirror inscriptions would thus mean merely that this rite has been performed, and that Wang Mang need not have felt affronted by praise only ritually bestowed on victories he never secured.[12] The rhymed inscription on the mirror of Pl. 94b is typical of many. It is translated by Professor Hansford as follows:

'This fine Shang Fang mirror is truly excellent. Upon it are immortals who know not old age; when thirsty they drink from the jade springs, when hungry they feed on gem-like fruits. They float above the world, and roam the Four Seas. They rove among the famous peaks gathering magic herbs. May your longevity be like that of metal and stone under Heaven's protection.'[13]

The Shang Fang was a factory established by the government in the Kuang Han Chün (prefecture) in Szechwan province, located a short distance to the north-east of the modern Sui Ning Hsien. It produced mirrors possibly as early as the end of the first century B.C., and is named in mirror inscriptions through the following two centuries and later. Until the last years of Han rule a single factory seems to be designated by the

name, and it may have specialized in the production of mirrors. Towards the end of the second century A.D. it was divided into three ('right', 'central' and 'left').[14] A little later other places of manufacture are occasionally named, as on a mirror dated to A.D. 224 which was made at Hui Chi Shan near Shao Ching Hsien in Kiangsu. A mirror of about the same age, excavated in Japan, bears the legend 'the metal came from Hsü Chou, the master from Loyang', a rare instance of the mention of a bronze-founder by name.[15] The production of fine mirrors in the Shao Hsing district of Chekiang, which will be mentioned below, dates from the end of the second century.

An example of a TLV mirror decorated in the manner typical of the class though differing from the fully developed Wang Mang type, was recently excavated from a first century B.C. tomb at Ch'ang Sha. An inscription in the 'small seal' character fills a raised zone immediately within the rim:

'When the sages make a mirror they draw essences from the Five Elements, it is born in the serenity of the Tao. It is adorned with designs and its brilliance is like that of the sun and moon. Its substance is pure and hard, so that it resembles jade. It removes baleful influences. May the Central Kingdom be at peace. May our descendants multiply and prosper. The Yellow Skirt and the Primordial Blessing are fast established.'[16]

A circle of close-set, thread-like lines dividing the main field of this mirror into equal parts, is punctuated by four small concave discs which lie between the angles of the central square and the peripheral Vs. The outer zone of the main field is filled with running and leaping monsters approximating to tigers and dragons, all surrounded by irregular cloud-scrolls. The inner zone is occupied by a similar medley of creatures, some only heads, among which the Dark Warrior of the North (i.e. the tortoise entwined with a snake), the White Tiger of the West, the Red Bird of the South and at least the head of the Green Dragon of the East are discernible. The central square is filled with a large quatrefoil set about the large domed knob which this mirror type regularly carries, in common with the rest of the Han mirrors after 100 B.C. The interstices of the leaves are filled with a strange mask, not unlike some portraits of the bellicose genius Ch'ih Yu.

The date of the TLV mirror from the Ch'ang Sha tomb cannot be closely estimated and the excavators place the grave merely in their category of 'Later Western Han tombs'. It was accompanied by another mirror, decorated with star-design at the centre which is thought to date from about the middle of the first century B.C. It is clear however that the essentials of the TLV mirror design which are assignable by their inscriptions to the Wang Mang period were already evolved some time previously, probably as early as the third quarter of the first century B.C. Judged by the standard of the Wang Mang type, the older features of the mirrors with pattern of TLV and heavenly monsters are (1) a circular band in the middle of the field which may be plain or carry the inscription, (2) a circular central band carrying the Ts instead of the regular square band and (3) a plain wide

rim, or a rim occupied by the inscription. All these are likely to belong to the second half of the first century B.C., before the last decade, when the Wang Mang style was adopted.

Characteristic TLV mirrors of the Wang Mang type have eight bosses in the main field, set in pairs either side of the top arm of the T, and often rising from star-shaped bases. The inscription surrounds the field and is bounded by a band filled with narrow radial strokes. Then follows the steeply sloping rise to the thick rim. This continues flat to the edge, and is decorated either with bands of dog-tooth ornament separated by a zigzag line, or by a single line of dog-tooth surrounded by a broader zone of continuous pattern said to represent clouds. Figures of creeping and cavorting animals and human figures may replace or mingle with the clouds, but the dog-tooth band is seldom absent.

Some borders are filled with a pattern of scrolled stems with leaves of palmette or irregular form and curling tendrils. The central knob with or without the quatrefoil at its base is surrounded by twelve bosses, following the lines of the central square, which represent the mansions of the zodiac, and are interspersed with the twelve cyclical characters naming them. The animals of the four quarters of heaven are usually identifiable, though the bird may be no more than a quail-like creature, and the tiger and dragon barely distinguishable from one another. The tiger may be shown in the noble stance of the stone lions of a later period, the dragon may leap and twist. Occasionally a tiger or dragon body terminates in a head, monstrous or approximately human, drawn full face, like some of the demiurges portrayed on the silk document from Ch'ang Sha.[17] Deer, birds, monkeys, goats, three-legged toads and the moon hare at his pounding of the herbs of immortality may be drawn with unmistakable humour. The human figures, generally the Feathered Men (*yü jen*) carrying feathers on their backs and below the arms, represent the immortals, *hsien*. They appear flying, seated and kneeling, riding on deer and tigers, and juggling with egg-shaped jewels.

The mythology of Taoism, as reflected in the mirror decoration and inscriptions in more or less fragmentary form, combines primitive beliefs with references to the sophisticated quest for life-prolonging techniques and substances, and to the cult of famous adepts who were already deemed immortal. Explicit allusions in inscriptions are frequent from the beginning of the second century A.D. The phrase may be merely 'above are spirit-men who know not old age' or 'in the great mountains immortals may be seen', or it may allude by name to such adepts as Wang Tzǔ-ch'iao and Ch'ih Sung-tzǔ who had solved the trick of immortality and were liable to manifest themselves to travellers in lonely mountains. These personages and the greater ones Hsi Wang Mu ('Queen Mother of the West') and Tung Wang Kung ('Eastern Royal Duke') appear in literature at the end of the Chou period.

In the TLV mirrors, the earliest which draw on the mythology for their decoration, only the symbolic animals and unnamed Feathered Men appear, their position subordinated to the astronomical symbols of the

main pattern. Early in the first century A.D. however Hsi Wang Mu and Tung Wang Kung begin to receive prominent treatment. The earliest mention of the goddess is in the *Shan Hai Ching* (Classic of the Mountains and Rivers), where she is described as 'in form like a human being, with the tail of a leopard, the teeth of a tiger, good at roaring, with hair dishevelled and crowned with a *shêng*'.[18] It is related that the Chou King Wu visited her in the course of his much mythologized journey, and already in the writings of Chuang Tzŭ she is credited with the *summum bonum* of the philosophers, the achievement of the Tao. Dubs has collected evidence to show that the goddess was the object of a popular cult combining sacrifice with riding in carriages and on horseback, and the passing from hand to hand of a wand, with the words 'I am transporting the wand of the goddess's edict'. A ceremonial staff indeed stands near to her on some mirror representations. One text refers to her 'couch, *shêng* and staff', the first and last being the traditional appurtenances of the aged.[19]

Of Tung Wang Kung, who in later Han times was regarded as Hsi Wang Mu's consort, much less is said in the ancient literature, and on the mirrors he never figures alone. Tung Wang Fu, Eastern Royal Father, was his earlier name, and it is not clear whether he was a mere pendant to the Queen at the start. He was perhaps related in origin to the cosmic heroes Fu Sang and Han I, and according to one text his name might be given to one of the heavenly emperors who were posted in the four cardinal regions and over the centre of the world.

Before describing the elaborate mirror schemes of the second and third centuries A.D. in which the Taoist gods and cosmic animals figure so prominently, something must be said of a numerous family of mirrors in which astronomical notions furnish the basis of the decoration without the assistance of the artistically more rewarding symbolic animals.

Hints of astronomical symbolism are found even before the Han period. The T-shaped figures of the Shou Hsien mirrors may stand for the heaven-bearing mountains of the popular cosmology, and the scalloped inner edge of the rims and related figures in the Loyang family may (as Harada suggested) allude, through a form of the written character, to fire and light. The star-shaped figure formed of arcs of circles is preserved on Han mirrors of a variety of designs. The star is nearly always eight-pointed (as it appears on some late Shou Hsien mirrors), and rendered as a depression enclosed in a circle of plain metal.

In a type of mirror with geometric ornament, made from early in the first century B.C. to about the middle of the first century A.D., the star is the dominant part of the design, occupying about half of the diameter of the field (Pl. 99*a*). A large pierced dome stands at the centre, with a quatrefoil at its base or ringed by flat bosses generally to the number of twelve, evidently representing the divisions of the ecliptic. Plain or decorated rings intervene between this centre and the eight-pointed star, and the outer field is given over to concentric bands of various design: hachured and smooth rings, and generally one or more bands filled with inscriptions (Pl. 101*b*). The heavy raised rim is either smooth or decorated

with lines of dog-tooth, in the manner of the TLV mirrors of the Wang Mang period. The inscriptions are often cast in a peculiarly mannered form of the small seal character. They usually refer to the brightness of the mirror's reflexion (hence a Chinese name *ming kuang ching*, or brilliance mirrors) and often to the purity of the materials used in its manufacture. They include the usual stereotyped good wishes and even such an uncommonly affecting phrase as 'seeing the light of the sun let us long not forget each other'. No allusions to Taoist mythology seem to be found in inscriptions cast on mirrors of this austere kind.

The symbolism of these concentric designs, as far as explicit meaning is to be attached to them, is quite banal: the heavens rotating and the centre at rest. In the words of S. Cammann: 'This conforms precisely with the contemporary philosophies which were greatly preoccupied with the concept of the centre of the world, the universal axis, the motionless turning point around which the universe revolved, the point of origin.'[20] The last words are near to some definitions of the Tao. Wang Mang, finding himself faced with defeat, tried to 'occupy the Centre' in order to save himself. The phrase 'ruling centre' or 'let the centre be ruled' (*chih chung yang*) occurs as a pious wish at the end of some inscriptions on TLV mirrors of Wang Mang date.

In the interstices of the main pieces of ornament on these 'astronomical' mirrors are often placed small groups of lines, lying more or less radially (Pl. 101*b*). Their strange shapes suggest that their purpose is other than mere embellishment, but their meaning is unknown. Sometimes groups of triple lines join the points of the star to the circle of the enclosure; similar triple lines may spring from the ring and end at the points of the star in small circles or hooks; triple, slightly curving lines join the inner ring to the re-entrant parts of the star-figure between the points; and more elaborate figures, formed generally of triple lines attached to short spirals, spring from semicircles. The curving lines possibly indicate the movements of planets, an idea more strongly suggested by the design of a related mirror scheme in which eccentrically curving lines link eight spirals or circles set in a band in the main field (Pl. 99*a*). The eight nodal points in this net of lines probably stand for the eight periods of the solar year, from the beginning of spring with the sun in Aquarius (*hsü*, the eleventh of the twelve stems) to the winter solstice with the sun in Capricorn (*yu*, the tenth stem); or they may mark the position of heaven-bearing pillars. A mirror of this type in the Fogg Art Museum bears a date corresponding to A.D. 64.

Star-cluster mirrors (called by the Chinese mirrors with a hundred nipples, or stars and clouds, or linked jewels) generally duplicate a sixteen-pointed star of arcs, at the edge and at the centre (Pl. 99*b*). The central point is a larger boss surrounded by eight small ones; around this and within the inner star are generally four bosses, separated by curving linear figures. In the main field are four equidistant clusters which separate eight groups of bosses set in threes and fours in asymmetric arrangements. The latter throw off lines tangentially and are joined by curving lines. The whole forms an attractive rhythmical pattern. In some rare and beautiful

mirrors a similar idea is interpreted by a combination of bosses with serpentine, barely recognizable, dragons, a scheme on which occasionally the TLV symbols are superimposed. The star-cluster mirrors seem never to be inscribed, and belong in the main to the first century B.C., though their manufacture probably continued into the following century.

In the *ts'ao-yeh* (grass and leaves) mirrors of the first century B.C. a square occupies the greater part of the field of decoration (Pl. 100*b*). Beyond it, opposite the middle of each side are four bosses; and the space between these, limited outwards by the arc star of the rim, is filled with stiff and symmetrical trefoils and a figure resembling an ear of corn or a conventionalized tree, four of the first and eight of the second. Sometimes the tree approximates to the motif which distinguishes one of the groups of dragon-scroll mirrors. Apart from their number, no astronomical allusion can be read into them. Central bosses of several shapes are found on mirrors of this class, including the small triple-band loop and zoomorphic loop which vouch for the initial date of the type about 100 B.C. The large, smooth central bosses of the first century B.C. are set on quatrefoils, from the middle of each leaf of which a long spike — an early feature in this motif — extends to the corners of the square.[21] The square carries the legend of good wishes or an allusion to brightness. The *ts'ao yeh* scheme also appears combined with the TLV symbols on mirrors which probably fall about the middle of the first century B.C. The inscription on the illustrated example of this type of mirror reads:

'Daily joy and wine and food enough; long honours and riches, pleasure free of trouble.'

When the ornament of the astronomical mirrors is reduced to its essentials it consists of a circular band and the characters of an inscription, interspersed with small spirals, circles or squares, four or eight in number. An equally simple scheme is found on uninscribed mirrors on which four bosses are separated by serpentine dragons reduced to plain S-figures backed by a few cloud scrolls (Pl. 93*b*). Mirrors of which the principal decoration consists of a band of dragons and other celestial animals portrayed more or less realistically — the *shou tai* or animal-zone mirrors of the Chinese writers — were made from the first century B.C. They continued through the remainder of the Han period and later, and ceased only when entirely new motifs of mirror decoration were introduced at the beginning of the T'ang period. Often all four heaven symbols, dragon, bird, tiger and tortoise-cum-serpent, are shown, though oftener only a selection of these is used, especially dragon with tiger. A pair of them may be duplicated, and hare, toad and Feather-Men occasionally figure in the procession. Fish, as an ancient token of fertility, and *wu chu* coins (punning for *chu niao*, the red bird of the south) may be interspersed.

Many of the animal-procession mirrors share with the TLV type their heavy rims and central quatrefoil. In such cases the mirrors can hardly antedate the last quarter of the first century B.C. The bosses in the field number four, eight or seven. In the last instance they represent the seven constellations of the southern quarter, an allusion given on one

mirror by a procession of seven birds. Typical sequences read anti-clockwise are (i) separated by four bosses: a pair of tigers, one apparently in pursuit of the other; a pair of dragons confronting each other angrily; tigers confronted, one in retreat; a dragon defied by a Feathered Man, (ii) separated by seven bosses: bird; bird; tiger; deer; tortoise and snake; dragon; Feathered Man; and (iii) separated by eight bosses: bird; bird; dragon; dragon; Feathered Man; stag; tiger; Feathered Man riding on a deer. Even on seven-boss mirrors all the animal symbols of the four quarters of heaven may be portrayed, approximately in their correct relative positions.

In the mirror of Pl. 100a the animal pattern is reduced to four masks, though the inscription alludes to tiger and dragon:

'The Shang Fang made this mirror. The foundations of the State are secure. On the left is the dragon, on the right the tiger. Evil influences are removed. The Chün Tzŭ (Confucius's superior man) and the nobleman are at one with marquis and prince. Husband and wife agree and progeny is ample. May your life endure like metal or stone. May endless felicitations be yours. The state and people be at rest and the Chiang and Hu barbarians subdued. May the Four Barbarians submit and the whole empire be at peace.'

A mixture of celestial animals with the deer and genii of Taoist lore furnishes ornament for mirrors until the opening decades of the second century A.D., thereafter the procession is typically confined to the bird, dragon, tiger and tortoise, with perhaps a Feathered Man or a horse substituted for one of them. About the beginning of the second century too a scheme was introduced in which the petals and other motifs filling the central frame give way to a dragon and tiger, or a pair or more of dragon-tigers writhing around and beneath the central knob. The mirror in the British Museum dated by its inscription to A.D. 121 is an unusual variant of this scheme (Pl. 97b). Here the inner circle of characters consists of an alternation of the eight divinatory symbols with the words of the sentence 'May your family be fortunate through the blessing of heaven'. The outer inscription reads:

'Fourth year of Yüan Ch'u, fifth month, day ping. The fire of sun and heaven helped the Shang Fang to refine the auspicious metal. Evil influences are removed. The Eight symbols are set out in order. Yin and Yang are harmonized. Read the omens yourself, see your own reflexion: your good fortune be assured. May riches, honours, long happiness attend you, and may descendants be granted you.'

The inscription on the mirror of Pl. 101b also alludes to the manufacture of the mirror:

'I refine and smelt and the metal flowers; I purify it and it gleams. With it I make a mirror, a worthy ornament. May your years be extended. May evil influences be removed. May (the mirror) be as bright as the sun, with light as infinite as heaven. (May you enjoy) a thousand myriad days.'

An attractive feature of the best mirrors of the second century is the

deeper modelling of their relief figures. Some inscriptions show that this new style was practised in the Shang Fang, but we cannot be certain that it developed there. The chief motifs of the Shang Fang designs, in one way or another, are based on astronomical notions. The new mirrors increasingly depict Taoist gods as principal figures. The change took place in the first half of the third century.

The mirror of Pl. 102 is one of many recovered from brick-built tombs, scattered widely in the vicinity of Shao Hsing, in Chekiang province. This was ancient territory of the kingdom of Wu, one of the states established in the fragmentation of the Han empire.[22] The Wu kings ruled from A.D. 221 to 280, and the life of the mirrors of the class to which this one belongs is measured approximately by these dates. Some of the mirrors have inscriptions, with dates ranging from A.D. 217 to 277. On them the Queen Mother of the West and the Lord King of the East most often share the honours of the decoration, enthroned at opposite sides of the circle with their attendants. On the mirror of Pl. 102 the guards flanking the Lord-King are denoted *tai lang*, servitors, by characters placed alongside. They hold *ko* halberds and have antlers over their headdresses, a trait linking them with a horned wooden head from a Ch'ang Sha tomb. The Queen, winged, is covered by a royal canopy. Feathered genii stand and kneel by the large figures and cloud-scrollery fills the interstices. Between these main groups are lively representations of a three-horse carriage and a cavalry skirmish.

Other third-century mirrors are filled with horizontal rows of seated figures, the scheme called *ch'ung lieh hua hsien*, immortals in rows (Pl. 103a). On these no inscriptions appear to identify the personages represented, but they must belong to the Taoist pantheon. Still another third-century scheme is characterized by a band of squares each containing a four-character inscription or a band with alternating inscribed squares and semicircles. Plate 104 illustrates an outstanding example of this type. Of the human figures the two seated alone at opposite sides represent the Lord King of the East and the Queen Mother of the West. The winged pair and the group of three set at the other quarters are other unidentifiable deities. All wear courtiers' caps, one of them with the three vertical spikes which surmount the king's headdress on the mirror of Pl. 102. The trio is engaged in some joint activity, and recalls another such group depicted in a Shao Hsing mirror, on which Feathered Men appear to be divining or playing a game around a square board marked with the L-figure of the TLV scheme. But here no board is visible.

The rest of the main field of the mirror is filled with four horned and winged dragons holding in their jaws the bars of a network which joins together a symmetrical arrangement of small concave discs. In a number of inscriptions the animals are called 'dragon-tigers' and are said to be holding *chü* in their mouths. The character of *chü*, in the simple form in which it appears, gives no acceptable meaning. Taken as an abbreviation of the kind common in the Han bronze inscriptions, and completed with a radical element, it can be made into 'set square' or 'torch'. Both of these

interpretations have been championed,[23] and another version is *kou*, a kind of hooked halberd. But the bars and circles of the design do not remotely resemble these objects. An astronomical metaphor seems to be intended. The tiger of the west and the dragon of the east are blended into a single animal. The constellations are conventionalized into a simple symmetrical pattern, and perhaps the bars connecting the stars denote their fixity. Similar astronomical abstractions of lines and circles have been mentioned above. The idea of giving the design greater coherence by making the animals hold the net of heaven in their jaws is a happy invention, and no doubt a purely artistic one.

The other two bands of animals enclose one of the most varied menageries to be found on the mirrors. The middle zone has tortoises entwined by snakes, birds with rich plumage, winged elephants and horses, other winged quadrupeds, marching or contorted, and two crayfish-like animals. One panel represents a Feathered Man with knee bent and arms extended as if in rapid motion. In the outer band a chariot drawn by a train of dragons carries two Feathered Men, several other genii astride winged animals, and a fierce contorted anthropomorphic figure with animal head who recalls the Ch'ih Yu seen in Han tomb reliefs. He grasps one of the double scrolled lines which are interwoven among the figures, coiling in spirals and mingling with cloud scrollery in the spaces between the figures. The mythology of Taoism had never supplied a richer imagery to the mirror maker, or been interpreted with greater verve.

The squares set in the band which surrounds the main field of ornament are each inscribed with a four-character phrase. Together they compose a text typical of the inscriptions cast on mirrors of the later second and third centuries:

'I have made a bright mirror, subtly refining the metal. The traditional rites are figured here and joined with images of the myriad spirits. The hundred creatures are vigorous and joyful, the host of spirits reveal their forms. May your years be increased, your life prolonged. Your riches and honours be multiplied.'

A Note on Bronze Technique

In his catalogue of the Eumorfopoulos collection W. P. Yetts expressed a prevailing opinion on the technique used in the manufacture of the ancient bronzes of high quality: that they were cast by the cire-perdue method. More recently evidence has been produced for direct casting, as described below, but the hypothesis of wax casting has not been wholly disproved. It cannot be assumed that one or the other method was used exclusively. In some respects cire-perdue technique is easier than that of permanent piece-moulds, and ensures the perfection of detail. In the West it was discovered early in the history of the bronze age, and it would be strange if no knowledge of it penetrated to China together with the knowledge of metallurgy itself. For this method a finished model of the intended casting is prepared in wax. The model is encased in clay, beginning with a wash or slip fine enough to espouse the surface detail without damaging it or leaving air pockets. Afterwards the clay is heated, the wax runs out through prepared vents, and molten bronze is poured into the space which it leaves. Since the clay has to be broken and picked from the surface of the finished casting, it is not likely that the cire-perdue method would leave recognizable traces of its use. But the excavations at Anyang produced numerous fragments of clay moulds, parts of sections with fitting and dowelled edges intended to build into composite moulds for casting. There are clear signs that these moulds had been in contact with molten bronze, having been used for direct casting and not merely (as might be supposed) for impressing wax models for use in the cire-perdue process.

One means adopted in making the moulds is perhaps shown by two objects which were recovered in excavations at Anyang (1936, Sector B). These were solid burnt-clay models of parts of bronze vessels. One is described by the excavators as the 'lower half of a *hu*'. On it were marked only lines, apparently to mark the places were the clay was to be cut when the model was used to impress parts of a piece-mould. The other piece, which was badly damaged, was a solid model of the 'middle section of a *fang yi*'. The flat top surface was marked with a cross, and a depression at either end. Evidently the model of the high lid was made separately and these devices served to centre it on the lower part. On the sides of the latter were remains of two zones of ornament: an upper band of small birds facing each other, and below these (distinguishable only on the less damaged longer sides) could be seen the 'horns and eyebrows' of *t'ao t'ieh*. The birds had been modelled or moulded separately and applied to the block constituting the body of the model. Whether or not the mask had

been formed in the same way we are not told. On the bodies of the birds was pattern painted in red, and on the flat surface around them *lei wen* similarly painted, and 'some of these had already been carved'.

The preparation of a mould thus seems to have been as follows:

1. A solid model of clay representing the body of the vessel without its ornament is made, in one or more parts as convenient.
2. Elements of the ornament which appear in relief are impressed in clay from carved moulds, probably of wood, and attached singly in position on the model block.
3. The whole is baked to pottery hardness.
4. Details of ornament, i.e. of *lei wen* and other minor motifs, both on the applied ornament and on the background are painted in red and engraved.
5. The negative mould is now made by pressing clay on to the model. It is removed in sections corresponding to the necessary subdivisions of the piece-mould. After the joints have been trued, and dowels added if necessary, the mould sections are baked to pottery hardness.

Both the containing space of the vessel and the hollow of the ring foot would require its separate core in the mould. Probably, since the foot-core was the lighter of the two and thus easier to suspend, the vessel was cast upside down. Plugs of bronze, or easily combustible matter — possibly wax — could be used for centring the cores. There are traces of other centring devices. Often the underside of the bottom of a vessel is covered with a net of straight lines (crossing to make lozenge-shaped divisions) which appear to be the cast of scorings made on the core with a sharp point. The scorings may have served some purpose in assembling the mould, but they have not been convincingly explained. On Shang vessels the scorings are as we have described them, but when they appear later they are thicker and decoratively arranged, as if a technical device, no longer essential, were now retained as mere ornament. The joints of the mould sections followed the vertical and horizontal divisions of the ornament, running down the flanges, the centre-line of handles, around the foot and neck. Traces of the joints were skilfully removed after casting.

Although there is thus a strong argument for direct casting as the method used by bronze founders in the Shang period, it does not follow that wax casting was unknown. It is arguable that the mould prepared in the manner described above was intended for, or could on occasion be used for producing, the positive wax model which represents the first stage of the cire-perdue procedure. For the complex surfaces of bronzes such as those of Pls. 30*a*, 36*a* and 79*a*, wax casting would be by far the simpler technique, and perhaps the only possible one. The same is suggested by the openwork foot of a *ku* (Pl. 22*b*). In later times openwork ornament cast in bronze, such as the 4th-century piece shown in Pl. 88*b*, leaves no doubt at all that the cire-perdue method was practised. On the other hand the pottery models found at Hou Ma in Shansi show that bronzes of the Li Yü style were manufactured in the manner inferred above for those of the Shang period.

A NOTE ON BRONZE TECHNIQUE

The composition of early Chinese bronze is remarkably at variance with the formula of $\frac{1}{10}$ tin $\frac{9}{10}$ copper which was adopted so early and maintained so constantly in the bronze age of the West. In China the proportion of tin in the whole alloy is far from constant from Shang to Han times, and often it is combined with a considerable ingredient of lead. Since tin is more effective than lead both in increasing the hardness and lowering the melting point of the alloy, it does not seem that lead was added for these reasons. There was possibly an economic motive, for lead was likely to be cheaper than tin. It could, in particular, be substituted for tin in bronzes destined, whether weapons or vessels, merely to be buried. Many of the surviving bronzes belong to this class. The greater part of the analyses so far published are of Shang and early Chou bronze. When lead is absent the proportion of tin varies between 14 and 20 per cent. When tin is present the proportion of lead varies from 1 to 18 per cent. In a few cases where only copper and lead are used the latter may rise to over 30 per cent of the whole. No correlation is apparent between the composition of the alloy and the nature of the object made from it. Weapons often contain a large ingredient of lead.

Lead, unlike tin, does not dissolve in alloy with copper and crystallize with it, but remains in suspension in the copper in minute globules. It thus helps the flow of the molten metal and reduces the likelihood of bubbles forming on the surface of the casting — a kind of flaw never seen in ancient Chinese bronze. The Greeks added lead to the bronze of their statuary to make it easier to work cold with the chisel. The Chinese also may have found the lead alloy advantageous in rendering and finishing the minute ornament of their ritual vessels. Throughout the period reviewed in this book examples of lead-rich bronze can be found, the proportion of lead being notably high in some mirrors of Han date.

Select Bibliography

The older Chinese and western literature on ancient Chinese bronzes is admirably listed in W. Perceval Yetts, *The George Eumorfopoulos Collection: Catalogue of the Chinese and Corean Bronzes,* etc. Vol. I (London 1929) and in the same author's *The Cull Bronzes* (London 1939). A general bibliography on the art and archaeology of ancient China will be found in William Watson, *China Before the Han Dynasty* (Ancient Peoples and Places) (London 1961); and sources of information on important recent finds are noted in William Watson, *Archaeology in China* (London 1961), and in the catalogue of the Chinese government's exhibition held at Burlington House in 1973. A bibliography of publications on the analysis of bronze is appended to the paper by Ch'en Meng-chia on the Hsi Pei Kang excavations which is listed below. The following select bibliography includes only the most important recent books and articles.

BMFEAS: Bulletin of the Museum of Far Eastern Antiquities, Stockholm.
KKHP: K'ao ku hsüeh pao.

Bachhofer, L., 'The Evolution of Shang and Early Chou Bronzes', *The Art Bulletin,* June 1944, 107–16.
Bunker, E., *The Art of Eastern Chou,* China House, New York 1962.
Bunker, E., Chatwin, C. B. and Farkas, A. R., *Animal Style Art from West to East,* Asia House, New York 1970.
Ch'en Meng-chia, 'Bronzes of the Yin Dynasty', *KKHP,* 1954 (7). (Chinese.) (The first part of this paper collects together all available information on the excavations at Hsi Pei Kang, and the second part is devoted to technology: the alloy, and the method of casting.)
Ch'en Meng-chia, *A Study of the Chronology of the Western Chou Period,* Shanghai 1945, 2nd edition, 1955. (Chinese: *Hsi Chou Nien Tai K'ao.*)
Ch'en Meng-chia, 'Chronology of the Bronze Vessels of Western Chou', *KKHP,* 9 (1955–6 (4)). (Chinese.)
Chou Heng, 'A Preliminary Study of the Material Remains from the Ancient Site of the Yin Period at Cheng Chou', *KKHP,* 1956 (3). (Chinese.)
Dubs, H., 'A Canon of Lunar Eclipses for Anyang and China, 1400 to 1000; *Harvard Journal of Asian Studies,* X (1974).
Hansford, H. S., *The Seligman Collection,* Vol. I, London 1957.
Honan Province Bureau of Culture, 'Excavation of Shang Dynasty Sites at Cheng Chou', *KKHP,* 1957 (1). (Chinese.)

SELECT BIBLIOGRAPHY

Higuchi Takayasu, 'A New Study of Western Chou Bronzes' (Japanese: *Seishū Dōkī no Kenkyū*), *Kyōto Daigaku Bungaku-bu kenkyū kiyō*, VII (1963).

Institute of Archaeology of the Academy of Sciences, Peking, *The Erh Li Kang Site at Cheng Chou*, Special Archaeological Series D, No. 7 (1959). (Chinese: *Cheng Chou Erh Li Kang*.)

Institute of Archaeology of the Academy of Sciences, Peking, *A Cemetery of the State of Kuo at Shang Ts'un Ling, Honan Province*, Special Archaeological Series 4, No. 10 (1959), Peking 1959. (Chinese: *Shang Ts'un Ling Kuo Kuo Mu Ti*.)

Institute of Archaeology of the Academy of Sciences, Peking, *Material from the Tomb of the Marquis of Ts'ai at Shou Hsien*, Special Archaeological Series B, No. 5 (1956). (Chinese: *Shou Hsien Ts'ai Hou Ch'u T'u Yi Wu*.)

Institute of Archaeology of the Academy of Sciences, Peking, *Report on Excavations at Hui Hsien*, Peking 1956. (Chinese: *Hui Hsien Fa Chüeh Pao Kao*.)

Institute of Archaeology of the Academy of Sciences, Peking, *Report on Excavations at Ch'ang Sha*, Special Archaeological Series D, No. 2 (1957). (Chinese: *Ch'ang Sha Fa Chüeh Pao Kao*.)

Institute of Archaeology of the Academy of Sciences, Peking, *Report on Excavations at Shan-piao-chen and Liu-li-ko*, Peking 1959. (Chinese: *Shan-piao-chen yü Liu-li-ko*.)

Institute of Archaeology of the Academy of Sciences, Peking, *Report on Excavations of Han Dynasty Tombs at Shao Kou, Loyang*, Peking 1959. (Chinese: *Lo Yang Shao Kou Han Mu*.)

Institute of Archaeology of the Academy of Sciences, Peking, *Report on Excavations at Chung Chou Lu, Loyang*, Peking 1959. (Chinese: *Loyang Chung Chou Lu*.)

Institute of Archaeology of the Academy of Sciences, Peking, *Report on Excavations at Fêng-hsi*, Peking 1962. (Chinese: *Fêng Hsi Fa Chueh Pao Kao*.)

Institute of Archaeology of the Academy of Sciences, Peking, *A Group of Bronze Vessels from Ch'i-chia-ts'un in Fu-fêng-hsien*, Peking 1963. (Chinese: *Fu-feng Ch'i-chia-ts'un ch'ing-t'ung ch'i-ch'eng*.)

Institute of Archaeology of the Academy of Sciences, Peking, *Report on Excavations at Hsin Ts'un in Hsün Hsien*, Peking 1964. (Chinese: *Hsun Hsien Hsin Ts'un*.)

Institute of History and Philology, Academia Sinica, *Reports of Excavations at Anyang*, Peking 1929–33. (Chinese: *An Yang Fa Chüeh Pao Kao*.) Institute of Archaeology of the Academy of Sciences, Peking, *Shan Piao Chen and Liu Li Ko*, Special Archaeological Series D, No. 11 (1959). (Chinese: *Shan Piao Chen Yü Liu Li Ko*.)

Jenyns, R. S. and Watson, W., *Chinese Art: The Minor Arts*, vols. I and II, Fribourg 1963, 1965.

Jung Keng, Institute of Archaeology of the Academy of Sciences, *An Account of the Bronze Vessels of Yin and Chou*, Special Archaeological

Series C, No. 2, Peking 1958. (Chinese: *Yin Chou Ch'ing T'ung Ch'i T'ung Lun*.)

Jung Keng, *A Comprehensive Study of the Ritual Vessels of Shang and Chou*, Peking, 1941. (Chinese: *Shang Chou Yi Ch'i T'ung K'ao*.)

Karlbeck, O., 'Anyang Moulds', *BMFEAS*, 7 (1935).

Karlgren, B., 'New Studies in Chinese Bronzes', *BMFEAS*, 9 (1937).

Karlgren, B., 'Some Early Chinese Bronze Masters', *BMFEAS*, 16 (1944).

Karlgren, B., 'Once Again the A and B Styles in Yin Ornamentation', *BMFEAS*, 18 (1946).

Karlgren, B., 'Bronzes in the Hellström Collection', *BMFEAS*, 20 (1948).

Karlgren, B., 'Some Bronzes in the Museum of Far Eastern Antiquities', *BMFEAS*, 21 (1949).

Karlgren, B., 'Notes on the Grammar of Early Chinese Bronze Décor', *BMFEAS*, 23 (1951).

Karlgren, B., A Catalogue of the Chinese Bronzes in the Alfred F. Pillsbury Collection, Minneapolis 1952.

Kelley, F. C. and Ch'en Meng-chia, *Chinese Bronzes from the Buckingham Collection*, Chicago 1946.

Kidder, J. E., *Early Chinese Bronzes in the City Art Museum of St Louis*, St Louis, 1956.

Komai Kazuchika, *A Study of Ancient Chinese Mirrors*, Kyoto 1953. (Japanese: *Chūgoku Kokyō no Kenkyō*.)

Kuo Mo-jo, *Corpus of Inscriptions on Bronze of both Chou periods*, with illustrations and interpretation, Peking, 2nd edition, 1958. (Chinese: *Liang Chou Chin Wen Tz'ŭ Ta Hsi T'u Lu K'ao Shih*.)

Kuo Pao-chün, 'Excavations at Yin Hsü in 1950', *KKHP*, 1951 (5). (Chinese.)

Lefebvre d'Argencé, R. Y., *Ancient Chinese Bronzes in the Avery Brundage Collection*, San Francisco, de Young Museum Society and Diablo Press 1966.

Leth, A., *Catalogue of Selected Objects of Chinese Art in the Museum of Decorative Art, Copenhagen*, Copenhagen 1959.

Li Chi, 'Bronze Vessels from Hsiao T'un', *KKHP*, 3, 4 (1948–9).

Li Chi, 'Studies of the Decorative Art of the Yin-Shang Period', Pt. I, *Bulletin of the Institute of History and Philology*, Academia Sinica, XXXIV, Pt. II (1968).

Li Chi and Wan Chia-pao, 'Studies of the Bronze *Ku*-Beaker', *Archaeologia Sinica*, N.S., No. 1, Academia Sinica, Taiwan 1964.

Li Chi and Wan Chia-pao, 'Studies of the Bronze Chüeh Cup', *ibid.*, No. 1, 1964.

Lion-Goldschmidt, D. and Moreau-Gobard, J.-C., *Chinese Art: Bronze, Jade, Sculpture, Ceramics*, Fribourg 1960.

Loehr, M., *The Bronze Styles of the Anyang Period*, Archives of the Chinese Art Society of America, VII (1953), 42–8.

Loehr, M., *Chinese Bronze Age Weapons*, Ann Arbor 1956.

Loehr, M., *Ritual Vessels of Bronze Age China*, Asia Society, New York 1968.

SELECT BIBLIOGRAPHY

Medley, M., *A Handbook of Chinese Art*, London 1973.

Mizuno, Seiichi, 'Problems of Dating Shang Bronzes', *Tōhō Gakuhō* (Kyoto), No. 23 (1953). (Japanese.)

Morgan, B. J. St M., *Early Chinese Art* (the Cunliffe collection of bronzes and jades), Bluett and Sons Ltd., London 1973.

Pope, J. A., Gettens, R., Cahill, J. and Barnard, N., *The Freer Chinese Bronzes*, vol. I Catalogue; vol. II Technical Studies, Washington 1967, 1969.

Plenderleith, H., 'Technical Notes on Chinese Bronzes', *Transactions of the O.C.S.*, 1938–9.

Shanghai Museum Bronzes (Chinese: *Shanghai Po Wu Kuan Ts'ang Ch'ing T'ung Chi*) 2 vols., Shanghai 1964.

Shensi Province Cultural Properties Commission, 'Excavation of a Western Chou Tomb at P'u Tu Ts'un, near Ch'ang An', *KKHP*, 1957 (1). (Chinese.)

Shih Chang-ju, 'Important Recent Finds at Yin Hsü, and on the Stratigraphy at Hsiao T'un', *KKHP*, 2 (1947). (Chinese.)

Shih Hsing-pang, 'Excavation of a Western Chou Tomb at P'u Tu Ts'un, near Ch'ang An', *KKHP*, 8 (1954). (Chinese.)

Soper, A. C., 'The Tomb of the Marquis of Ts'ai', *Oriental Art* X, No. 3 (Autumn 1964).

Soper, A. C., 'Early, Middle and Late Shang: a Note', *Antibus Asiae* XXVII (1966).

Umehara, Sueji, *Ancient Treasures Found at Anyang Yin Sites*, Kyoto 1940. (Japanese: *Ka-nan Anyō Ihō*.)

Umehara, Sueji, *Studies on Relics from Anyang, Honan*, Kyoto 1941. (Japanese: *Ka-nan Anyō Imotsu no Kenkyū*.)

Umehara, Sueji, *Catalogue of the Impressions of Wooden Objects Discovered in Yin Tombs*, Kyoto 1959. (Japanese: *Inbo Hakken Mokki In-ei Zuroku*.)

Watson, W., *Handbook to the Collection of Early Chinese Antiquities*, The Trustees of the British Museum, London 1963.

Watson, W., *Cultural Frontiers in Ancient East Asia*, Edinburgh University Press 1971.

Watson, W., 'Traditions of Material Culture in the Territory of Ch'u', in N. Barnard (ed.), *Early Chinese Art and its Possible Influence in the Pacific Basin*, Columbia University 1972.

Watson, W., *The Genius of China: An Exhibition of the Archaeological Finds of the People's Republic of China held at the Royal Academy*, Times Newspapers Ltd, London 1973.

Watson, W., *Style in the Arts of China*, Pelican Books 1974.

Watson, W., 'A Chinese Bronze Bell of the Fifth Century B.C.', *British Museum Quarterly*, vol. XXX (1965) p. 50 ff.

Watson, W., 'On Some Categories of Archaism in Chinese Bronzes', *Ars Orientalis*, IX (1973) p. 1 ff.

Weber, G. W., *The Ornament of Late Chou Bronzes*, New Brunswick 1973.

White, W. C., *Bronze Culture of Ancient China*, Toronto 1956.

SELECT BIBLIOGRAPHY

Yetts, W. P., *The George Eumorfopoulos Collection: Catalogue of the Chinese and Korean Bronzes, Sculpture, Jade, Jewellery and Miscellaneous Objects*, 3 vols., London 1929–32.

Yetts, W. P., *The Cull Chinese Bronzes*, London 1939.

Yetts, W. P., 'Notes on some Chinese Bronzes', *Transactions of the O.C.S.*, 1942–3.

Yoshida, Terukuni, 'A Note on Yin Art', *Tōhō Gakuhō* (Kyoto), No. 23 (1953). (Japanese.)

Notes

PREFACE TO SECOND EDITION

1. E.g. two radiocarbon dates (converted from the Chinese figures to standard form) corroborate the later date for the end of the Shang dynasty. The late-Shang spectacular tomb at Wu-kuan-ts'un was dated to 999 ± 100 B.C.; and a sample from Hsiao-t'un gave 1028 ± 90 B.C.

2. See H. Dubs in the Select Bibliography.

3. Cf. the involved argument in M. Loehr, *Ritual and Vessels of Bronze Age China*, item 41, p. 100.

4. The term 'northern zone' is used here in a more restricted sense than in Loehr's writings, and in the author's *Cultural Frontiers in Ancient East Asia*; the Shensi-Shansi-Hopei region is included in the larger category, together with Manchuria and parts of Mongolia.

CHAPTER I

1. The first mention of the bronze vessels in England was by P. P. Thoms, in *A Dissertation on the Ancient Vases of the Shang Dynasty*, London 1851. See W. P. Yetts, *Early Chinese Bronzes* (Catalogue of an Exhibition held by the Oriental Ceramics Society), London 1951.

2. Juan Yuan, *On the Bronze Vessels of Shang and Chou (Shang Chou T'ung Ch'i Shuo)*, appended to *Inscriptions on Sacrificial Vessels in the Chi Ku Chai Studio*, 1804.

3. Kaizuka Shigeki, *Chūgoku Kodai Shigaku no Hatten*, p. 735 f.

4. K. K. Flug, *Istoriya kitaiskoi pechatnoi knigi sunskoi epokhi*, p. 243, footnote.

5. The fullest summary of the history of the Anyang site is W. P. Yetts' *Anyang, A Retrospect*, The China Society, London 1942.

6. Lo Chen-yü, *A Study of the Script of the Shang Oracle Inscriptions (Yin Shang Cheng Pu Wen Tzŭ K'ao)*, 1910; ejusd.: *Oracle-bone Inscriptions from the Waste of Yin (Yin Hsü Shu Ch'i)*, corpus I, 1912, corpus II, 1916; Wang Kuo-wei, *The Former Princes and Kings of Yin Studied from The Oracle Sentences (Yin Pu Tz'ŭ Chung So Chien Hsien Kung Hsien Wang k'ao)*, 1917; Tung Tso-pin, *Excerpts from a Study of the Chronology of the Oracle Bones (Chia Ku Tuan Tai Yen Chiu Li)*, 1933.

7. William Watson, *China Before the Han Dynasty*, p. 59 ff.

8. Ch'en Meng-chia, *A Study of the Chronology of the Western Chou Period (Hsi Chou Nien Tai K'ao)*, 1945.

117

Chapter II

1. *Wen Wu Ts'an K'ao Tzŭ Liao*, 1955, no. 10, p. 32, figs. 4, 5.

2. *K'ao Ku Hsüeh Pao*, vol. 7 (1954), p. 42, Pls. 60–3.

3. Jung Keng, *Yin Chou Ch'ing T'ung Ch'i T'ung Lun*, Pl. 5, no. 10.

4. Ibid., Pl. 62, no. 121. The find-place is not known.

5. *K'ao Ku Hsüeh Pao*, 1957, I, p. 75 ff, Pl. 4, nos. 5, 6.

6. *The Cemetery of the State of Kuo at Shang Ts'un Ling*, Pl. 41, no. 1.

7. *Finds from the Tomb of the Marquis of Ts'ai at Shou Hsien*, Pl. 5, no. 3.

8. Cf. Jung Keng, op. cit., Pl. 17, no. 33; Pl. 18, no. 34.

9. Kuo Mo-jo, *Liang Chou Chin Wen Tz'ŭ Ta Hsi*, 203/183.

10. J. G. Andersson, 'Prehistory of the Chinese', *Bulletin of the Museum of Far Eastern Antiquities*, no. 15 (1943), p. 259 f.

11. Institute of Archaeology, Peking: *Hui Hsien Excavation Report*, p. 64, fig. 77.

12. Jung Keng, op. cit., Pl. 20, no. 39.

13. *K'ao Ku Hsüeh Pao*, vol. 7 (1954), p. 27, Pl. 21, no. 28.

14. Ibid., p. 25, Pl. 9.

15. William Watson, *Archaeology in China*, Pl. 63a.

16. There is something unaccountable in the shapes and decoration of the *kuei* with Ch'i inscriptions. They may have been intentionally archaistic. The *kuei* in the British Museum which belongs to this group has the inscription *engraved* on one of the handles, and any engraved inscription on a bronze of Shang or Chou date incurs suspicion. Another *kuei* attributable to the state of Ch'i by its inscription is illustrated by Karlgren. See Karlgren, *Yin and Chou in Chinese Bronzes*, Pl. XLII (C166); Pl. LIV (C152).

17. Harada Yoshito, *Shūkan Ihō*, Pl. 11.

18. *The Cemetery of the State of Kuo at Shang Ts'un Ling*, Pl. 34, no. 4.

19. Exceptions to this generalization on the earliest date of bronze *tou* are some small pieces of primitive workmanship, such as one from the Ingram collection now in the Museum of Eastern Art in Oxford (see W. P. Yetts, 'An Exhibition of Chinese Bronzes in London', *Bulletin, Museum van Aziatische Kunst*, no. 36, March 1952). This piece is only 12 cms high, of which the stem accounts for more than half, and is decorated only with two thin cordons. If it is not provincial and aberrant, it must belong to the earlier period of Anyang. It is strange that this shape should not appear in the customary range of Shang ritual bronze vessels.

20. William Watson, op. cit., Pl. 85.

21. The *chüeh* illustrated in William Watson, op. cit., Pl. 43 is of this early type.

22. A few *chiao* in modern collections have lids in the shape of swallow-like birds whose wings spread over the mouth of the vessel and tails project behind. This form of *chiao* was not known to the Sung cataloguers.

In at least one instance in the author's experience a lid of recent manufacture was adapted to a genuine *chiao*.

23. Li Chi, A Note on the Bronzes Excavated at Hsiao T'un, *K'ao Ku Hsüeh Pao*, no. 3 (1948), p. 40; Kuo Pao-chün, Interpretations of the names of Ancient Vessels, *Academia Sinica, Studies presented to Ts'ai Yüan-p'ei*, p. 689 ff; W. P. Yetts, *The Cull Bronzes*, p. 29 f.

24. William Watson, op. cit., Pl. 44.

25. Ibid., Pl. 38.

26. Cheng Meng-chia suggests that the first character in this formula should be read *tien*, to perform a sacrifice, or consecrate.

27. William Watson, op. cit., Pl. 80.

28. Cf. ibid., p. 24, Pl. 63b.

29. *K'ao Ku Hsüeh Pao*, 1957, II, p. 1 ff.

30. *The Cemetery of the State of Kuo at Shang Ts'un Ling*, Pl. 18.

31. Kuo Mo-jo, op. cit., 127/129.

Chapter III

1. In the Pillsbury collection (B. Karlgren, *The Pillsbury collection of Chinese Bronzes*, no. 15). An identical *yu* is preserved in China, both having once been in the Imperial collection. Ch'en Meng-chia argues (*K'ao ku hsüeh pao*, 1956, III, p. 115) that only one complete vessel is genuine, the body of the Pillsbury piece and the lid of the other being of recent manufacture.

2. B. Karlgren, *The Book of Odes*, 261.6.

3. Archives of the Chinese Art Society of America, VI (1952), p. 41 ff.

4. Cf. J. Leroy Davidson, Towards a Grouping of Early Chinese Bronzes, *Parnassus*, vol. IX (1937), no. 4.

5. *Wen Wu*, 1960, no. 10, p. 57 f; *K'ao ku hsüeh pao*, vol. 7 (1954), Pl. 42.

6. Bachhofer, 'The Evolution of Shang and Early Chou bronzes', *The Art Bulletin*, XXVI (June, 1944), p. 107 ff.

7. The chemical analysis of the inlay shows no ingredient which could prove that lacquer or a siliceous frit was used, though both are possibilities. The tenacity of the inlay suggests that it was applied with heat. A paste based on lacquer is not likely to have remained as unaltered as the inlay appears on some bronzes, e.g. a ladle in the British Museum, in which the interstices of the bronze design are filled with a red substance.

8. B. Karlgren, 'Yin and Chou in Chinese Bronzes', *Bulletin of the Museum of Far Eastern Antiquities*, no. 8 (1936); 'New Studies in Chinese Bronzes', ibid., no. 9 (1937). Karlgren mentions two inscriptions in which the *ya hsing* and the *hsi sun tzŭ* signs occur with texts in which personalities apparently belonging to Chou times are mentioned, but as against the 817 cases he examines in which any suggestion of Chou date is absent, he feels justified in suspecting the two exceptional inscriptions of being forgeries, or deliberate archaisms on early Chou vessels.

9. In 'New Studies in Chinese Bronzes' Karlgren analysed some differences in the manner in which the Shang motifs of his list combine together in schemes of ornament. He makes three groups of them: (a) the solid *t'ao*

t'ieh mask, bodied *t'ao t'ieh* and bovine *t'ao t'ieh* (Pls. 23*b*, 15*a*, 5 lower), the cicada and vertical *k'uei* dragon; and a 'unidecor', in which the mask covers the whole available field without the addition of other horizontal zones of ornament (Pl. 15*a*); (*b*) the dissolved *t'ao t'ieh* (Pl. 31*b* lower), 'animal triple band' (Pl. 41*a*), bird with separated tail (Pl. 19*b*), vertical ribs on the sides of vessels, bosses, interlocked T pattern (Pl. 9*b*), the 'square with crescents' (Pl. 40*b*), lozenge-shaped figures as ground, and minor bands with filling of small circles or spirals combined with an eye derived from the mask; (*c*) deformed *t'ao t'ieh* (Pl. 22*b*), *t'ao t'ieh* clearly represented as confronted *k'uei* (Pl. 28*b*), all forms of dragon other than the vertical variety, bird, snake, 'blade' patterns, whirligig roundel and spiral band.

Karlgren demonstrates that motifs of (*c*) occur together with those of (*a*) and (*b*), while none of (*a*) ever combines with motifs of (*b*). He believed that the (*a*) motifs in general preceded those of (*b*), though they partly co-existed with them. Underlying this inference is the belief that a 'realistic' form of *t'ao t'ieh* was the earliest form and by fanciful treatment gave rise to the separated and dissolved versions, the whole evolution having taken place within the Shang period. The style of the ornament on the bronze vessels excavated at Cheng Chou does not however bear out this assumption. From early times the 'naturalistic' and the fantastic *t'ao t'ieh* may have existed side by side. The differences noted by Karlgren, which are readily perceptible as a broad stylistic divergence, may reflect the practices of different workshops working at the same time, rather than a distinction of date.

10. *The Cemetery of the State of Kuo at Shang Ts'un Ling*, Pl. 15, no. 1.

11. Cf. Bronze Vessels Excavated at Pai Chia Chuang, Cheng Chou. See *Wen Wu ts'an k'ao tzŭ liao*, 1955, no. 10, p. 24 ff.

12. Kuo Mo-jo, *Liang Chou Chin Wen Tz'ŭ Ta Hsi*, 66/81, fig. 67.

13. Ibid., 1/1, fig. 254. It is here called *Ta Feng Kuei*.

14. Sun Tso-yün, On the theory that the T'ien Wu Kuei was cast under Wu Wang before the defeat of Shang, *Wen Wu ts'an k'ao tzŭ liao*, 1958, no. 1, p. 29 ff.

15. C. F. Kelley and Ch'en Meng-chia, *Chinese Bronzes from the Buckingham Collection*, Pl. XX.

16. Umehara, 'The Second Altar Set Unearthed in Pao Chi Hsien, Shensi Province', *Tōhō Gakkiyō*, I (1959), p. 1 ff; Okada Yoshimi, 'Pao Chi Tou Chi T'ai no shoki ni tsuite', *Tōhōgakuhō* (Kyoto), vol. 23 (1953), p. 219 ff.

17. L. Bachhofer, loc. cit.

18. The author accepts the early date for the Nieh Ling group of vessels as argued by Kuo Mo-jo and other Chinese scholars. The debate has turned on the meaning to be attached to the phrase *k'ang kung* occurring in the inscriptions, i.e. whether it refers to a temple dedicated to K'ang Wang, or only to a 'resplendent hall', *k'ang* being taken as an epithet. The first supposition implies a date about half a century later than the reign of Ch'eng Wang to which the bronzes have otherwise been attributed.

The inscription of the *kuei* found at Yen Tun Shan (assuming that Nieh is the same person as Nieh Ling) supports the earlier date, which places the bronzes in the more convincing context of the transitional period. Cf. following reference.

19. William Watson, *Archaeology in China*, p. 24, Pl. 63*b*.

20. Ibid., p. 23, Pls. 57–62.

21. As the contents of tombs are excavated and published together it becomes increasingly possible to discern stylistic groups which bear a provincial character when compared with the metropolitan style of the royal bronzes of the Western Chou period. The Yen Tun Shan group is one of these. Another is that excavated at Mei Hsien in Shensi (*K'ao ku hsüeh pao*, 1957, II, p. 1 ff) which is provisionally assigned by Kuo Mo-jo to the reign of Yi Wang (mid ninth century B.C.). The whirligig roundel and surrounding dragon-figures which furnish the ornament are outlined with the hooks and spurs characteristic of what I have called the mannered style; the heavy and unusual handles of a square-bodied vase *tsun* and a *fang yi*, broken by projections of the kind seen in the jagged flanges of the earliest Chou decades (but fewer and larger), are in the Shensi tradition of grotesque tendency exemplified by the Pao Chi bronzes. A group of bronzes from an outlying site, a tomb at Tun Hsi in Anhui (*K'ao ku hsüeh pao*, 1959, IV, p. 59 ff) includes a vase *tsun* with a large and typical mannered *t'ao t'ieh*. The other vessels, *ting*, *p'an*, *tsun* and *yu*, all of sedate profile, are decorated with an individual version of compressed dragons verging on, but not realizing, the effect of interlacery. Versions of twisted dragons, feathered dragons and large paired birds all link with the main development we have traced, but like the pieces from Yen Tun Shan, have a marked local flavour. In both instances the work of local foundries, and not of foundries of the Chou centre, seems to be implied. The handles of a *kuei* found at Tun Hsi are decorated with projecting openwork composed of small dragon-derived elements. Such resource is unparalleled in other bronzes of the time (which is estimated by the excavators as ninth or early eighth century) and anticipates invention of the late Chou period associated with the Huai style.

22. The Lu *Kuei*, Kuo Mo-jo, op. cit., 34/62, fig. 83.

23. Ch'en Meng-chia, *K'ao ku hsüeh pao*, 1956, III, p. 121 ff.

24. B. Karlgren, *Yin and Chou in Chinese Bronzes*, Pl. XXXIV, B 142, Pl. XXXVIII, B 143.

25. This style seems to constitute the main element of Yetts's 'second phase' in the development of the bronze ornament. The 'third phase' embraces the Huai style and its sequel. The concept of the three phases of the history of Chinese bronze art from Shang to the end of Chou, sketching the stylistic changes in the broadest fashion, was never explained by the author in detail. Writing on the Burlington House Exhibition (1936–7) Yetts defined it in 1936 in the following words (*Burlington Magazine*, LXVIII, p. 221):

'The first phase includes those bronzes displaying the standards established in the Shang-Yin period, and it lasted from earliest times to the

tenth century B.C. The second phase includes the style distinctive of Chou culture, and it lasted from the tenth century to dates which varied in different parts of the country. The third phase corresponds generally to what is known as the Ch'in or the Huai style. Again there is variation according to locality, one of the earliest examples belongs to the Ch'in state, and probably was cast at the end of the seventh century B.C.'

The catalogue prepared by Yetts for the exhibition of bronzes held by the Oriental Ceramic Society in 1952 allots each exhibit to its phase.

26. Kuo Mo-jo, op. cit., 40/71 et seq.; figs. 9, 10, 84–6.

27. Cf. Hsü Chung-shu, 'On the Yü *ting*', *K'ao ku Hsüeh pao*, III, p. 53 ff. This *ting* has the broad wave pattern used on some of the Sung pieces, combined with a degenerate bird frieze. The author argues from the mention of the Prince Wu in the inscription that the *ting* was cast in the time of Li Wang, i.e. 857 to 828 B.C. (Ch'en Meng-chia's chronology), which agrees with the dating for the Sung bronzes accepted here.

28. Kuo Mo-jo, op. cit., figs. 92–5.

29. Shang Ts'un Ling, see note 10 above.

30. Sun Hai-p'o, *Hsin Cheng Yi Ch'i*, 1937.

31. Georges Salles, 'Les bronzes de Li Yu', *Revue des Arts Asiatiques*, VIII (1930), p. 146 ff. The veracity of the account of the find at Li Yü was questioned (verbally) by Yetts, but the later finds mentioned in the text tend to remove this doubt.

32. *Wen Wu*, 1960, nos. 8/9, p. 14; *K'ao ku hsüeh pao*, 1957, I, p. 103 ff.

33. William Watson, op. cit., p. 27 f, Pls. 85–8.

34. Cf. N. Vandier, 'Note sur un vase Chinois du Musée du Louvre', *Revue des Arts Asiatiques*, XII (1938), p. 133 ff.

35. Cf. William Watson, *China Before The Han Dynasty*, p. 170, fig. 54. E. von Erdberg Consten, A Hu with Pictorial Decoration, *Archives of the Chinese Art Society of America*, VI (1952), p. 18 ff.

36. Kuo Mo-jo, op. cit., 266/227, fig. 193; Jung Keng, *Shang Chou Yi Ch'i t'ung k'ao*, Pl. 406, no. 769.

37. *Finds made in the tomb of the Marquis of Ts'ai, Shou Hsien*, 1956.

38. A report on excavations recently conducted at Shan Piao Chen and Liu Li Ko in Honan (Institute of Archaeology of the Academy of Sciences, Peking, Special Archaeological Series D, No. 11, published in Sept. 1959, but owing to restrictions of export available to the writer only on going to press) describes bronzes of great importance for the history of the bronze art in the period here discussed. The single great tomb at Shan Piao Chen, of the early 5th century B.C., contained a *hu* similar to that of our Pl. 55, but with a more primitive version of the interlaced bands; another *hu* is covered with reduced interlacery much like that of the *fu* of Pl. 56*b*; a *tou* is a close parallel to that of Pl. 61*b*; and a *chien* like that of Pl. 60*b* has similar handles but is engraved with human figures, mainly soldiers. This material affords further evidence of the northern, Honan, origin of the Huai style. The tombs excavated at Liu Li Ko, ranging in date from the 6th to the 3rd century, included some bronzes analogous to the earlier pieces from Hsin Cheng, others in pure Li Yü style, two hunting *hu* com-

parable to that of our Pl. 70a, and a *hu* inlaid in the geometric style of the 3rd century B.C.

39. Orvar Karlbeck, *Catalogue of the Collection of Chinese and Korean bronzes at Hallwyl House, Stockholm*, Stockholm 1938.

40. According to Jung Keng the similar splendid *chien* now in the Pillsbury Collection was found together with the Freer Gallery piece.

41. W. P. Yetts, *The Cull Bronzes*, p. 45 ff.

42. William Watson, *Archaeology in China*, p. 24 f, Pls. 67–9.

43. *K'ao ku hsüeh pao*, 1959, I, p. 41 ff, Pls. 9–11.

CHAPTER IV

1. S. H. Hansford, *The Seligman Collection of Oriental Art*, p. 45 ff.

2. Sir Herbert Ingram, *Ya Hsing, what does it mean?* Privately printed, 1952.

3. A. Bulling, *The Meaning of China's Most Ancient Art*, p. 128 ff.

4. *K'ao ku t'u*, 1792 ed., Ch. 4, p. 5.

5. Lo Chen-ÿü, *Notes on the Yin script* (*Yin Wen ts'un*), 1917.

6. Wang Kuo-wei, 'An Interpretation of the Lo Kao, chapter of the Shu Ching', *Kuan t'ang chi lin*, 1927.

7. *Seioku Seidō* (Santei edition), no. 105, p. 79 f.

8. Ma Heng, 'The Date of Chinese Bronzes', *Kōkogaku ronsō*, 1, 1928.

9. André Leth, *Kinesisk Kunst i Kunstindustri Museet*, Copenhagen 1959, No. 18.

10. Kuo Mo-jo, *Liang Chou Chin Wen Tz'ŭ Ta Hsi*, 183/168.

11. W. P. Yetts, 'A Ch'u Bronze', *Burlington Magazine*, Nov. 1930.

12. The most comprehensive works on all aspects of the Chou inscriptions are Kuo Mo-jo's *A Systematic Corpus of the Bronze Inscriptions of the Western and Eastern Chou periods* (*Liang chu chin wen tz'ŭ ta hsi*) 1935, already much cited in this book; and Ch'en Meng-chia's 'A Chronological Treatment of Western Chou Bronze Vessels' (Hsi chou t'ung ch'i tuan tai), *K'ao ku hsüeh pao*, vol. 9 (1955)–1956, no. 4.

13. *K'ao ku hsüeh pao*, 1956, no. 3, p. 121 ff.

14. Tso Chuan, *Ch'eng Kung*, 13th year.

15. *Catalogue of the Eumorfopoulos Collection*, Vol. I, p. 29, fig. 33.

16. William Watson, *Archaeology in China*, p. 24, Pl. 69c. The find is published in *Wen wu ts'an k'ao tzŭ liao*, 1955, no. 5, p. 58 ff. For the inscription on the kuei, v. Ch'en Meng-chia, ibid. p. 63 ff; and Ch'en Pang-fu, ibid. p. 67 ff.

17. W. P. Yetts, *The Cull Bronzes*, p. 45 ff. The uncertainty of translation depends on the meaning and position of 'Yü'. Here it is taken as a name and placed at the end. It has also been considered as the first word of the inscription, as a name and a verb.

18. Freer Gallery of Art, *A descriptive and illustrated Catalogue of Chinese Bronzes*, p. 43 ff.

19. Kuo Mo-jo, op. cit., 81/92; Ch'en Meng-chia, *K'ao ku hsüeh pao*, 1956, no. 4, p. 114 ff, Pls. 3, 4.

20. *Catalogue of the Eumorfopoulos Collection*, vol. I, p. 26, fig. 32; Ch'en Meng-chia, *K'ao ku hsüeh pao*, 1956, no. 1, p. 73 ff.

21. Kuo Mo-jo, op. cit., 40/71 et seq.

CHAPTER V

1. *K'ao ku hsüeh pao*, vol. 7 (1954), p. 25, Pl. no. 15 (this last properly 16a); Kao Chü-hsün, 'Problems of the bronze mirror discovered from a Shang burial', *Bulletin of the Institute of History and Philology, Academia Sinica*, Taipei, XXIX (1958), 685 ff; Umehara Sueji, 'Chūgoku inshū no kokyō', *Shirin*, no. 4 (1959).

2. *The cemetery of the state of Kuo at Shang Ts'un Ling*, Pl. 23, nos. 1, 2.

3. B. Karlgren, Huai and Han, *Bulletin of the Museum of Far Eastern Antiquities*, Pl. 7, A2.

4. Institute of Archaeology, Peking: *Loyang Chung Chou Lu*, Pl. 74, no. 16.

5. Komai Kazuchika, *Chūgoku kokyō no kenkyū*, p. 15.

6. Ibid., p. 82.

7. B. Karlgren, op. cit., p. 62.

8. Institute of Archaeology of the Academy of Science, Peking, Special Archaeological Series 4, *Report on the Excavations at Ch'ang Sha*, Pl. 44, 4.

9. *K'ao Ku Hsüeh Pao*, 1958, no. 2, p. 70, Pl. 14, nos. 4 and 5.

10. Quoted by Komai Kazuchika, op. cit.

11. Cf. W. P. Yetts, *The Cull Bronzes*, p. 150 ff; S. Cammann, 'The TLV pattern on cosmic mirrors of the Han Dynasty', *Journal of the American Oriental Society*, vol. 68 (1948), p. 159 ff; A. Bulling, *The Decoration of Mirrors of the Han Period*, p. 36 ff, p. 46 ff; L. S. Yang, 'A note on the so-called TLV mirrors and the game *liu po*', *Harvard Journal of Asiatic Studies*, vol. 9 (1945–7), p. 202 ff.

12. A. Bulling, op. cit., p. 37.

13. S. Howard Hansford, *The Seligman Collection of Oriental Art*, p. 73.

14. William Watson, 'A Bronze Mirror from Shao Hsing, Chekiang Province', *British Museum Quarterly*, vol. XIX (1954), p. 41 ff.

15. Komai Kazuchika, op. cit., p. 28.

16. Institute of Archaeology, Peking: Report of excavations at Ch'ang Sha, p. 116. The 'yellow skirt' (symbolizing the middle colour as the golden mean, and the earth as opposed to heaven), and the 'primordial blessing' are quoted from the *K'uen* section of the *Yi Ching*.

17. Cf. Noel Barnard, 'A preliminary study of the Ch'u silk manuscript', *Monumenta Serica*, vol. XVII (1958), p. 1 ff.

18. The *sheng* is taken to be the headdress which is regularly worn by Hsi Wang Mu in her portrait on the mirrors. Komai suspects that its mention in this earliest description is an interpolation from later texts. The origin of the goddess's name is obscure. Possibly it is involved with a place name. Even the original sex is questionable, although *mu* 'mother' is always used in the transcription.

NOTES

19. H. H. Dubs, 'An ancient Chinese mystery cult', *Harvard Theological review*, 1942, p. 232 ff (cited by A. Bulling).

20. S. Cammann, op. cit.

21. A. Bulling first drew attention to this point.

22. William Watson, 'A Bronze Mirror from Shao Hsing, Chekiang Province', *British Museum Quarterly*, vol. XIX (1954), p. 41 ff.

23. See Komai, op. cit., p. 132.

Index

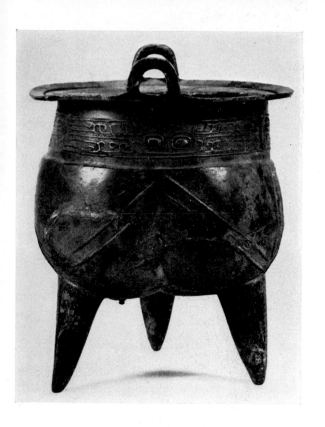

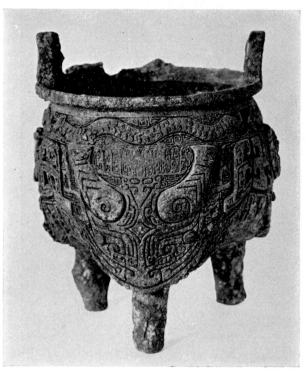

1a. Ting.
Excavated at Hui Hsien,
Honan.
15–13th century B.C.
Shang Dynasty. Ht. 7⅞ ins.
China.

1b. Li.
12–11th century B.C.
Shang Dynasty. Ht. 7⅛ ins.
Museum of Far Eastern
Antiquities, Stockholm.

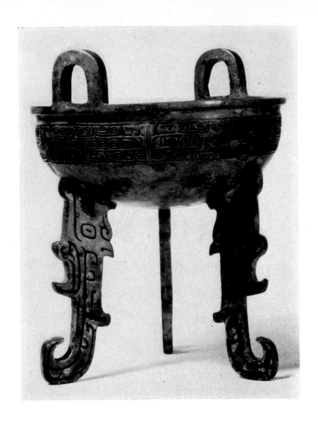

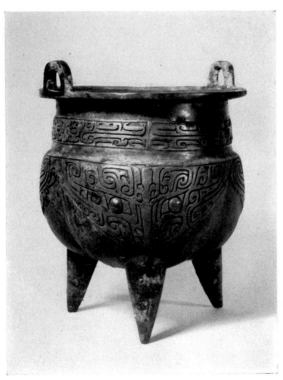

2a. Ting.
13–12th century B.C.
Shang Dynasty. Ht. 7 ins.
Museum of Eastern Art,
Oxford.

2b. Ting.
15–13th century B.C.
Shang Dynasty. Ht. 6¾ ins.
Museum of Eastern Art,
Oxford.

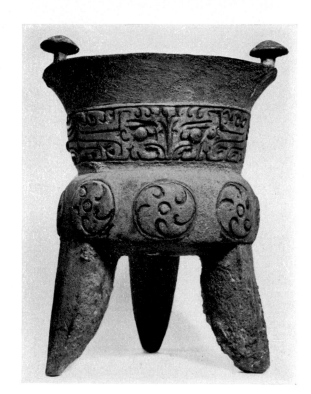

3*a*. Chia.
15–13th century B.C.
Shang Dynasty. Ht. 9⅞ ins.
British Museum.

3*b*. Lei.
13–12th century B.C.
Shang Dynasty. Ht. 8 ins.
Seligman bequest,
British Museum

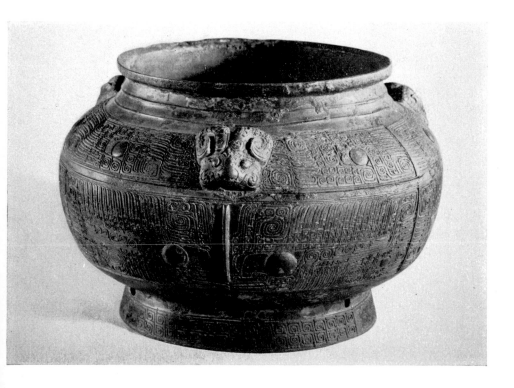

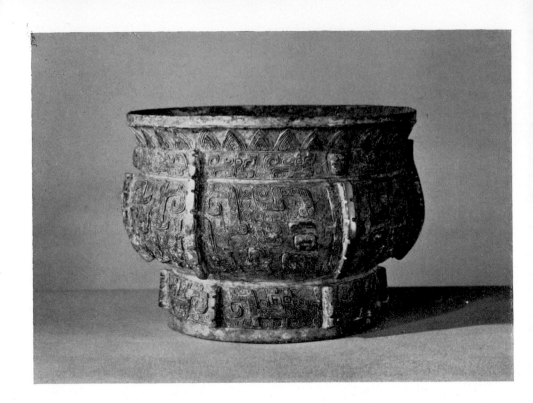

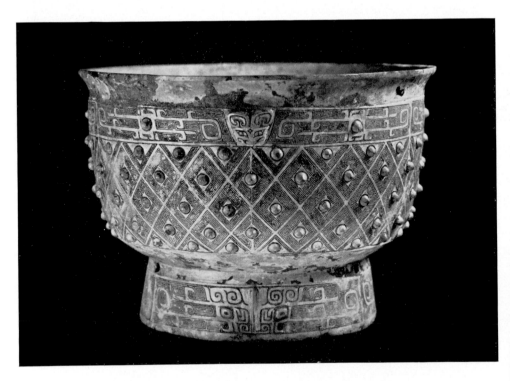

4*a*. Kuei. 12–11th century B.C. Shang Dynasty.
Ht. 4¾ ins. Museum van Aziatische Kunst, Amsterdam.

4*b*. Kuei. 12–11th century B.C. Shang Dynasty.
Ht. 6¼ ins. The Mount Trust. Inscription, fig. 6 (7).

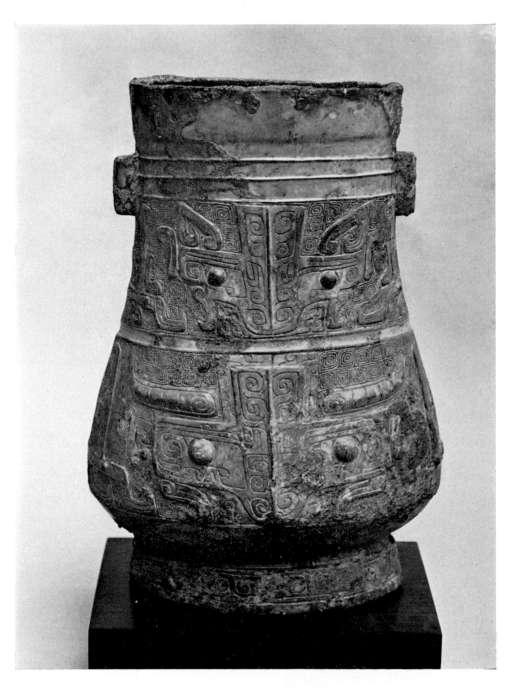

5. Hu. 12–11th century B.C. Shang Dynasty.
Ht. 11⅝ ins. British Museum.

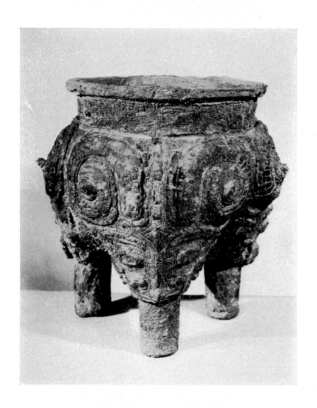

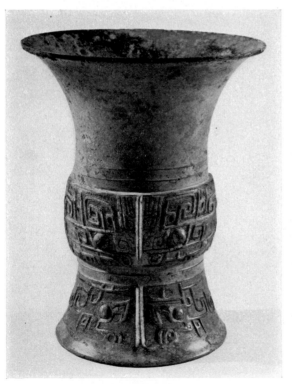

6a. Li.
12–11th century B.C.
Shang Dynasty. Ht. 11¾ ins.
M. Calmann collection.

6b. Tsun.
12–11th century B.C.
Shang Dynasty. Ht. 10 ins.
Formerly in the possession of
Messrs Sotheby.

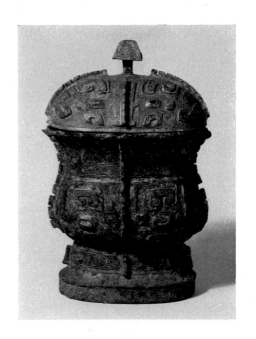

7a. Chih.
12–11th century B.C.
Shang Dynasty. Ht. 8⅝ ins.
Museum of Eastern Art, Oxford.

7b. Hu. Excavated at Anyang.
12–11th century B.C. Shang Dynasty.
Ht. 12¼ ins. China.

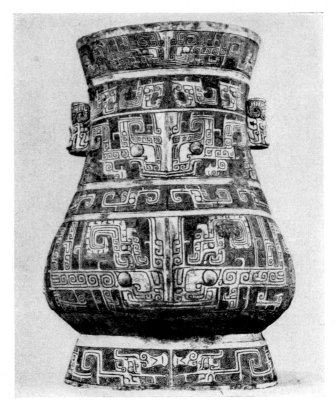

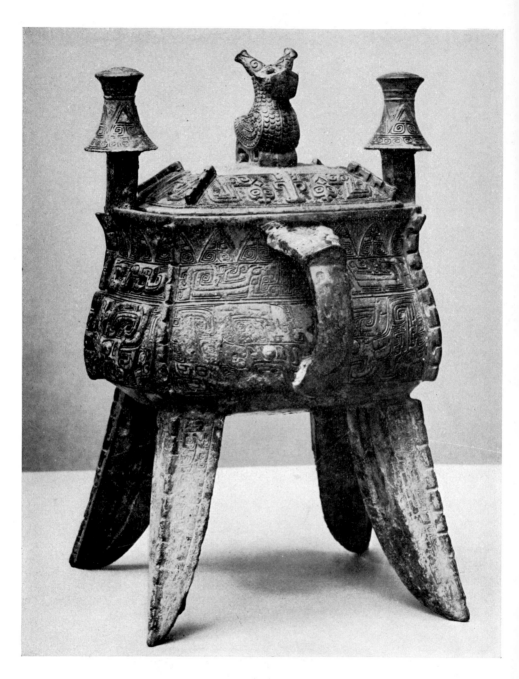

8. Chia. 12–11th century B.C. Shang Dynasty.
Ht. 9¾ ins. British Museum.

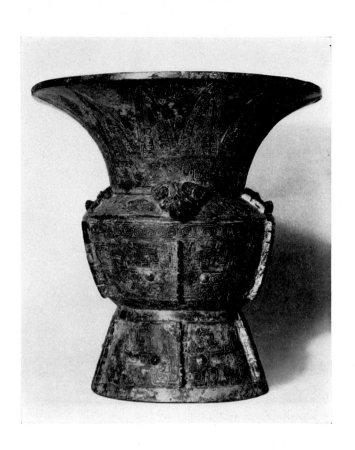

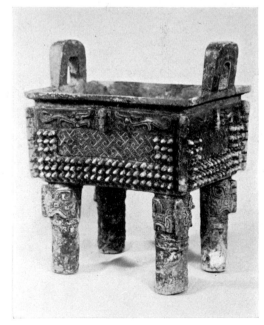

9*a*. Tsun.
12–11th century B.C.
Shang Dynasty. Ht. 12 ins.
British Museum.

9*b*. Ting.
Late 11th century B.C.
Ht. 9¼ ins.
Formerly in the possession of
T. Y. King, Hong Kong.

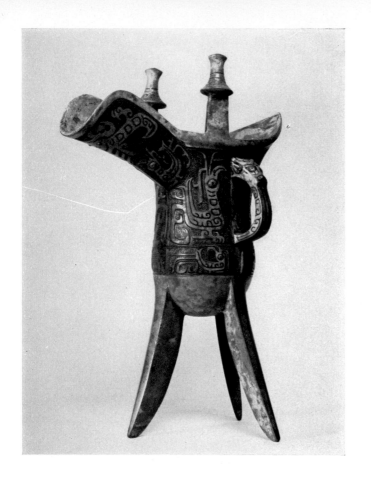

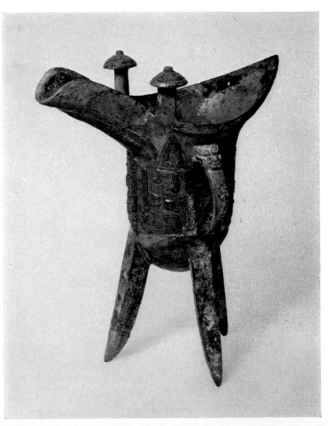

10*a*. Chüeh.
Late 11th century B.C.
Transitional style.
Ht. 8¾ ins.
Formerly in the
collection of
Lord Cunliffe.

10*b*. Chüeh.
12–11th century B.C.
Shang Dynasty.
Ht. 7¾ ins.
British Museum.

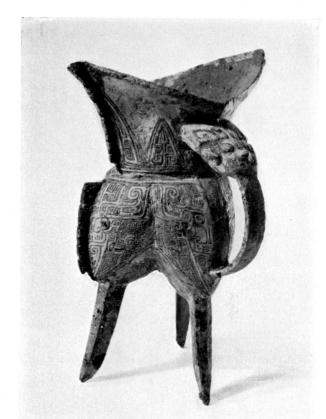

11a. Chiao.
12–11th century B.C.
Shang Dynasty. Ht. 8 ins.
Museum of Eastern Art,
Oxford.

11b. Chiao.
12–11th century B.C.
Shang Dynasty. Ht. 9¼ ins.
The Mount Trust.

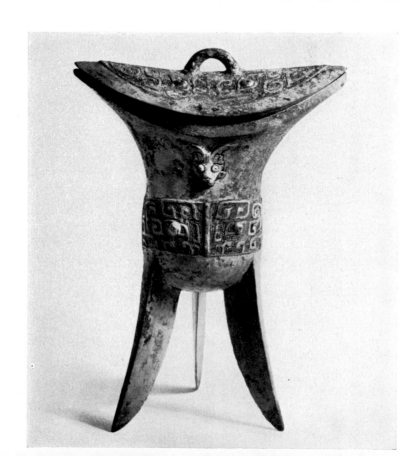

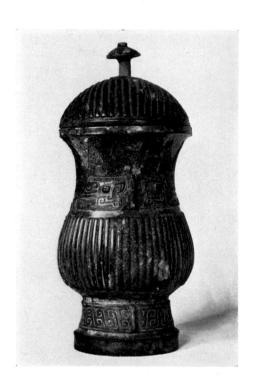

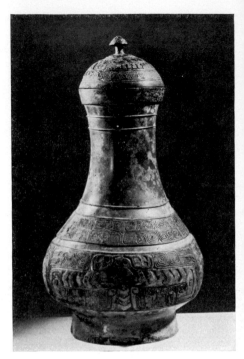

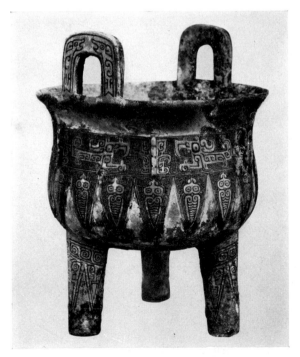

12a. Chih.
12–11th century B.C.
Shang Dynasty. Ht. 7⅛ ins.
Formerly in the
collection of
Captain E. G. Spencer
Churchill.

12b. Chih.
12–11th century B.C.
Shang Dynasty. Ht. 9 ins.
The Mount Trust.

12c. Ting.
12–11th century B.C.
Shang Dynasty. Ht. 9 ins.
Formerly in the
collection of
F. Brodie Lodge, Esq.

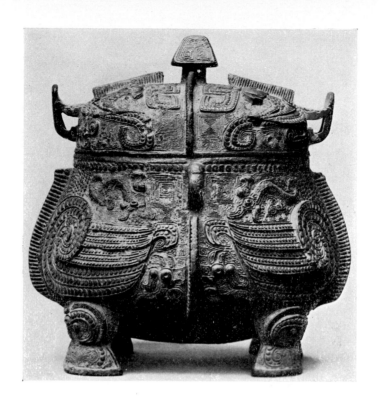

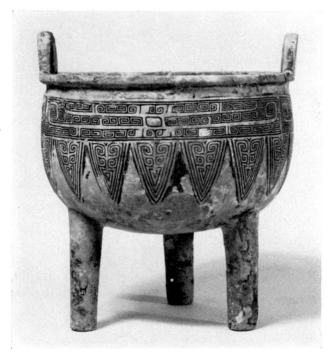

13a. Owl tsun. 11th century B.C. Shang Dynasty.
Ht. 6 ins. British Museum.

13b. Ting. 12–11th century B.C. Shang Dynasty.
Ht. 5 ins. Formerly in the collection of Lord Cunliffe.

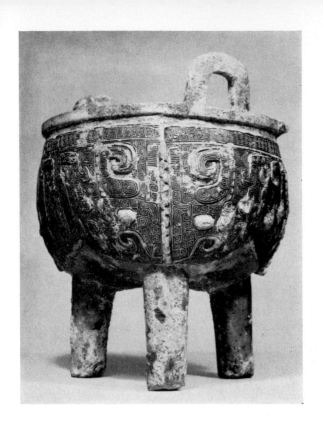

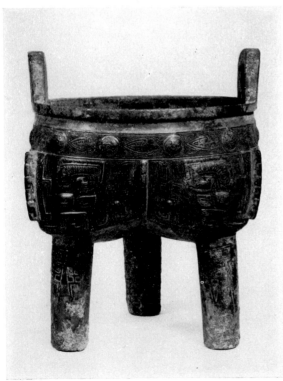

14a. Ting.
12–11th century B.C.
Shang style. Ht. 8 ins.
British Museum.

14b. Ting.
11th century B.C.
Transitional style. Ht. 7¾ ins.
British Museum.

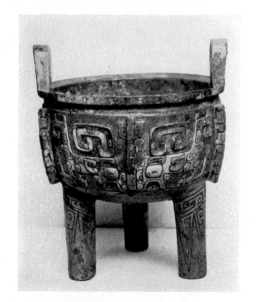

15*a*. Ting.
11th century B.C.
Ht. 9¼ ins.
Formerly in the collection of
E. K. Burnett, Esq.

15*b*. Hsien.
Excavated at P'u Tu Ts'un,
Shensi. 10th century B.C.
Ht. 16¼ ins. China.

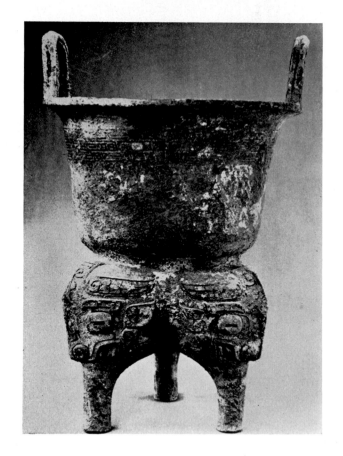

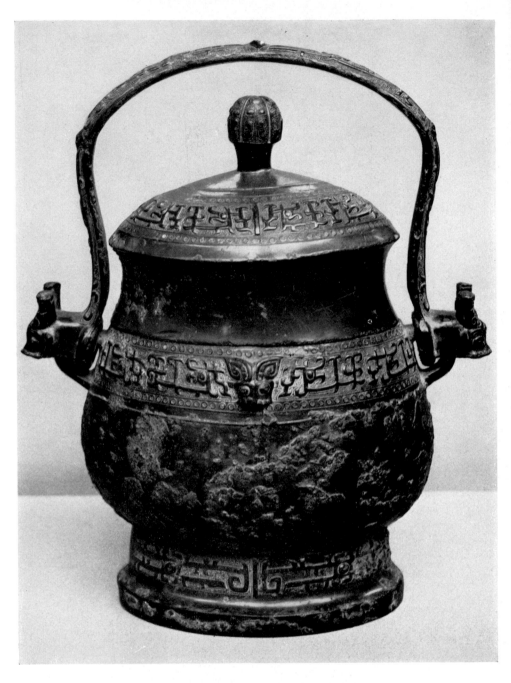

16. Yu. Late 11th–early 10th century B.C. Transitional style.
Ht. 12 ins. Victoria and Albert Museum.

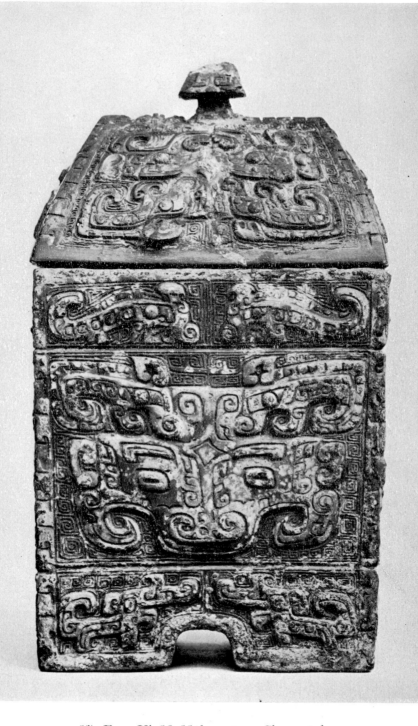

17. Fang Yi. 12–11th century. Shang style.
Ht. 7¼ ins. Formerly in the collection of R. E. Luff, Esq.
Inscription, fig. 5 (15).

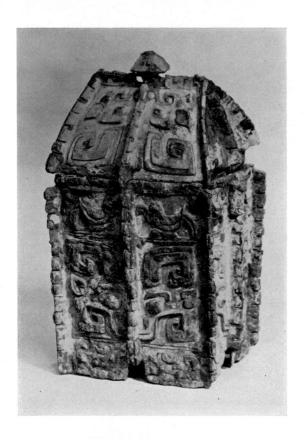

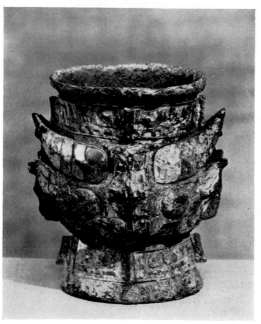

18a. Fang Yi.
12–11th century B.C.
Shang style. Ht. $8\frac{1}{4}$ ins.
Sedgwick bequest.
British Museum.

18b. Chih.
12–11th century B.C.
Ht. $5\frac{3}{4}$ ins.
Sedgwick bequest.
British Museum.

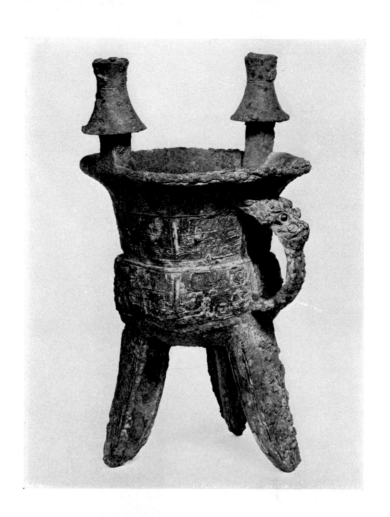

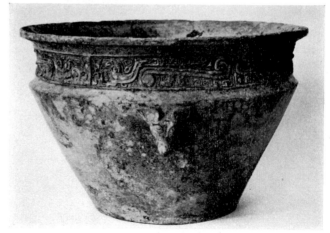

19a. Chia.
12–11th century B.C.
Ht. 12¼ ins.
British Museum.

19b. Bowl.
Late 11th century B.C.
Transitional style.
Ht. 6½ ins.
Museum of Far Eastern
Antiquities, Stockholm.

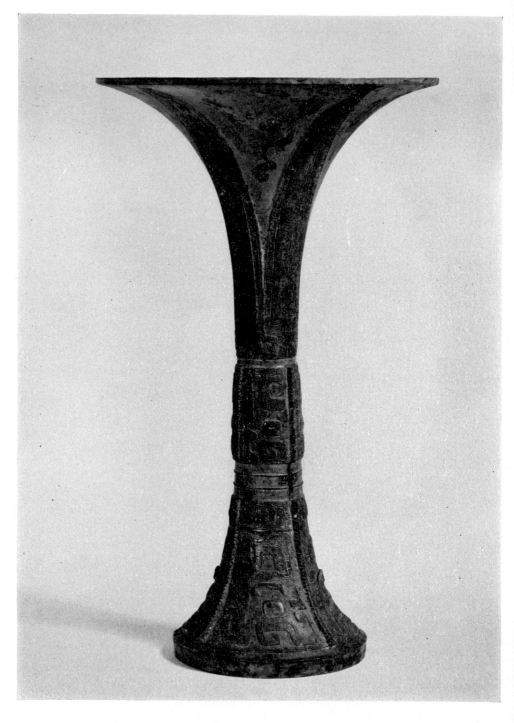

20. Ku. 12–11th century B.C. Shang style.
Ht. 12¼ ins. Formerly in the collection of Denis Cohen, Esq.

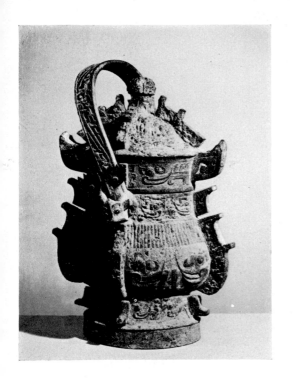

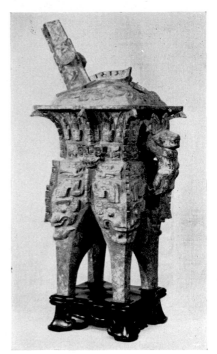

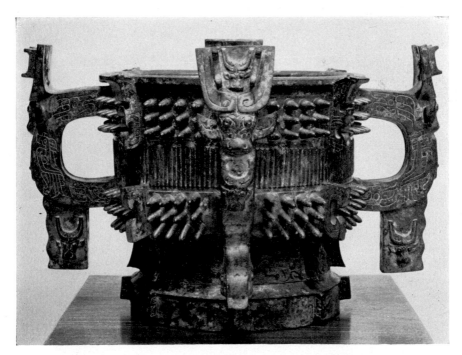

21a. Yu. Late 11th–early 10th century B.C. Chou style.
Ht. 18¾ ins. Metropolitan Museum, New York.

21b. Ho. Late 11th century B.C. Shang style.
Ht. 28¾ ins. Nezu Collection, Tokyo.

21c. Kuei. Late 11th century. Shang style.
Ht. 9⅛ ins. Freer Gallery of Art.

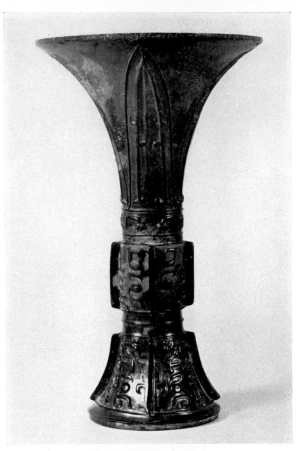

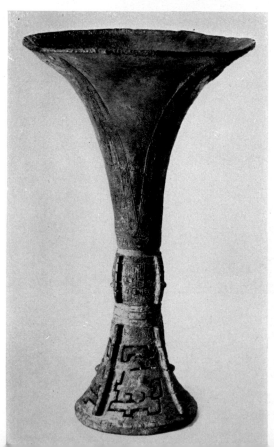

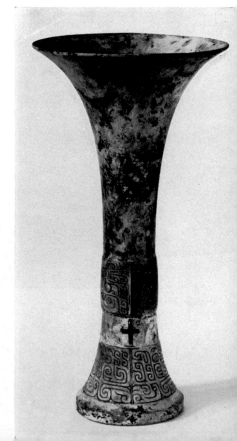

22a. Ku.
Late 11th century B.C.
Transitional style. Ht. 8¼ ins
Formerly in the collection of
Lord Cunliffe.

22b. Ku.
12–11th century B.C.
Shang style. Ht. 10 3/16 ins.
British Museum.

22c. Ku.
13–12th century B.C.
Shang style. Ht. 11 3/16 ins.
British Museum.

23a. Yu.
Later 11th century B.C.
Transitional style.
Ht. 8 ins.
Museum of Eastern
Antiquities, Oxford.

23b. Yu.
11th century B.C.
Shang style.
Ht. 8¾ ins.
British Museum.

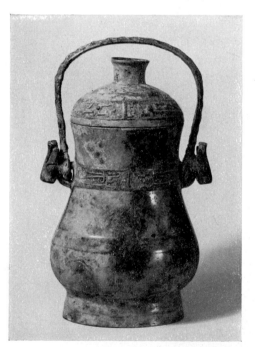

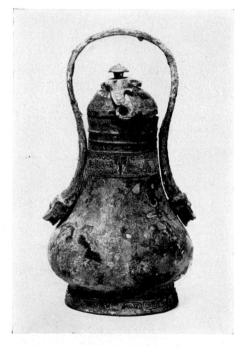

24a. Yu. Late 11th–early 10th century B.C. Chou style.
Ht. 8½ ins. Formerly in the collection of R. E. Luff, Esq.

24b. Yu. Late 11th–early 10th century B.C. Transitional style.
Ht. 10 ins. Barlow bequest. University of Sussex.

24c. Yu. 11th century B.C. Shang style.
Ht. 10½ ins. Museum of Far Eastern Antiquities, Stockholm.

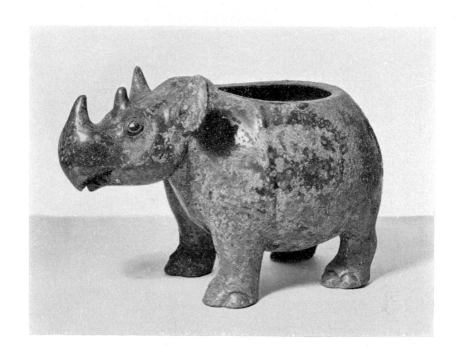

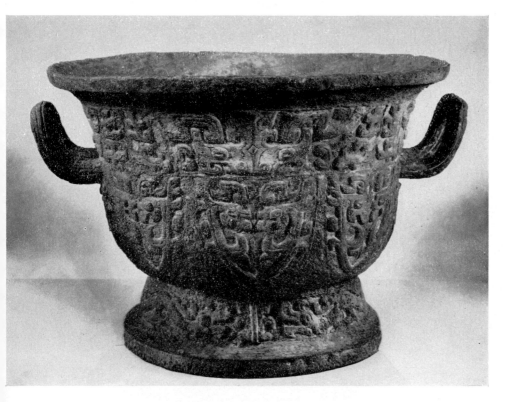

25a. Rhinoceros tsun. Late 11th century B.C.
Ht. 8½ ins. The Asian Art Museum of San Francisco.
Avery Brundage Collection.

25b. Yü. Early 10th century B.C.
Ht. 11½ ins. Toledo Museum of Art.
Inscription, page 83.

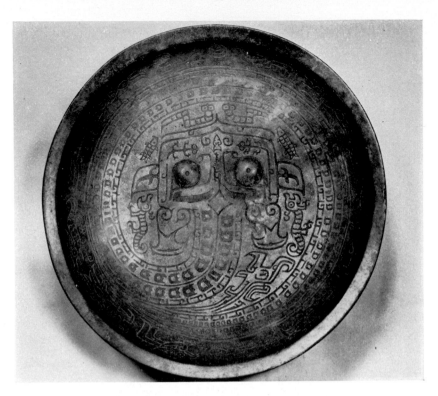

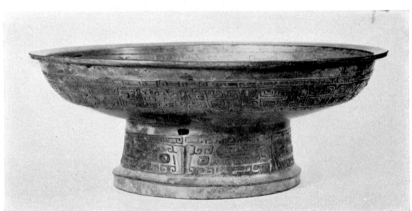

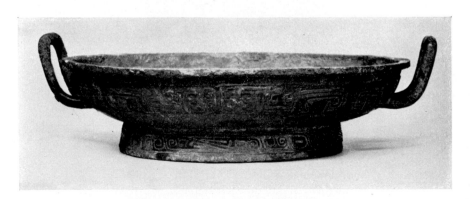

26a, b. P'an. 11th century B.C. Shang style.
Diameter 13½ ins. British Museum.

26c. The Shou Kung p'an. Later 10th century B.C.
Diam. 17¼ ins. Sedgwick bequest. Fitzwilliam Museum. Inscription, page 87.

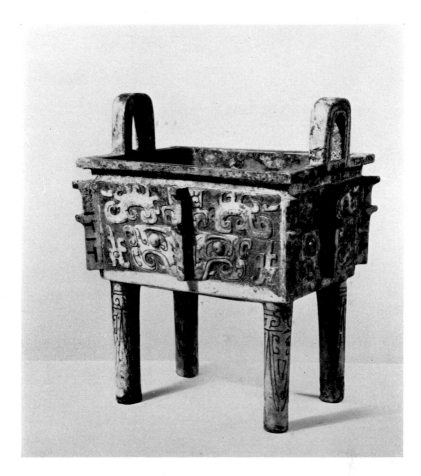

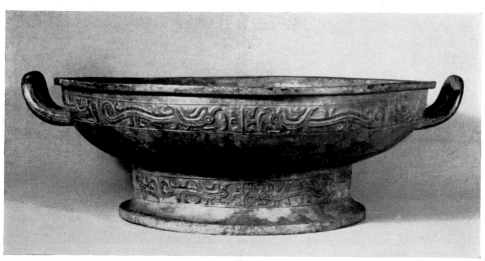

27a. Ting. Late 11th or early 10th century B.C. Transitional style.
Ht. 10½ ins. Seligman bequest. British Museum.
Inscription, fig. 5 (10).

27b. P'an. 10th century B.C.
Diam. with handles 21¼ ins. British Museum.

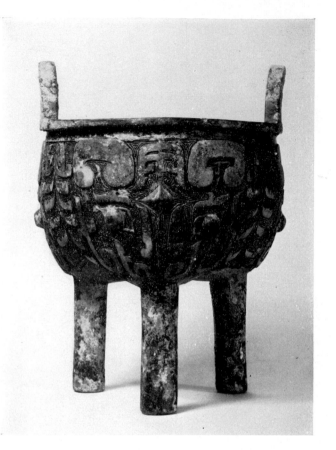

28a. Ting.
11th century B.C.
Shang style. Ht. 9½ ins.
Barlow bequest.
University of Sussex.

28b. 11th century B.C.
Shang style. Ht. 10 ins.
British Museum.

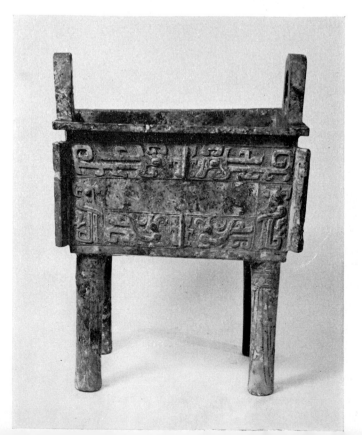

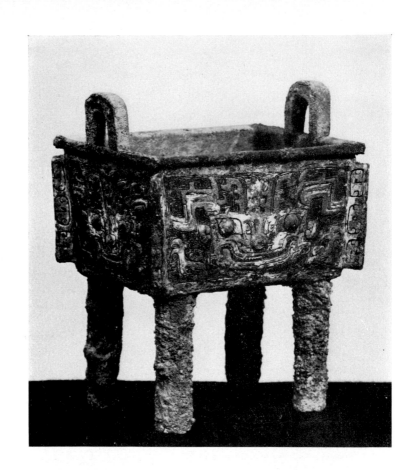

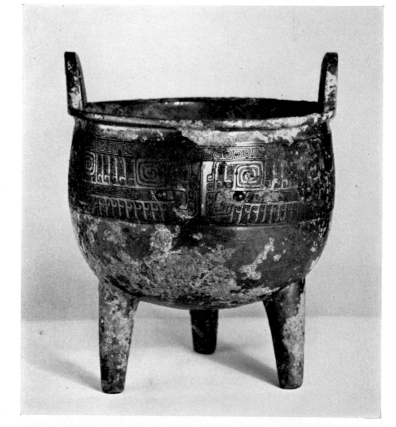

29a. Ting.
11th century B.C.
Shang style.
Ht. 7¼ ins.
W. K. Vander-
bilt.

29b. Ting.
13–11th century
B.C. Shang style.
Ht. 8⅛ ins.
The Mount
Trust.

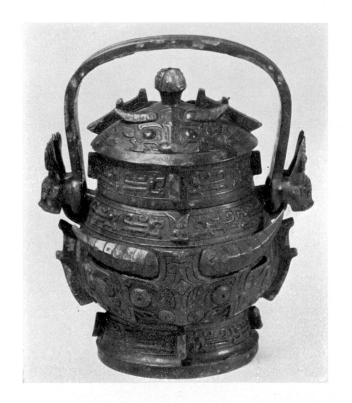

30a. Yu.
Late 11th century B.C.
Chou style. Ht. 10¼ ins.
Victoria and Albert
Museum.
Inscription, fig. 5 (5).

30b. Elephant tsun.
11th century B.C.
Shang style. Ht. 10¼ ins.
Formerly in the
collection of
Herr H. G. Oeder.
Inscription, fig. 5 (1).

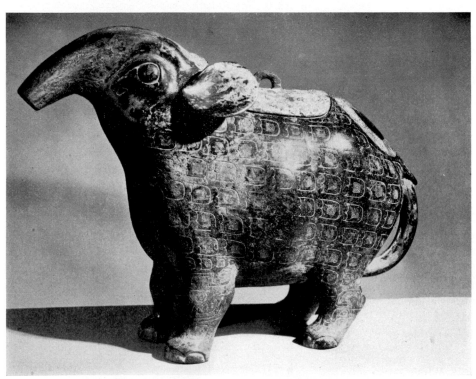

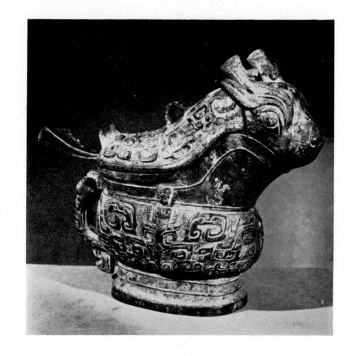

31*a*. Kuang.
Late 11th–early 10th
century B.C.
Transitional style.
Length 8¼ ins. Ht. 7⅛ ins.
Fitzwilliam Museum.
Inscription, page 83.

31*b*. Kuang.
12–11th century B.C.
Shang style. Ht. 9¼ ins.
Sedgwick bequest.
British Museum.

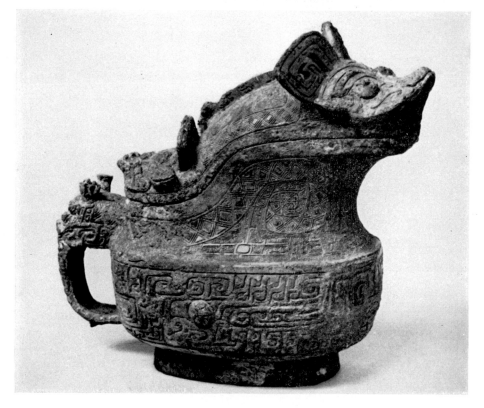

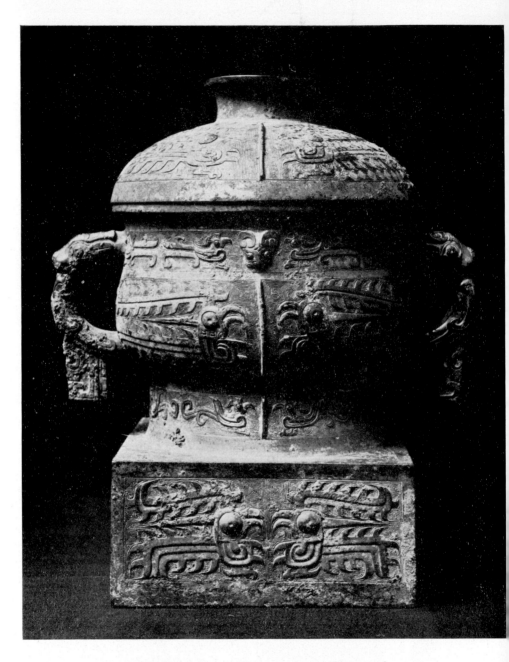

32. Kuei. Late 11th century B.C. Chou style.
Ht. 13¾ ins. Formerly in the possession of Messrs Yamanaka.

33a. The Ling Fang Yi.
Late 11th century B.C.
Transitional style.
Ht. 13$\frac{3}{16}$ ins.
Freer Gallery of Art.
Inscription, page 86.

33b. Yu.
Late 11th century B.C.
Chou style. Ht. 15$\frac{3}{4}$ ins.
Formerly in the possession of
Messrs Yamanaka.

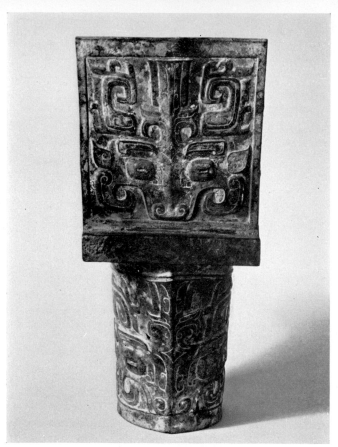

34a.
Fitting for chariot
pole. Late 11th or
early 10th century B.C.
Chou style.
Length $9\frac{1}{2}$ ins.
British Museum.

34b.
Fitting for chariot
pole. Late 11th or
early 10th century B.C.
Chou style.
Length $8\frac{1}{2}$ ins.
Dugald Malcolm, Esq.

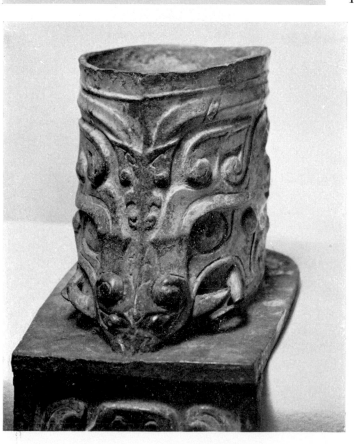

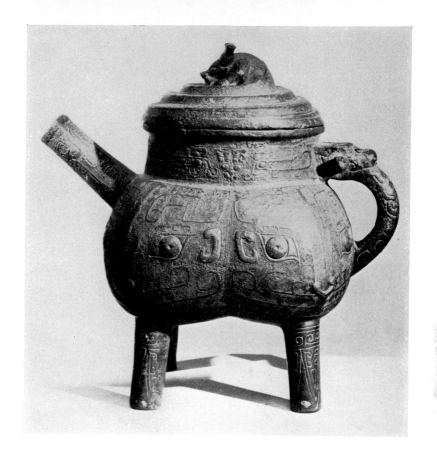

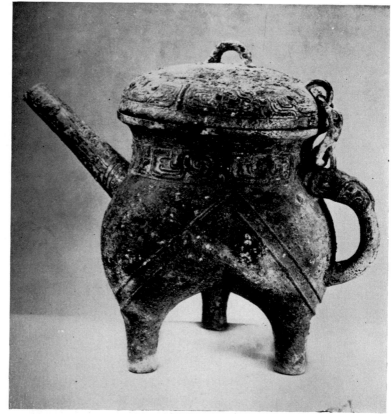

35a. Ho.
Late 11th–early
10th century B.C.
Transitional
style.
Ht. 10¾ ins.
China. Inscrip-
tion, fig. 6 (6).

35b. Ho.
Excavated at
P'u-tu-ts'un,
Shensi. Mid
10th century B.C.
Ht. 10⅞ ins.
China.
Inscription,
page 85.

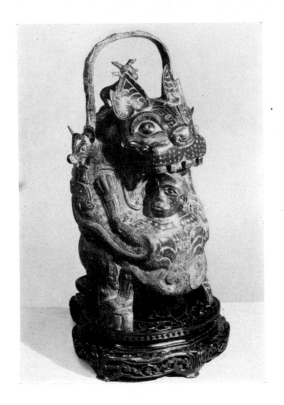

36a. Monster tsun.
11th century B.C.
Shang style. Ht. 9¾ ins.
Sumitomo collection. Kyoto.

36b. Owl tsun.
11th century B.C.
Shang style. Ht. 8¾ ins.
Victoria and Albert Museum.

36c. Owl tsun, said to have
been found at Chün Hsien,
Honan. 11th century B.C.
Ht. 9¼ ins.
Hakuzuru Museum, Kobe.

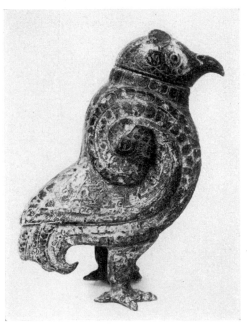

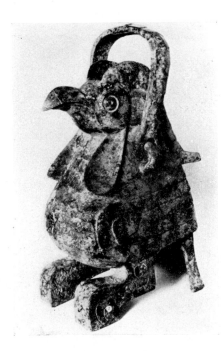

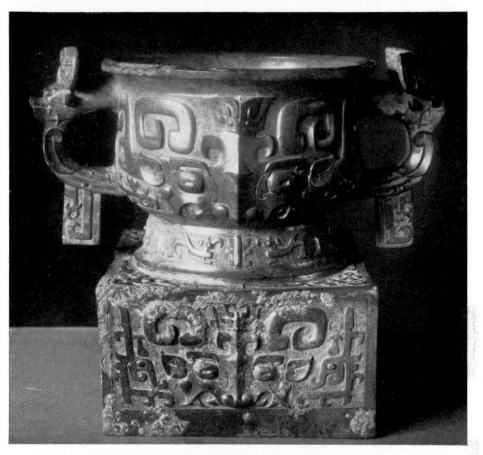

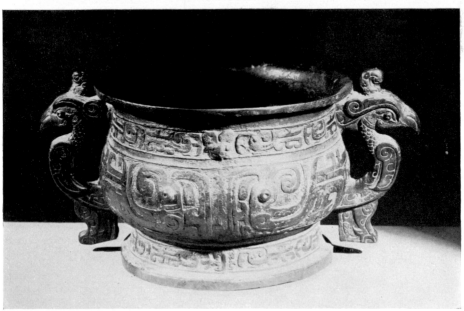

37a. Kuei. Late 11th–early 10th century B.C. Chou style.
Ht. 10½ ins. Formerly in the possession of Messrs Yamanaka.

37b. Kuei, archaistic, in the style of the early 10th century B.C.
Ht. 6⅛ ins. Formerly in the Palace Museum, Peking.
See page 21, and, for the inscription, page 83.

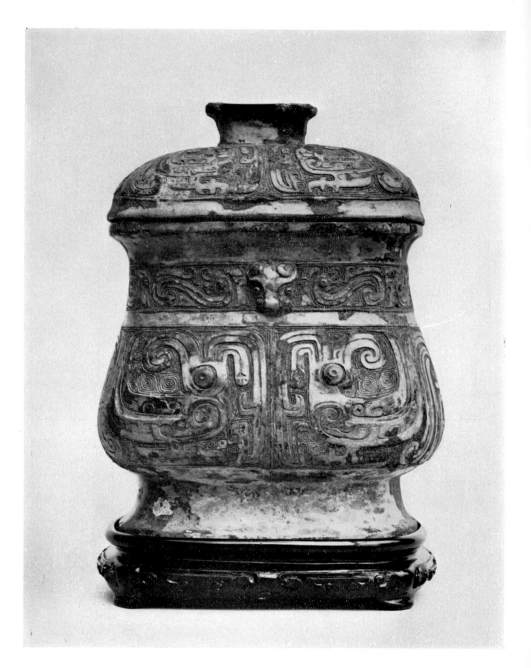

38. Chih. 10th century B.C. Chou style.
Ht. 7¾ ins. British Museum.

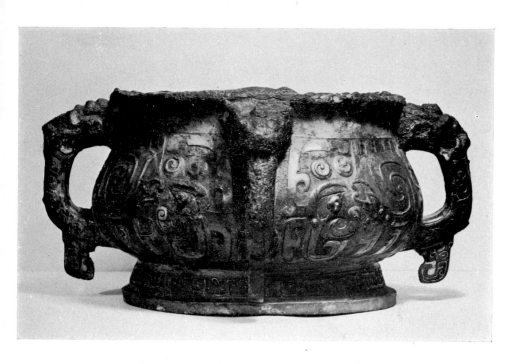

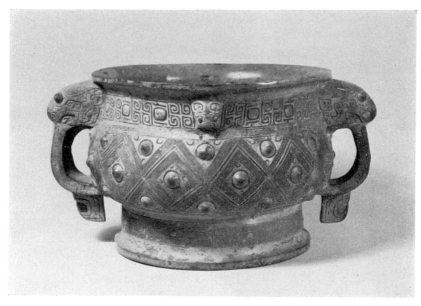

39*a*. Hsing Hou kuei. Late 11th century B.C.
Ht. 7½ ins. British Museum. Inscription, page 87.

39*b*. Kuei. Late 11th–early 10th century B.C.
Chou style. Ht. 6 ins. Formerly in the collection of Lord Cunliffe.
Inscription, page 83.

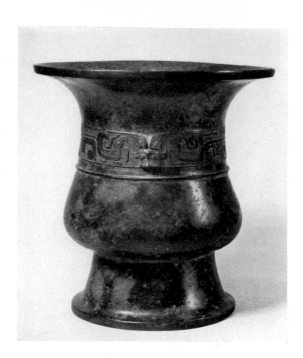

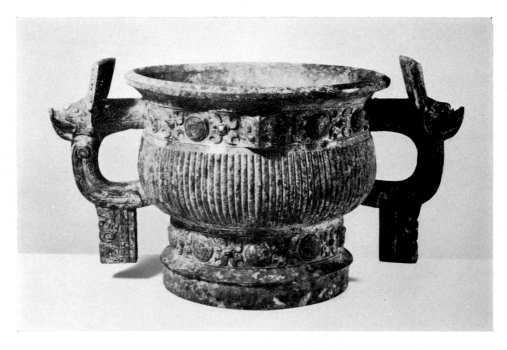

40*a*. Tsun. Late 11–10th century B.C. Transitional style.
Ht. 6 ins. Museum of Eastern Art, Oxford.

40*b*. The K'ang Hou kuei. Late 11th century B.C. Chou style.
Ht. 8¼ ins. Dugald Malcolm, Esq.
For detail of the handle see Pl. 81*b*.

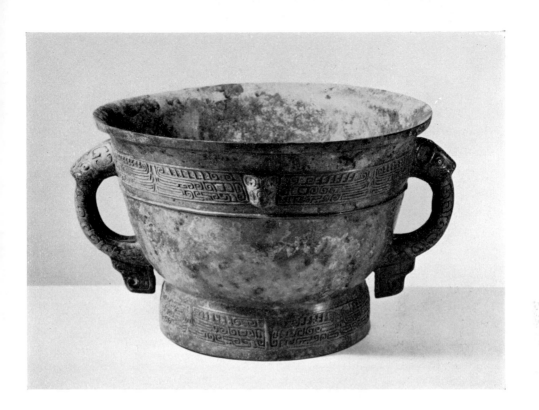

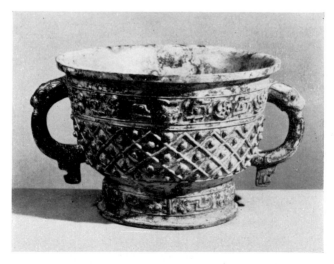

41a. Kuei. Late 11th century B.C. Transitional style.
Ht. 5¼ ins. Dugald Malcolm, Esq.

41b. Kuei. Late 11th century B.C. Chou style.
Ht. 6 ins. Formerly in the collection of Madame Wannieck.

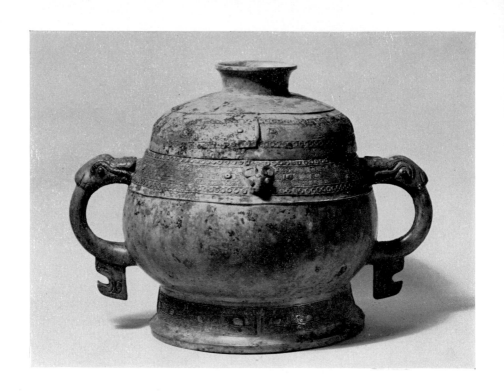

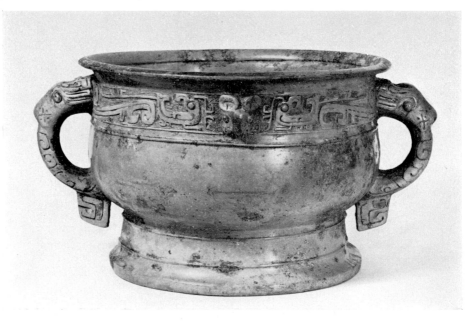

42*a*. Kuei. Late 11th–early 10th century B.C.
Transitional style. Ht. 6 ins.
Formerly in the collection of Denis Cohen, Esq.
Inscription, page 83.

42*b*. Kuei. Late 11th–early 10th century B.C.
Transitional style. Ht. 12 ins. British Museum.

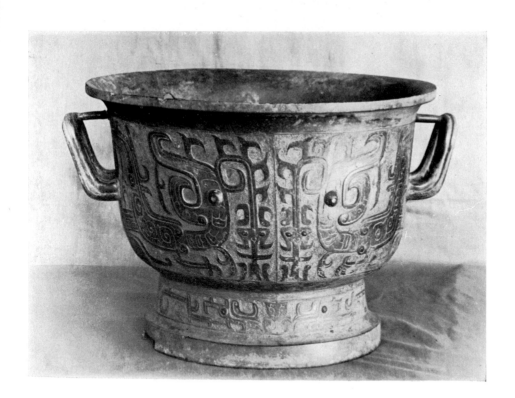

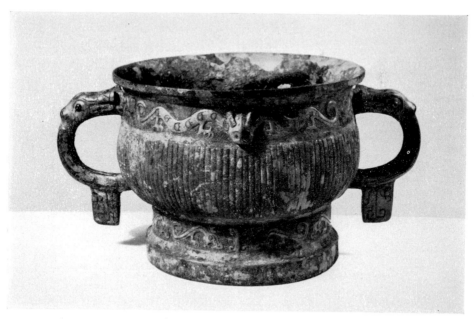

43a. Yen Hou Yü. Excavated at Hai Tao Ying Tzu, Ling Yüan Hsien, Jehol.
Late 11th or early 10th century B.C. Chou style.
Ht. 9½ ins. National Museum, Peking.

43b. Kuei. Late 11th–early 10th century B.C. Transitional style.
Ht. 6¾ ins. Museum of Far Eastern Art, Oxford.

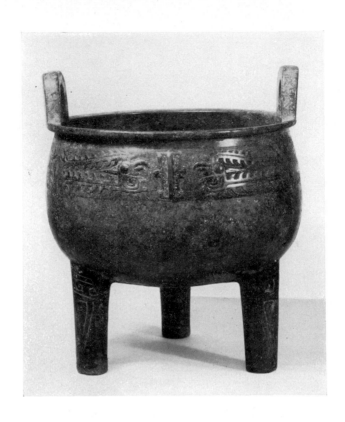

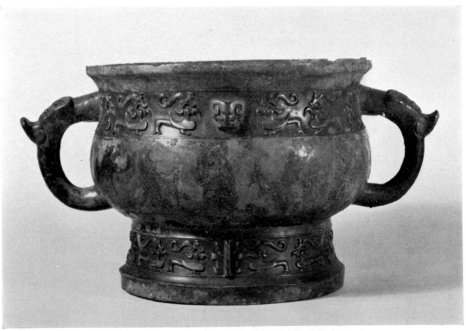

44a. Ting. Early 10th century B.C. Chou style.
Ht. 12½ ins. British Museum.

44b. Kuei. Late 11th–early 10th century B.C. Chou style.
Ht. 5¾ ins. Formerly in the collection of Lord Cunliffe.

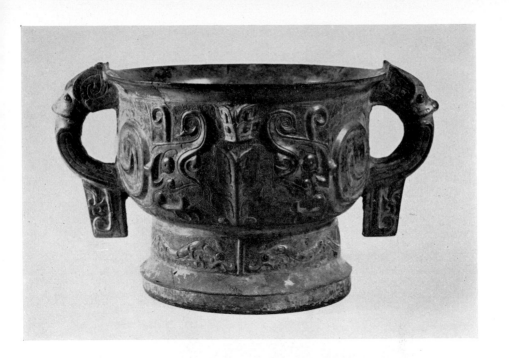

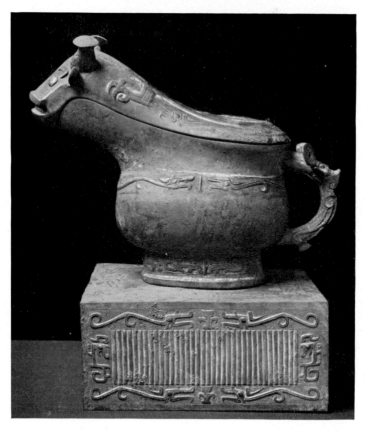

45a. Kuei. Late 11th–early 10th century B.C. Chou style.
Ht. 5·9 ins. Museum of Far Eastern Art, Oxford.

45b. Kuang. Excavated at Pao Chi Hsien, Shensi.
Late 11th century B.C. Chou style. Ht. 17 ins. Mr Ch'en Jen-t'ao.

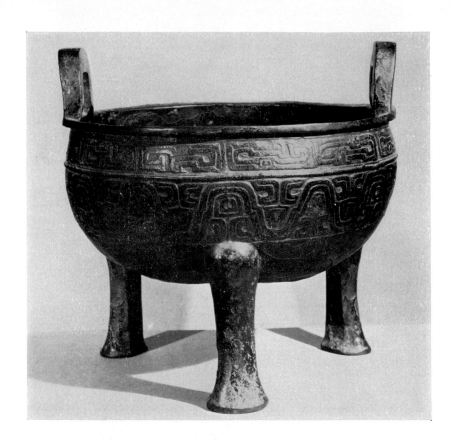

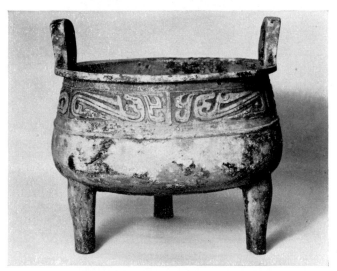

46a. T'se Jui Kung ting.
Late 9th century B.C.
Ht. 13½ ins.
Formerly Palace
Museum, Peking.

46b. Ting.
Mid 10th century B.C.
Ht. 8¼ ins.
British Museum.

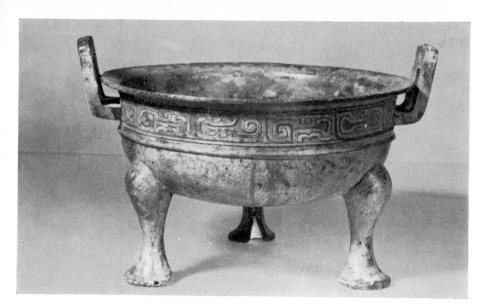

47a. Ting.
Late 10th–early 8th century
B.C. Ht. 9¼ ins.
Kunstindustrimuseum,
Copenhagen.
Inscription, page 83.

47b. Kuei.
9th century B.C. Ht. 5⅝ ins.
Museum of Far Eastern Art,
Oxford.

47c. Ting.
Excavated at Hai Tao Ying
Tzu, Ling Yüan Hsien, Jehol.
10th century B.C.
Ht. 9¼ ins. China.

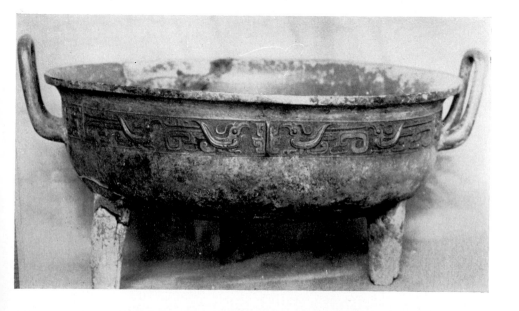

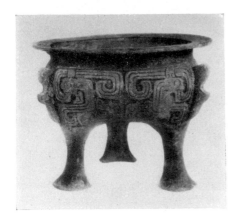

48a. Li.
Excavated at Hsin Cheng,
Honan. 8th century B.C.
Ht. 4¼ ins. China.

48b. Kuei.
Late 9th century B.C.
Ht. 12 ins.
William Rockhill Nelson
Gallery of Art,
Kansas City.
Inscription, page 87.

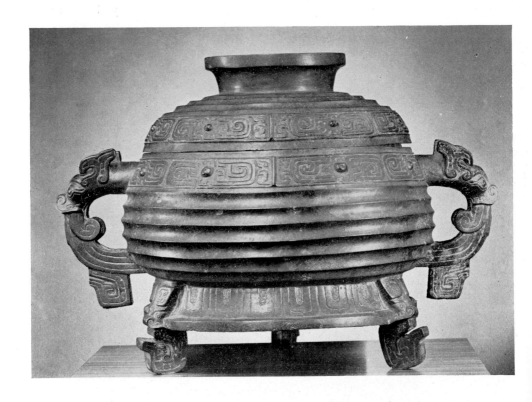

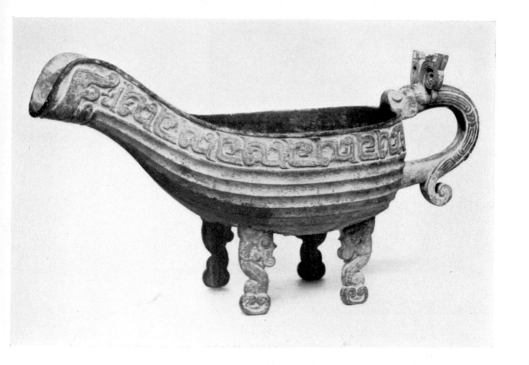

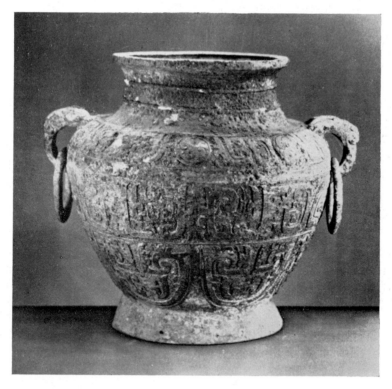

49a. The Ch'u Huan Yi. 8th or early 7th century B.C.
Length 15 ins. Sedgwick bequest. British Museum.
Inscription, page 84.

49b. Lei, excavated at P'u Tu Ts'un, Shensi.
10th century B.C. 9¾ ins. China.

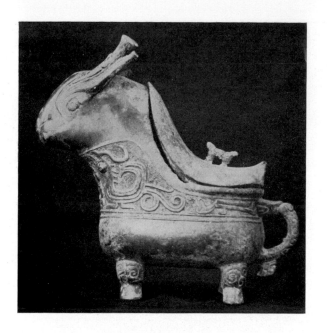

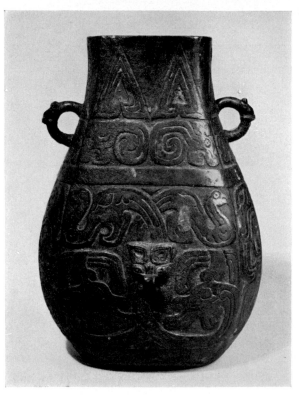

50a. Kuang, excavated at
Yen Tun Shan, Kiangsu.
10th century B.C.
Ht. 8¼ ins. China.

50b. Hu, archaistic, with
ornament based upon motifs
of the 8th–6th century B.C.
Ht. 9¾ ins.
Seligman bequest.
British Museum.
See page 21.

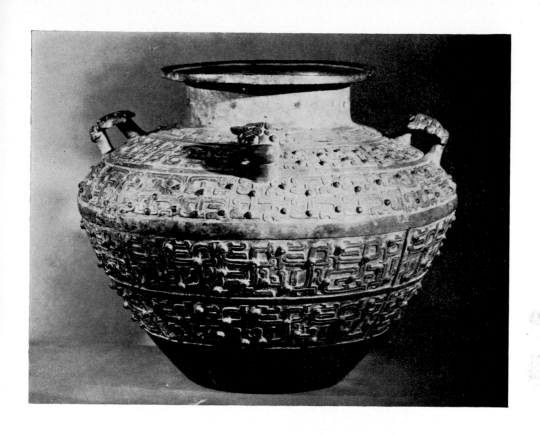

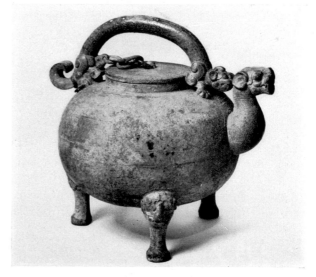

51a. Lei. 7th century B.C.
Ht. 9⅞ ins.
Buckingham collection.
The Art Institute of Chicago.

51b. Ho.
5th century B.C. Ht. 7 ins.
Dugald Malcolm, Esq.

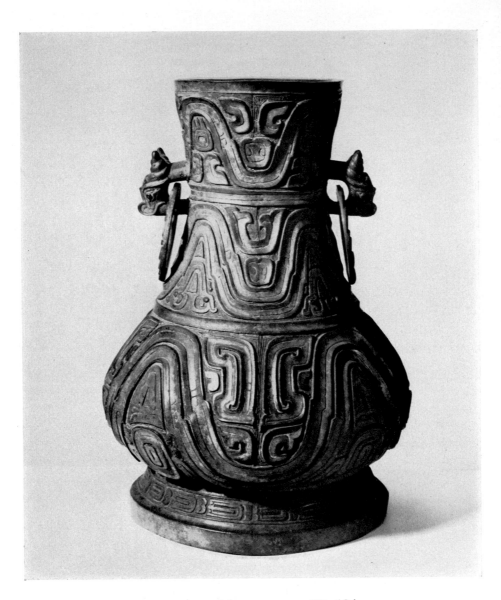

52. Hu. Late 9th century B.C. Ht. 18 ins.
British Museum. Inscription, page 83.

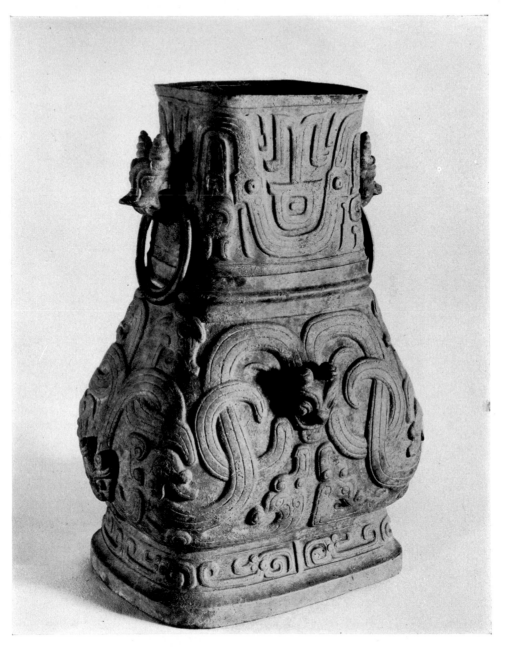

53. Hu. Late 9th or 8th century B.C.
Ht. 20⅛ ins. Art Institute of Chicago.

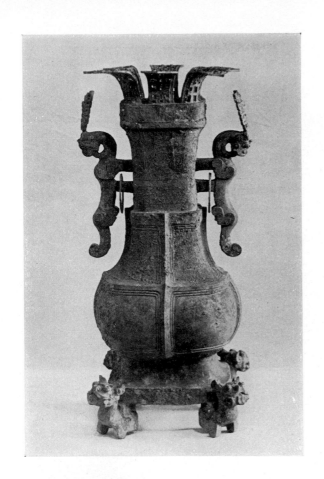

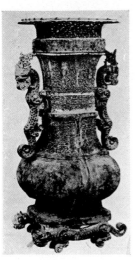

54a. Hu, from the tomb of the
Marquis of Ts'ai at Shou
Hsien, Anhui.
Early 5th century B.C.
Ht. 31½ ins. China.

54b. Hu, excavated at Hsin
Cheng, Honan.
Early 5th century B.C.
Ht. 20 ins. China.

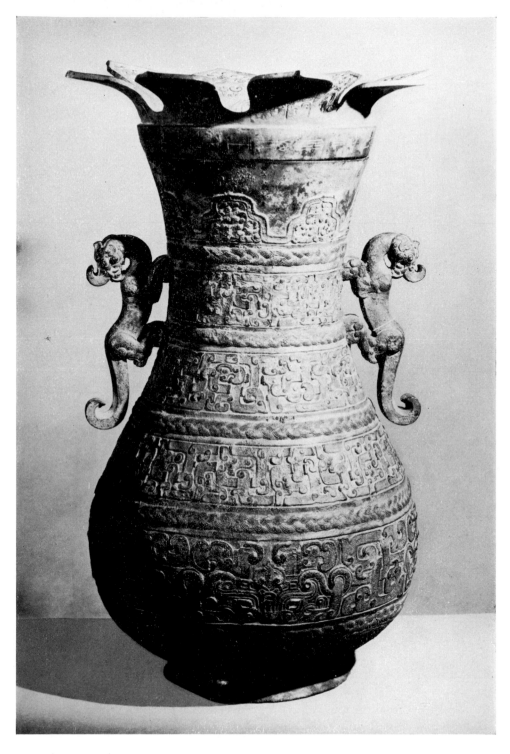

55. Hu, said to have been found with the bell of Pl. 68*a*. Early 5th century B.C.
Ht. 19 ins. British Museum, given in memory of A. E. K. Cull, Esq.
Inscription, page 86.

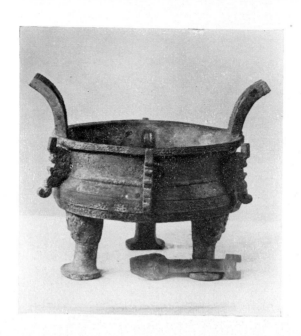

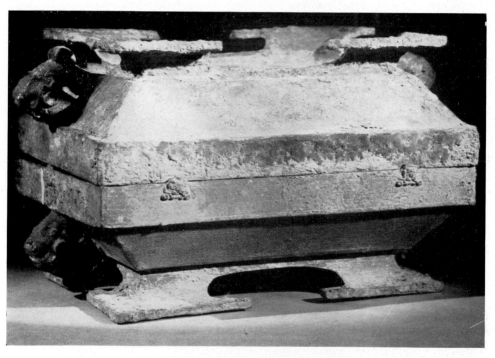

56a. Ting, from the tomb of the Marquis of Ts'ai at Shou Hsien, Anhui.
Early 5th century B.C. Ht. 7¾ ins. China.

56b. Fu, excavated at Hsin Cheng, Honan.
Late 6th or early 5th century B.C. Ht. 7⅞ ins. China.

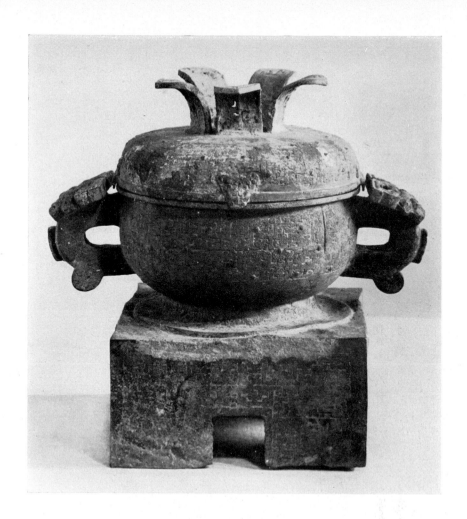

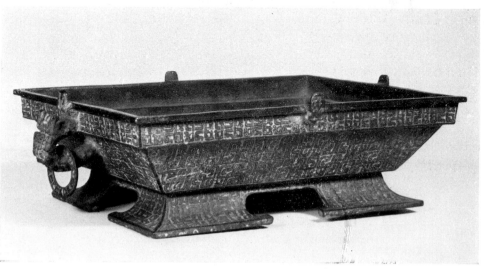

57*a*. Kuei, from the tomb of the Marquis of Ts'ai at Shou Hsien, Anhui.
Early 5th century B.C. Ht. 14⅛ ins. China.

57*b*. The Ch'u Tzŭ fu (lower part only). 6th or early 7th century B.C.
Ht. 4½ ins. Formerly in the collection of Lord Cunliffe. Inscription, page 84.

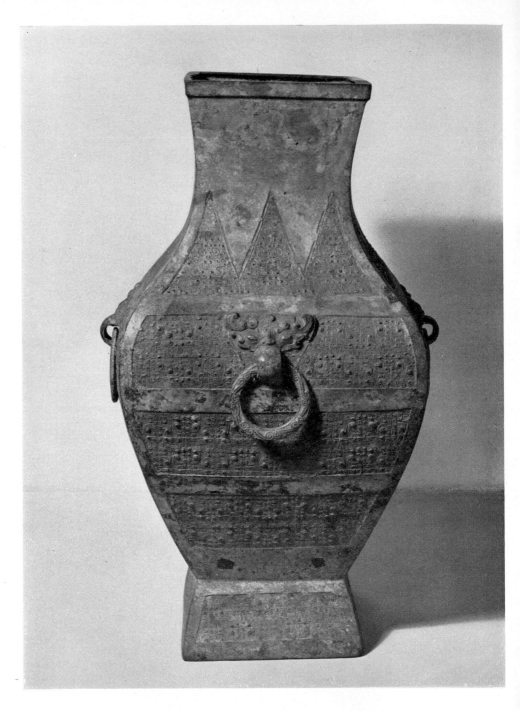

58. Hu. Late 5–4th century B.C. Ht. $16\frac{7}{8}$ ins.
Museum of Eastern Antiquities, Oxford.

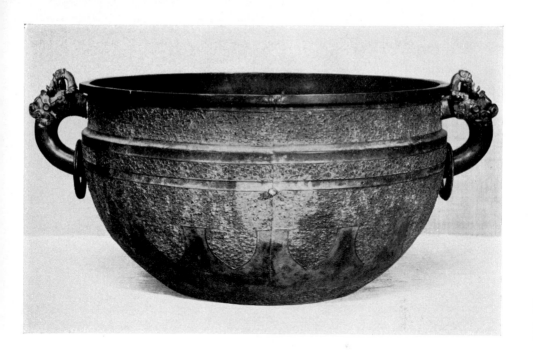

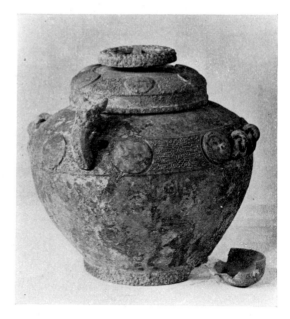

59a. Chien.
First half of the 5th century
B.C. Ht. 16⅜ ins.
Formerly in the collection of
Herr H. G. Oeder.

59b. Lei, from the tomb of the
Marquis of Ts'ai at Shou
Hsien, Anhui.
Early 5th century B.C.
Ht. 14⅛ ins. China.

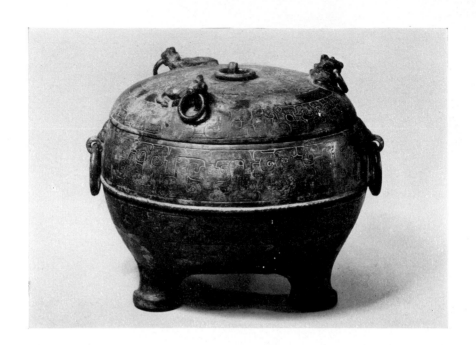

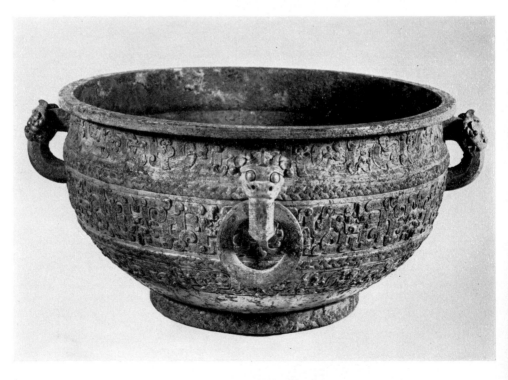

60a. Ting. Late 6th–early 5th century B.C.
Ht. 7¾ ins. British Museum.

60b. The Chih Chün Tzŭ chien. Early 5th century B.C.
Ht. 8¼ ins. Freer Gallery of Art.

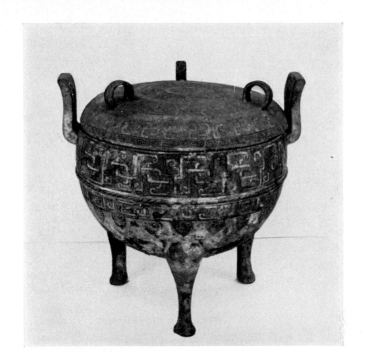

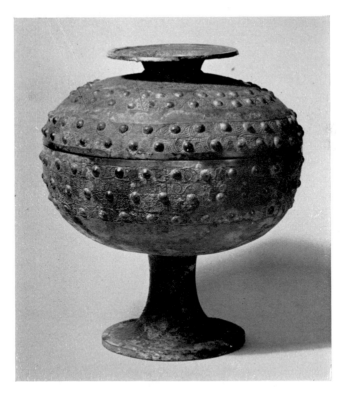

61*a*. Ting. 5th century B.C. Ht. *c.* 7 ins.
Formerly in the collection of the Marquess of Normanby.

61*b*. Tou. Late 5–4th century B.C. Ht. 8¼ ins.
Formerly in the collection of George de Menasce, Esq.

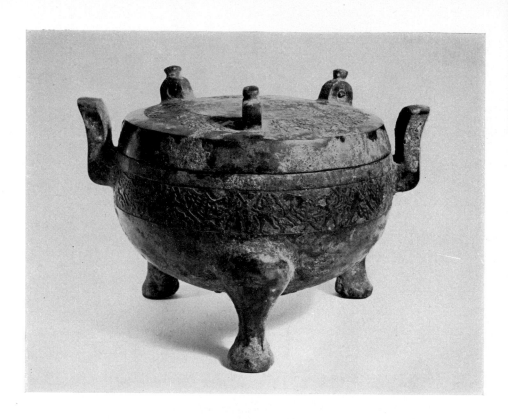

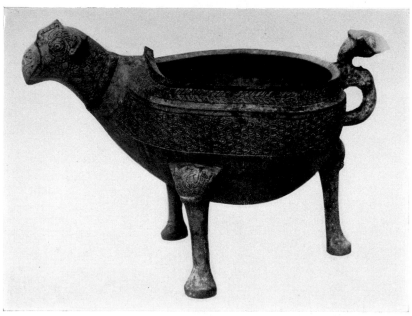

62a. Ting. 5th century B.C. Ht. 8⅛ ins.
Museum of Eastern Art, Oxford.

62b. Yi, excavated at T'ang Shan, Hopei. 5th century B.C.
Ht. 6¼ ins. China.

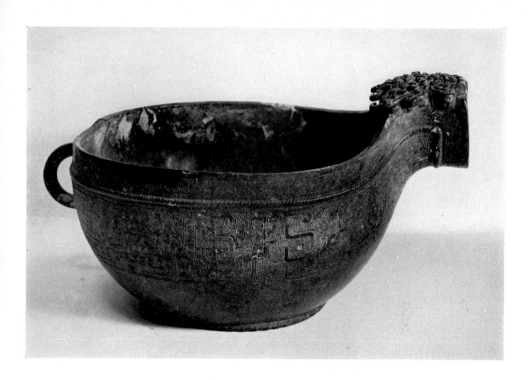

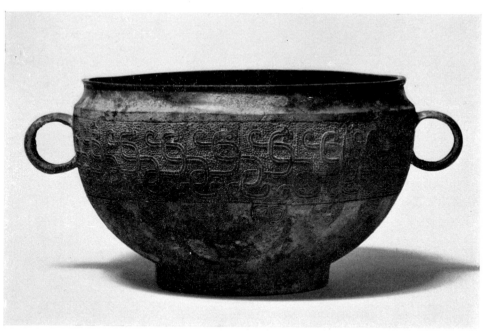

63a. Yi. 5th century B.C. Length 10 ins.
Formerly in the collection of H. Tozer, Esq.

63b. Bowl. Late 5th–early 4th century B.C. Ht. 7 ins.
Formerly in the collection of George de Menasce, Esq.

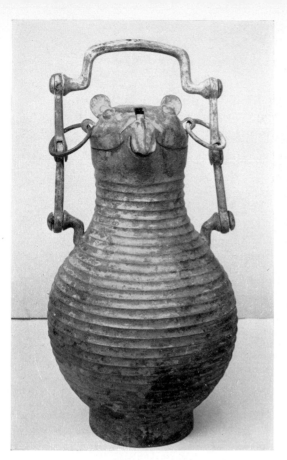

64a. Hu. 5–4th century B.C.
Ht. 10½ ins.
Formerly in the collection of
Baron Paul Hatvany.

64b. Hu, excavated at T'ang
Shan, Hopei. 5th century B.C.
Ht. 13¾ ins. China.

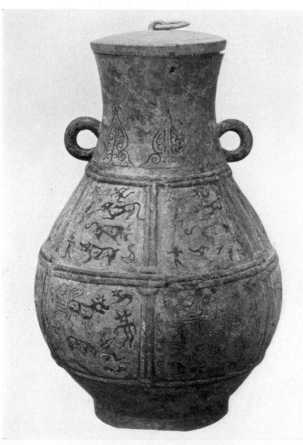

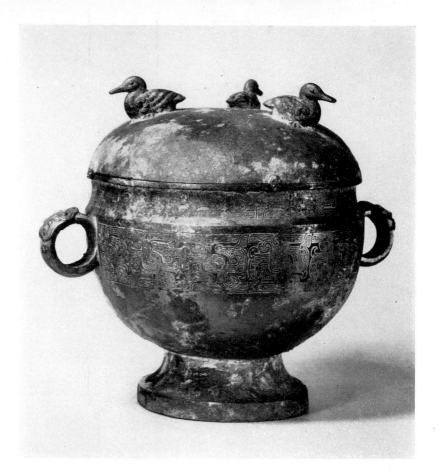

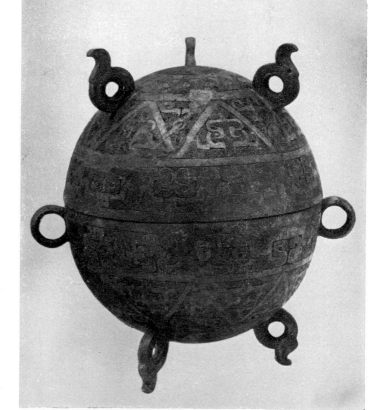

65a. Tou.
5th century B.C.
Ht. 6 ins.
Freer Gallery of
Art.

65b. Tui,
excavated at
T'ang Shan, Hopei.
5th century B.C.
Ht. 8⅝ ins. China.

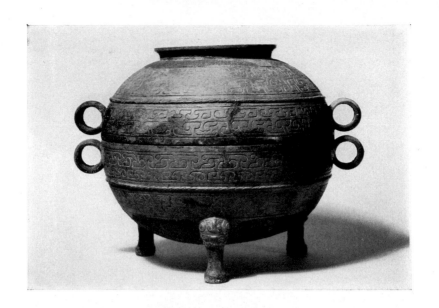

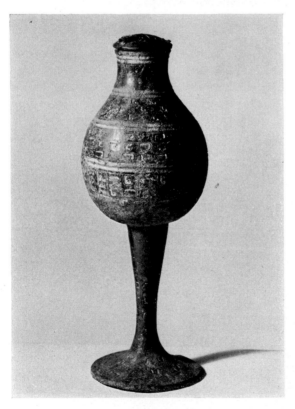

66a. Ting.
Late 5–4th century B.C.
Ht. 6½ ins.
Museum of Eastern Art,
Oxford.

66b. Hu on high foot.
4th century B.C. Ht. 11½ ins.
British Museum.

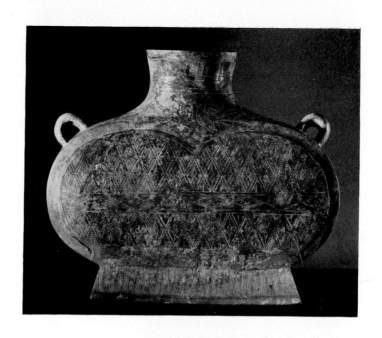

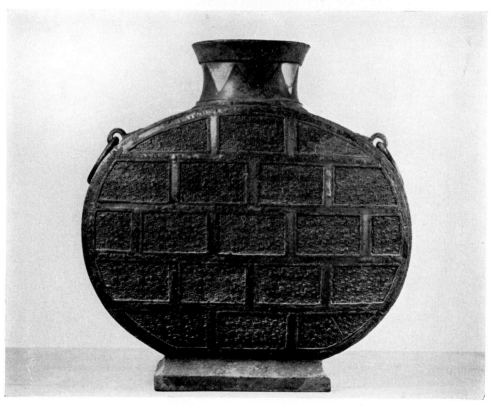

67a. Pien hu. 2nd–1st century B.C.
Ht. 8⅞ ins. The Art Institute of Chicago.

67b. Pien hu. 4th century B.C.
Ht. 13¼ ins. The Mount Trust.

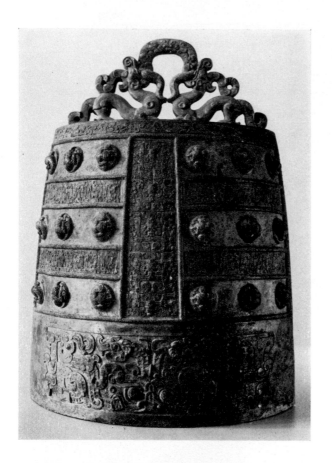

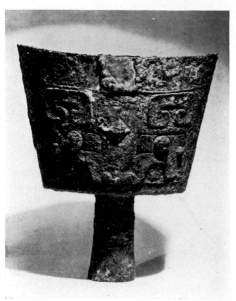

68a. Bell (chung) said to have
been found with the Cull Hu
Pl. 55. 5th century B.C.
Ht. 23 ins.
Museum van Aziatische
Kunst, Amsterdam.

68b. Bell (cheng).
12–11th century B.C.
Ht. 7¾ ins. British Museum.

69*a*. Bell (chung).
5th century B.C. Ht. 6 ins.
The Museum of Eastern
Art, Oxford.

69*b*. Bell (chung).
5th century B.C. Ht. 12 ins.
British Museum.

69*c*. Bell (chung).
5th century B.C. Ht. 9½ ins.
Formerly in the collection
of E. K. Burnett, Esq.
Inscription, page 85.

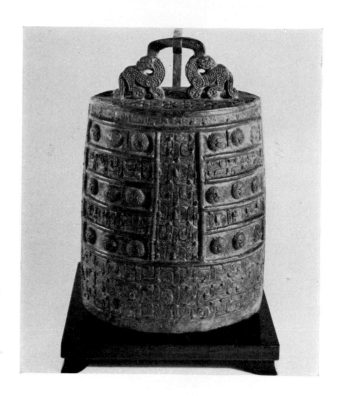

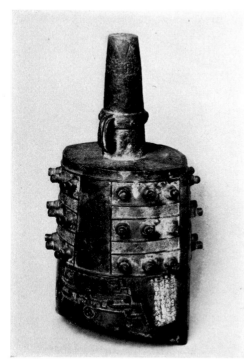

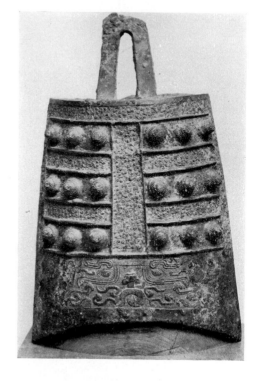

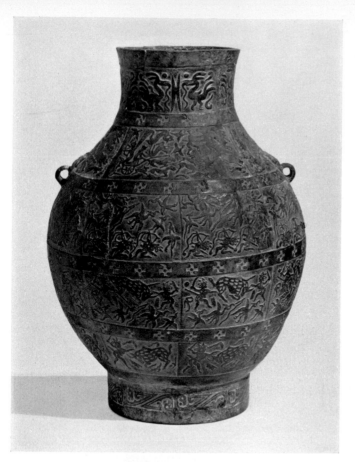

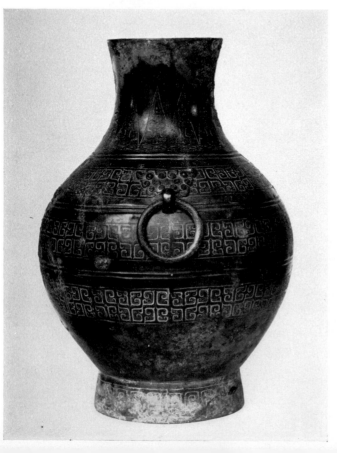

70*a*. Hu.
Late 5–4th century B.C.
Ht. 13¾ ins.
Kunstindustrimuseum,
Copenhagen.

70*b*. Hu.
4th–3rd century B.C.
Ht. 12½ ins.
British Museum.

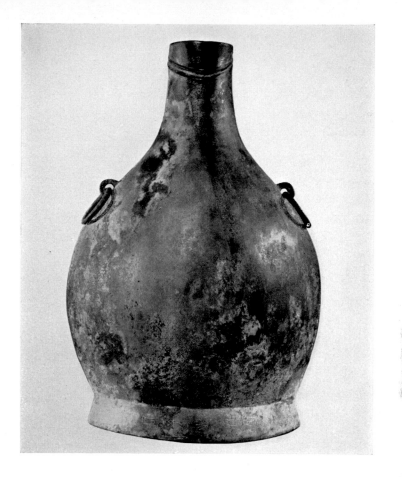

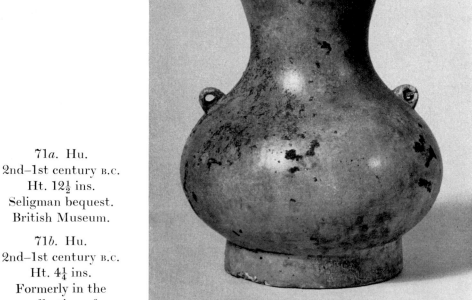

71a. Hu.
2nd–1st century B.C.
Ht. 12½ ins.
Seligman bequest.
British Museum.

71b. Hu.
2nd–1st century B.C.
Ht. 4¼ ins.
Formerly in the
collection of
Lord Cunliffe.

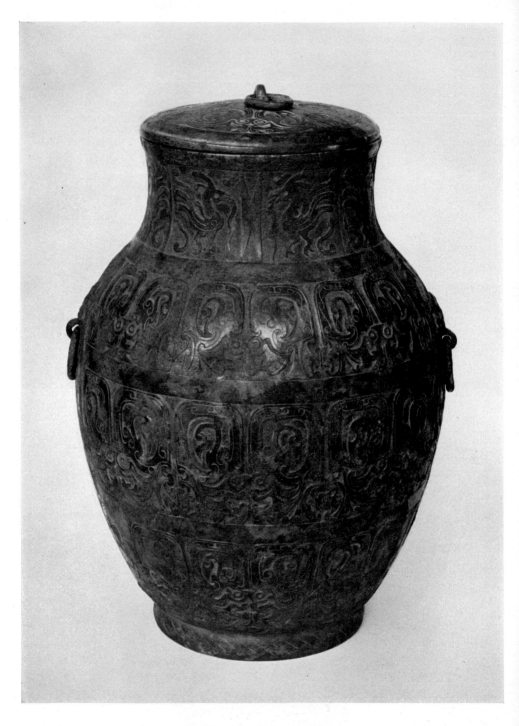

72. Hu. 4th–3rd century B.C.
Ht. 10 ins. British Museum.

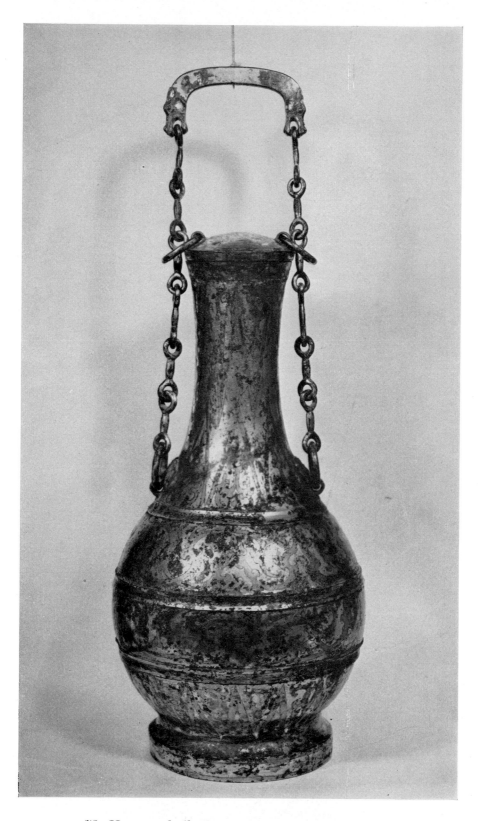

73. Hu, parcel-gilt. 1st century B.C.–1st century A.D.
Ht. 14¼ ins. Guimet Museum, gift of David Weill.

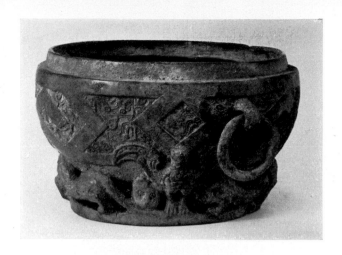

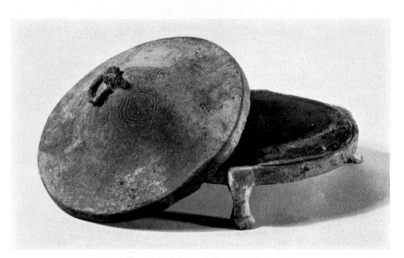

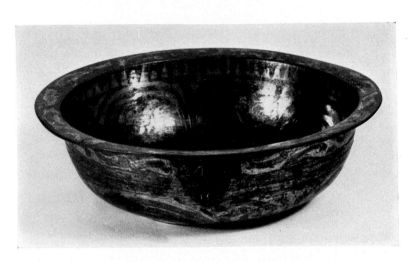

74*a*. Bowl. 4th–3rd century B.C. Ht. 2½ ins.
Museum of Far Eastern Antiquities, Stockholm.

74*b*. Ink stone holder. 1st century B.C.–1st century A.D.
Diam. 4½ ins. Museum of Eastern Art, Oxford.

74*c*. Bowl, parcel-gilt. 1st century B.C.–1st century A.D.
Diam. 7 ins. Museum of Eastern Art, Oxford.

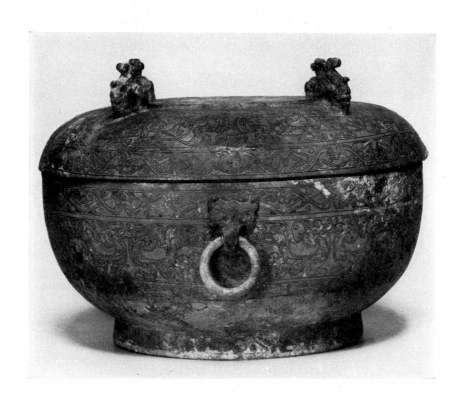

75a. Bowl with cover.
4th–3rd century B.C.
Ht. 5¾ ins.
The Freer Gallery of Art.

75b. Pien hu.
1st century B.C.–1st century
A.D. Ht. c. 6½ ins.
Museum of Far Eastern
Antiquities, Stockholm.

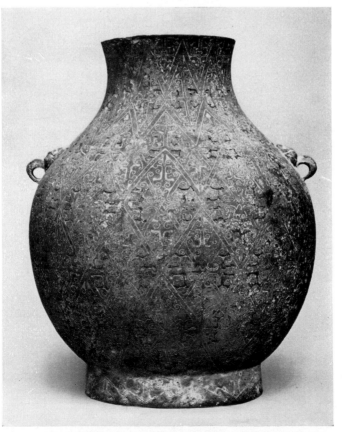

76a. Hu.
4th–3rd century B.C.
Ht. 10 ins.
British Museum.

76b. Hu with inlay of
silver and turquoise.
4th–3rd century B.C.
Ht. 9¾ ins.
British Museum.

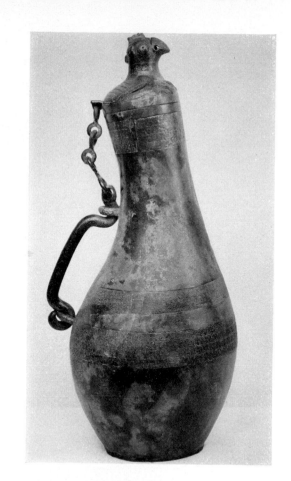

77a. Asymmetric hu.
4th–3rd century B.C.
Ht. 12⅝ ins.
Seligman bequest.
British Museum.

77b. Hu. 2nd–1st century B.C.
Ht. 8¼ ins.
Museum of Eastern Art,
Oxford.

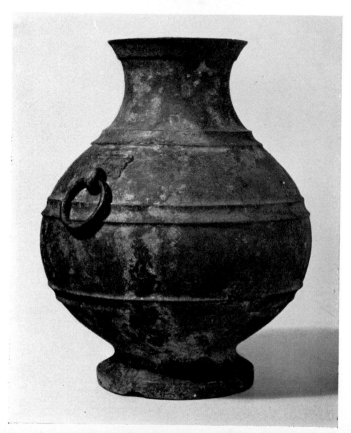

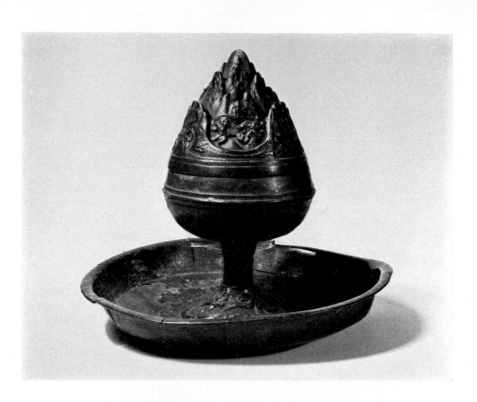

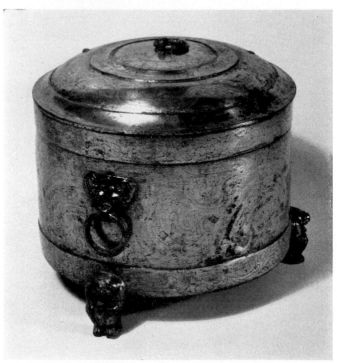

78a. Hill censer. 1st century B.C.–1st century A.D.
Ht. 7 ins. Victoria and Albert Museum.

78b. Lien, parcel-gilt. 1st century B.C.–1st century A.D.
Ht. 5½ ins. Victoria and Albert Museum.

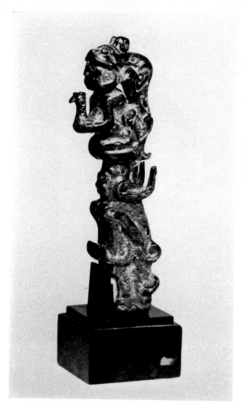

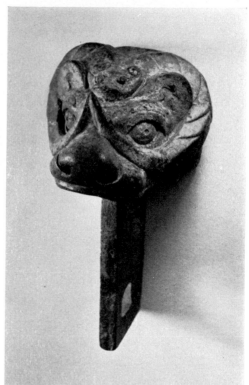

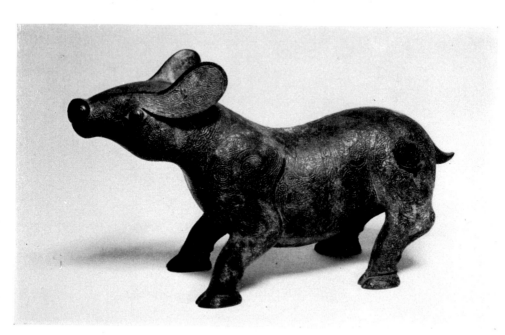

79a. Finial in form of monster, man and bird.
Early Chou dynasty. Ht. 5½ ins. Sedgwick bequest. British Museum.

79b. Ram-head linch-pin. 9–6th century B.C.
Length 4¾ ins. Dugald Malcolm, Esq.

79c. Tapir. Late 6th–early 5th century B.C.
Length 8 ins. British Museum.

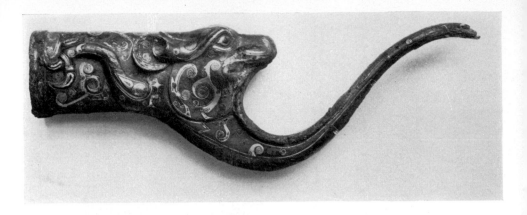

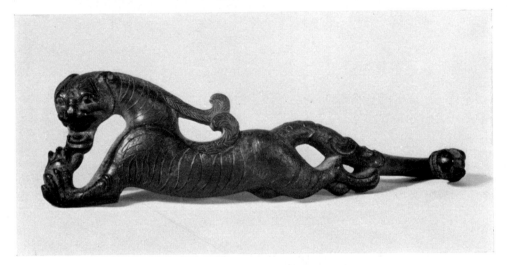

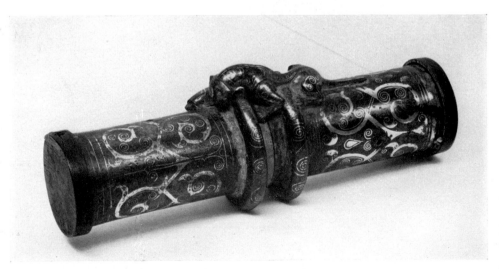

80*a*. Chariot part inlaid with gold. Excavated at Chin Ts'un, Honan.
4th century B.C. Length 10¼ ins. British Museum.

80*b*. Belt hook. 2nd–1st century B.C.
Length 6¼ ins. British Museum.

80*c*. Chariot part inlaid with gold. 3rd century B.C. Length 7½ ins.
Formerly in the collection of Monsieur J. Homberg.

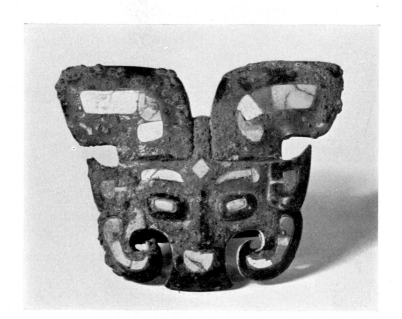

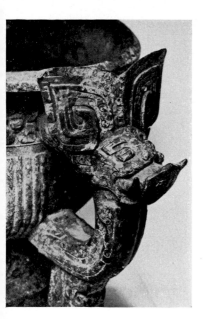

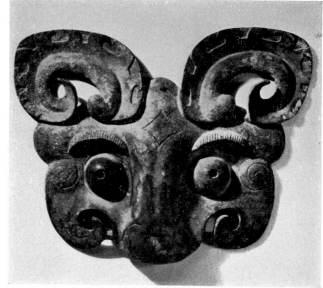

81*a*. T'ao t'ieh with inlay of stones. 9–7th century B.C.
Ht. 4½ ins. Museum of Eastern Art, Oxford.

81*b*. Detail of the kuei of Pl. 40*b*.

81*c*. T'ao t'ieh. 9–7th century B.C.
Width 7¾ ins. Dugald Malcolm, Esq.

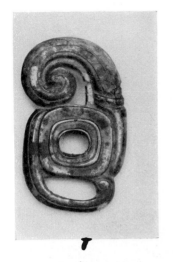

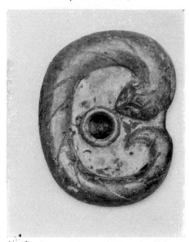

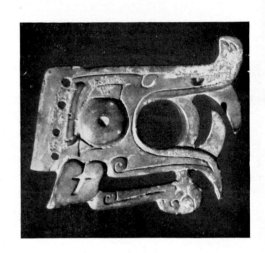

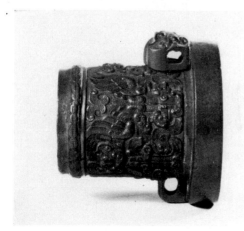

82*a–d*. Bridle cheek-pieces.
8–6th centuries B.C.
Bottom right, Kunstindustri-
museum, Copenhagen;
remainder, British Museum.

82*e*. Axle-cap from chariot.
4th century B.C. Length $3\frac{3}{4}$ ins.
Victoria and Albert Museum.

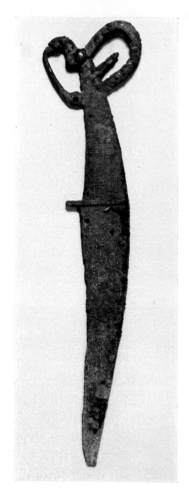

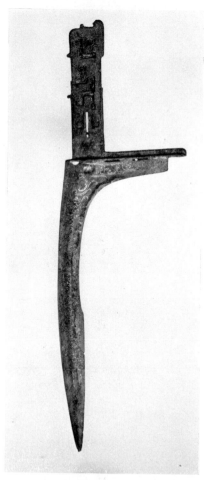

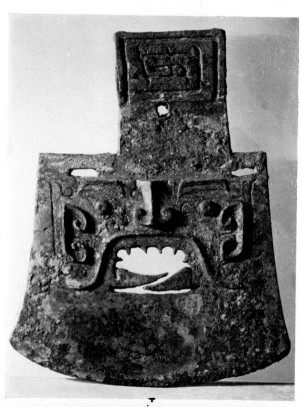

83a. Knife with ibex-head
pommel, the eye inlaid with
turquoise.
12–11th century B.C.
Length 14 ins.
Formerly in the collection
of Lord Cunliffe.

83b. Ko with inlaid gold
decoration.
4th–3rd century B.C.
Length 12 ins.
British Museum.

83c. Axe, yüeh.
12–11th century B.C.
Ht. 9¾ ins. British Museum.

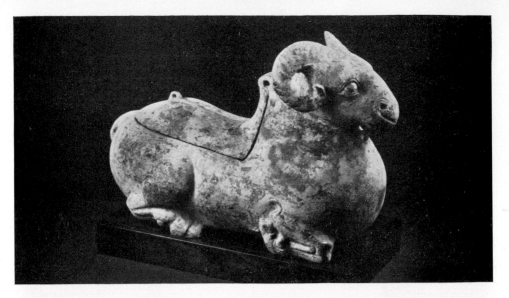

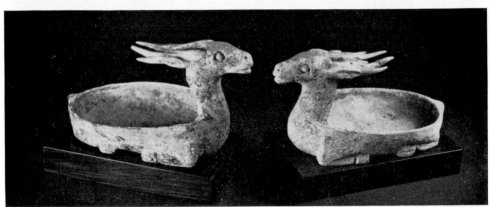

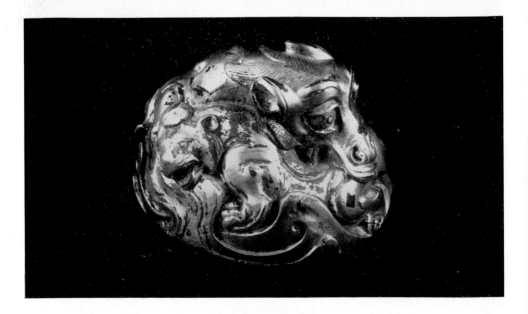

84*a*, *b*. Lamps in shapes of ram and deer. Han Dynasty.
Length resp. 9 ins, 4½ ins. The Mount Trust.

84*c*. Gilt bronze ornament. Han Dynasty.
Width 4¼ ins. The Mount Trust.

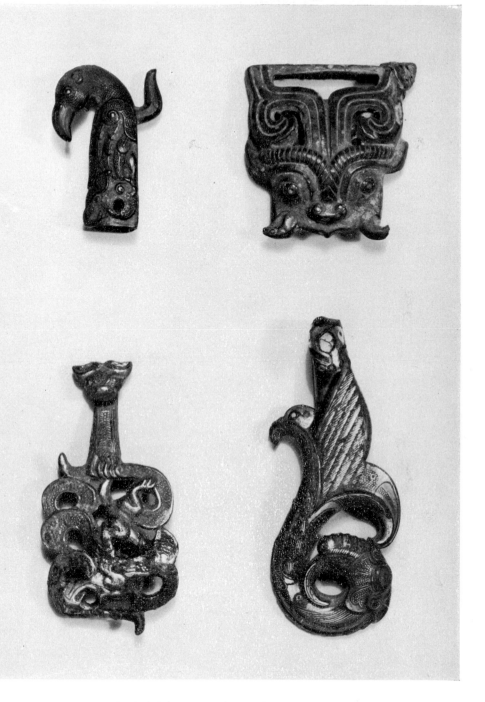

85a. Pole finial from chariot. 3rd–2nd century B.C.
Length 2¼ ins. British Museum.

85b. Harness buckle. 7–6th century B.C.
Ht. 1¾ ins. British Museum.

85c. Gilt bronze belt hook. 4th–3rd century B.C.
Length 3¾ ins. British Museum.

85d. Belt hook inlaid with gold and turquoise.
Han Dynasty. Length 4 ins. British Museum.

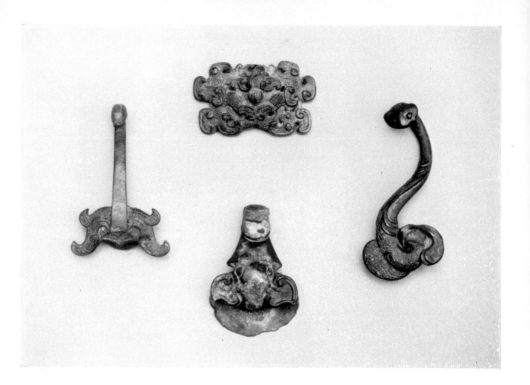

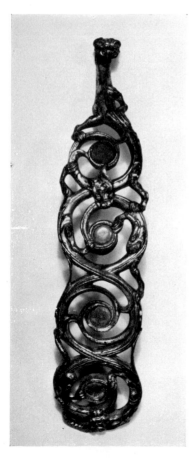

86a. Belt hooks. 4th–3rd century B.C.
Length of hook on left 3⅛ ins.
British Museum.

86b. Belt hook, gilt bronze with jade inlay.
3rd–2nd century B.C. British Museum.

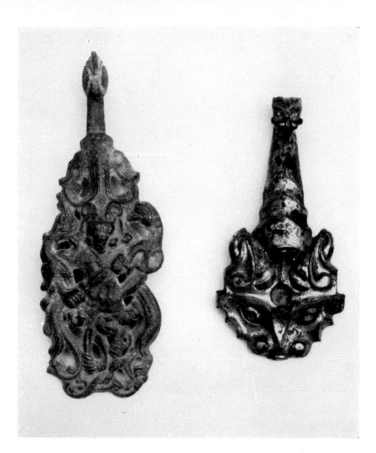

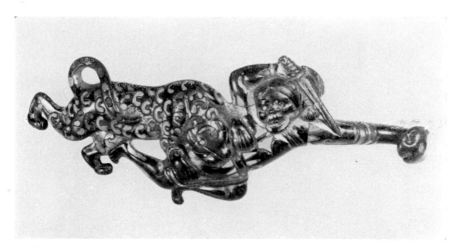

87*a*. Gilt bronze belt hook. 2nd–1st century B.C.
Length 4⅞ ins. British Museum.

87*b, c*. Left: belt hook portraying the bellicose monster Chʻih Yu.
1st–2nd century A.D. Length 5¾ ins.
Right: Gilt bronze belt hook. 2nd–1st century B.C. Length 4½ ins. British Museum.

87*d*. Belt hook with turquoise inlay. 1st century B.C.–1st century A.D.
Length 4⅞ ins. Kunstindustrimuseum, Copenhagen.

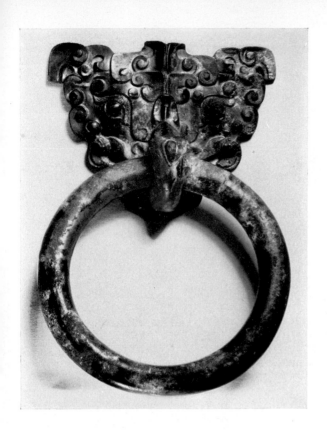

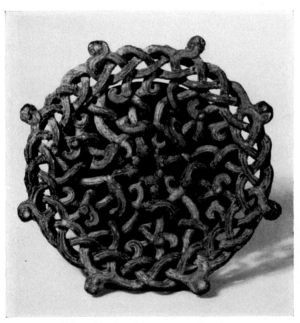

88*a*. Coffin handle.
3rd–2nd century B.C.
Ht. 8¼ ins.
Dugald Malcolm, Esq.

88*b*. Openwork ornament.
4th century B.C.
Diameter 4½ ins.
Museum of Eastern Art,
Oxford.

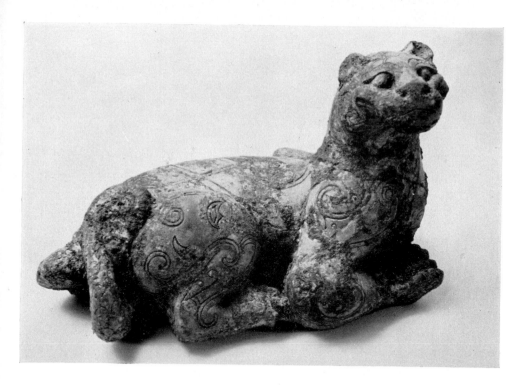

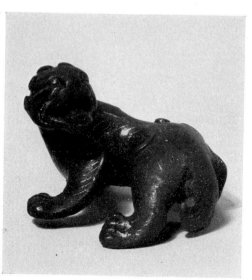

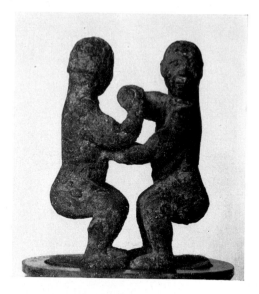

89*a*. Tiger. 4th–3rd century B.C. Length 6⅝ ins.
Museum of Far Eastern Antiquities, Stockholm.

89*b*. Tiger. 3rd–1st century B.C. Length 2½ ins.
Formerly in the collection of Lord Cunliffe.

89*c*. Wrestlers. 5th–3rd century B.C.
Ht. 6 ins. British Museum.

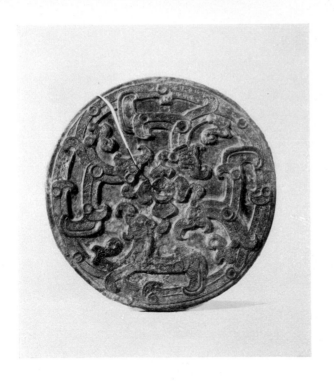

90a. Mirror.
4th century B.C.
Diameter 4½ ins.
Stoclet collection.

90b. Mirror.
4th century B.C.
Diameter 7¼ ins.
Stoclet collection.

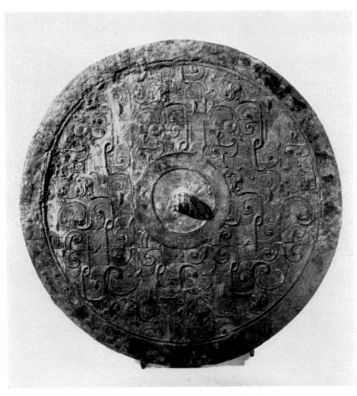

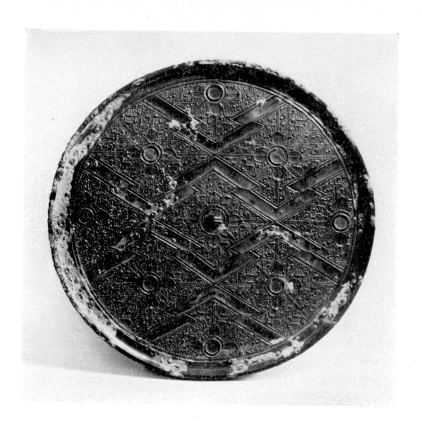

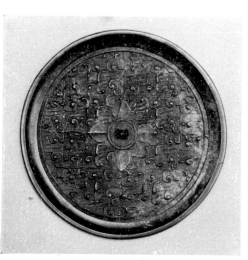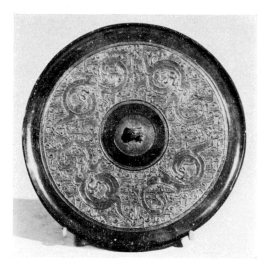

91a. Mirror. Shou Hsien type. Late 4th–3rd century B.C.
Diameter 9¼ ins. British Museum.

91b. Mirror. Shou Hsien type. Late 4th–3rd century B.C.
Diameter 3⅞ ins. British Museum.

91c. Mirror. Shou Hsien type. Late 4th–3rd century B.C.
Diameter 6 ins. Sedgwick bequest. British Museum.

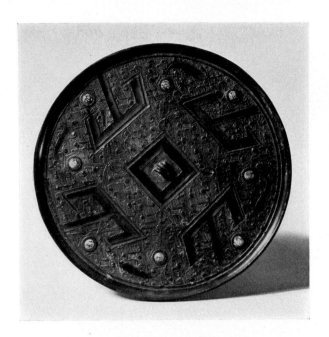

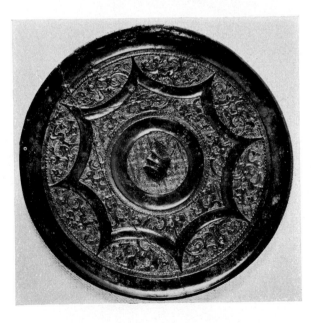

92a. Mirror with turquoise
inlay. Shou Hsien type.
3rd century B.C.
Diameter 6 ins.
Museum of Eastern Art,
Oxford.

92b. Mirror.
2nd century B.C.
Diameter 7 ins.
National Museum of Scotland.

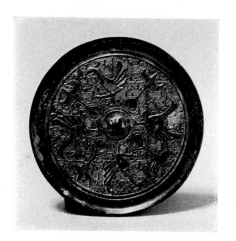

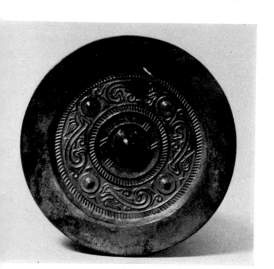

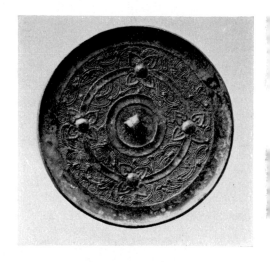

93a. Mirror. Shou Hsien type.
Diameter 4⅝ ins. British Museum.

93b. Mirror with dragon band. 1st century B.C. Diameter 4½ ins.
Formerly in the collection of Lord Cunliffe.

93c. Mirror. Late Shou Hsien type. 2nd century B.C.
Diameter 4⅞ ins. In the collection of
His Late Majesty King Gustav VI Adolph.

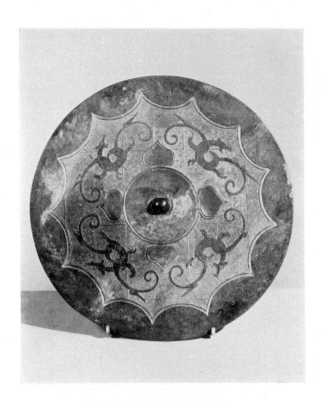

94*a*. Mirror. Loyang type.
3rd century B.C.
Diameter 8⅝ ins.
M. Calmann.

94*b*. TLV mirror.
Late 1st century B.C.
Diameter 6¼ ins.
Seligman bequest.
British Museum.
Inscription, page 100.

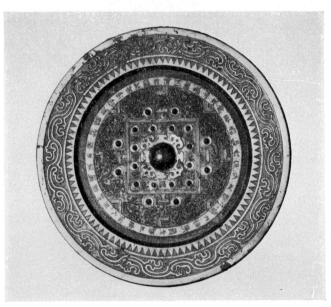

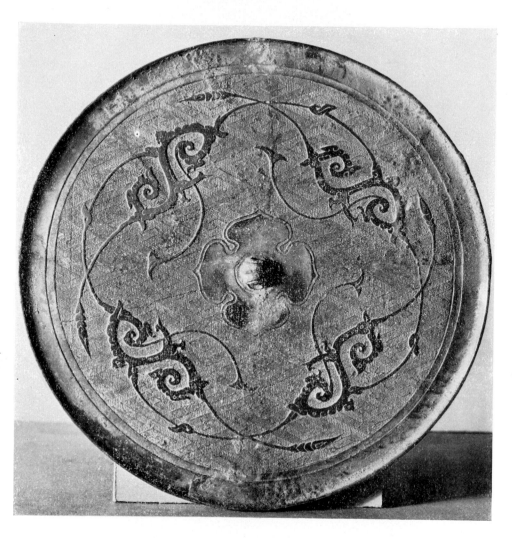

95. Mirror. Loyang type. 3rd century B.C.
Diameter 8⅜ ins. The Art Institute of Chicago.

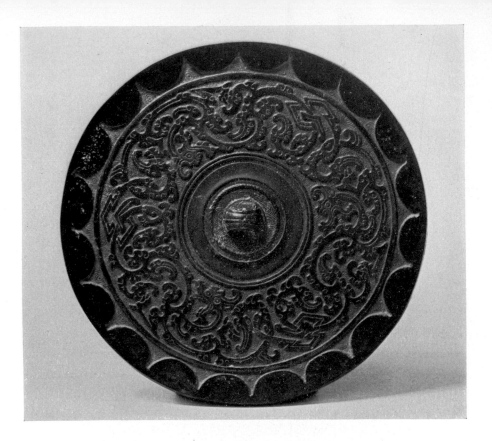

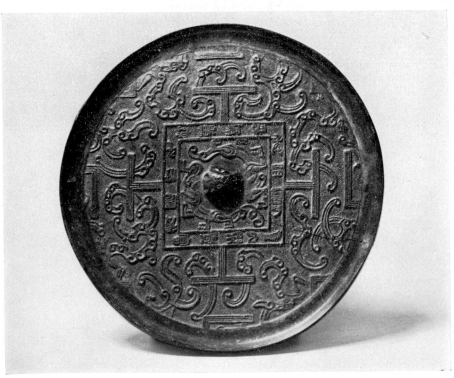

96*a*. Dragon scroll mirror. 2nd century B.C.
Diameter 5½ ins. British Museum.

96*b*. TLV mirror with cloud scrolls. Late 2nd or early 1st century B.C.
Diameter 4½ ins. British Museum.

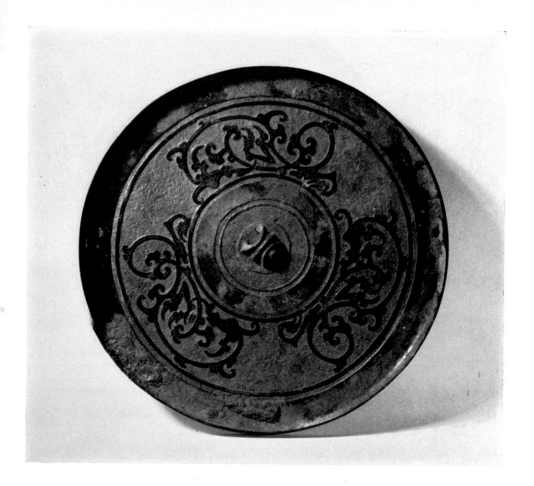

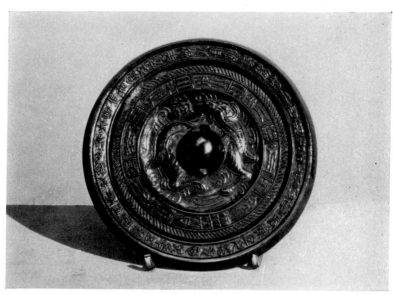

97a. Mirror. Loyang type. Late 3rd–early 2nd century B.C.
Diameter 7½ ins. Museum of Eastern Art, Oxford.

97b. Astronomical mirror. Dated A.D. 121. Diameter 3⅞ ins.
British Museum. Inscription, page 106.

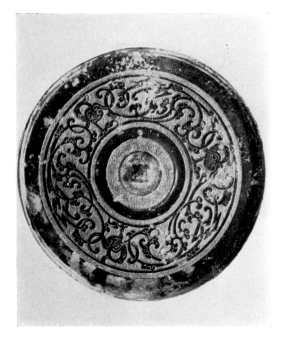

98*a*. Dragon scroll mirror.
Late 3rd–2nd century B.C.
Diameter 5$\frac{5}{16}$ ins.
In the collection of
His Late Majesty King
Gustav VI Adolph.

98*b*. Dragon scroll mirror.
2nd century B.C.
Diam. 7$\frac{1}{2}$ ins.
In the collection of
His Late Majesty King
Gustav VI Adolph.

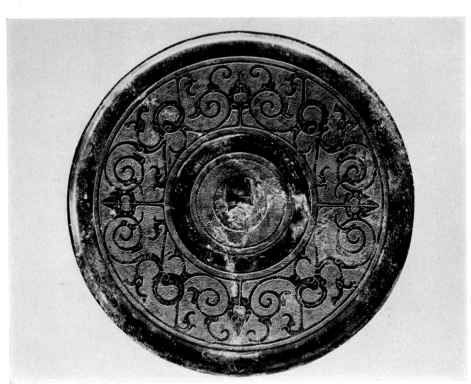

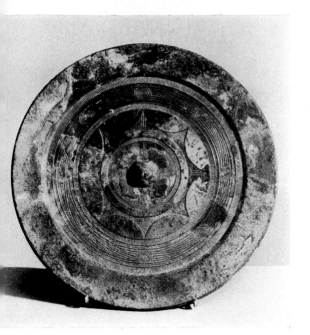

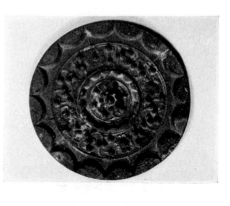

99*a*. Astronomical
mirror. 1st century A.D
Diam. 8½ ins.
Monsieur D. David Weill.

99*b*. Star-cluster
mirror. 1st century B.C.
Diam. 4 ins.
Musée Guimet.

99*c*. Astronomical
mirror. 1st century B.C.
Diam. 7¾ ins.
Formerly in the
collection of
Lord Cunliffe.

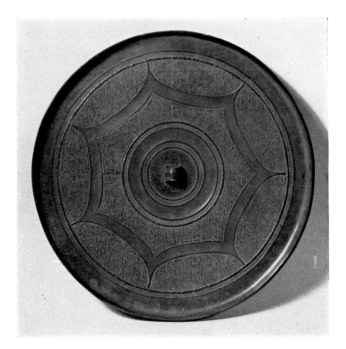

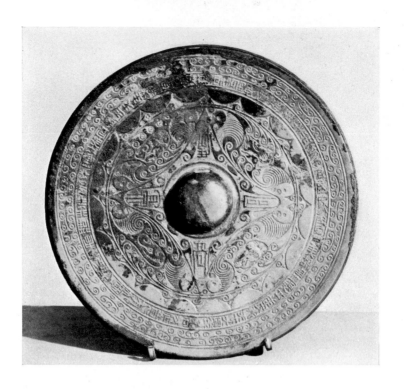

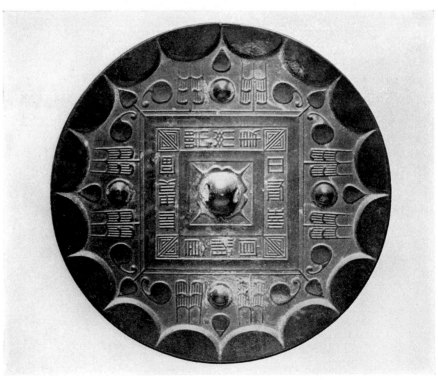

100*a*. Animal mask mirror. 2nd century A.D. Diam. 5½ ins.
Monsieur D. David Weill. Inscription, page 106.

100*b*. Ts'ao yeh mirror. 1st century A.D.
Diam. 6¼ ins. Hallwyl collection, Stockholm.
Inscription, page 105.

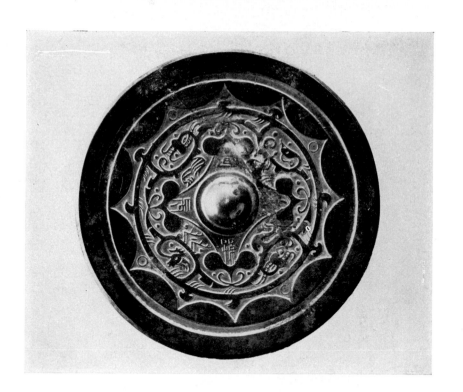

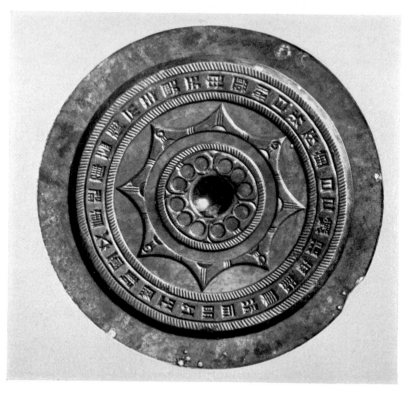

101*a*. Dragon-band mirror. 2nd century A.D.
Diam. 4¼ ins. In the collection of
His Late Majesty King Gustav VI Adolph.

101*b*. Astronomical mirror. 1st century A.D. Diam. 6 ins.
British Museum. Inscription, page 106.

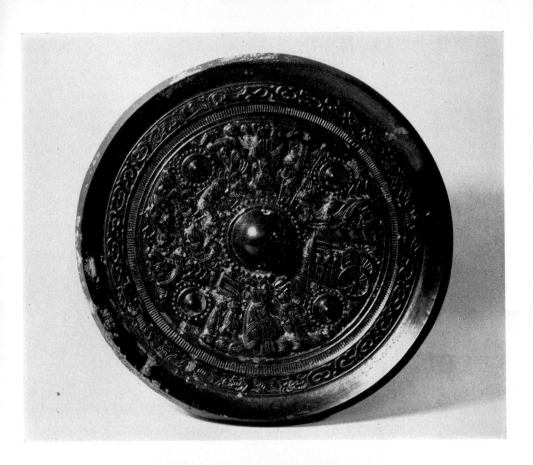

102a. Mirror depicting Taoist deities, carriage and cavalry skirmish, with (b) detail.
Found at Shao Hsing, K'iangsu. Late 2nd century A.D.
Diam. 8¼ ins. British Museum.

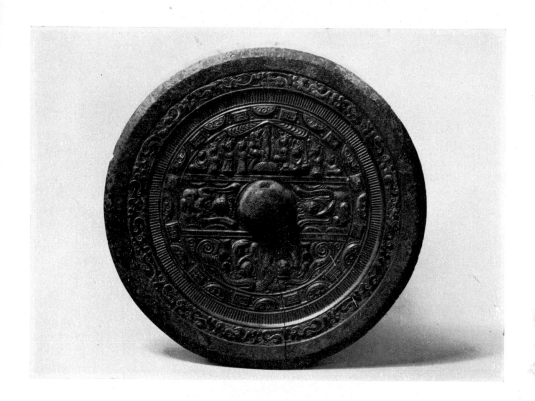

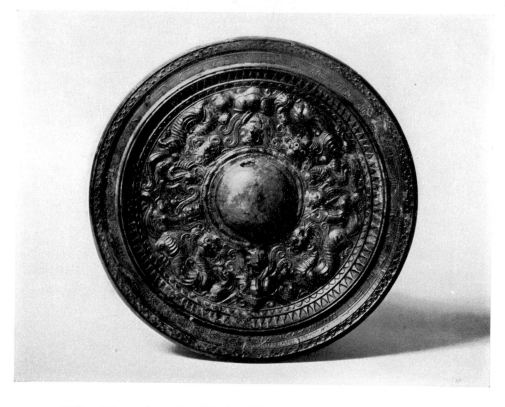

103a. Mirror depicting Taoist deities. Late 2nd–3rd century A.D.
Diam. 6 ins. British Museum.

103b. Mirror depicting Taoist deities with dragons. Late 2nd–3rd century A.D.
Diam. 5¾ ins. The Museum of Eastern Art, Oxford.

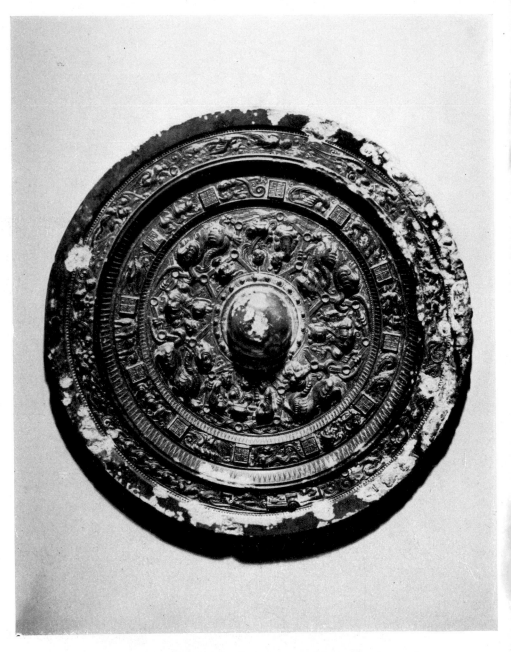

104. Mirror with Taoist deities and heavenly animals. Late 2nd–3rd century A.D. Diam. $5\frac{11}{16}$ ins. Formerly in the collection of Desmond Gure, Esq. Inscription, page 107 f.